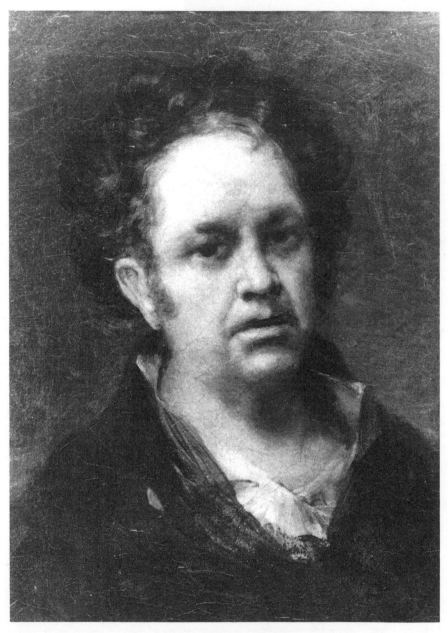

Goya, Self Portrait

Cincinnati
nov 6th, 94

Goya:
Man Among Kings

Goya,
últivca vretij uele

MONICA

By the same author

Charles III and the Revival of Spain

University Press of America
Washington, D.C. 1980

From a Foreign Shore (poems)

Scrivener Press
Oxford, England, 1956

Weather in Spectrum (poems)

Cambridge Circle Press
Cambridge, Mass., 1969

Goya:
Man Among Kings

Anthony H. Hull

MADISON BOOKS
Lanham • New York • London

Goya *was originally published by Hamilton Press, an
imprint of Madison Books, in 1987.*

Madison Books
4720 Boston Way
Lanham, Maryland 20706

Distributed by National Book Network

The paper used in this publication meets the minimum
requirements of American National Standard for
Information Sciences—Permanence of Paper for
Printed Library Materials, ANSI Z39.48–1984. ∞™
Manufactured in the United States of America.

Library of Congress Cataloging-in-Publication Data
Hull, Anthony H.
Goya : man among kings.
Bibliography.
Includes index.
1. Goya, Francisco, 1746–1828. 2. Artists—Spain—
Biography. I. Title.
N7113.G68H84 1986
760'.092'4 [B] 86-25651

ISBN 0–8191–5241–2 (cloth : alk. paper)
ISBN 1–56833–000–6 (pbk. : alk. paper)

Contents

List of Illustrations

LOCATION

Goya, self-portrait, Frontispiece Prado

FOLLOWING PAGE 116:

Josefa Bayeu (?)	Prado
Francisco Bayeu	Prado
Martín Zapater	Cramer Gallery, The Hague
The Duchess of Alba	Hispanic Society, New York
The Duchess of Alba showing her Hair	Prado
The Straw Man being Tossed in a Sheet	Prado
Charles III	Prado
Charles IV and family	Prado
Ferdinand VII	Prado
The May 2, 1808, Uprising	Prado
The May 3, 1808, Executions	Prado
Leocadia Zorrilla (from the *Black Paintings*)	Prado

Front map: Spain and Adjacent Areas
Back map: Towns of Spain

Foreword

There are not many satisfactory treatments of Goya in English. This is hardly surprising, for he was a complex man living in a complex age, and the task in comprehensive terms would be enormous. There are of course the conventional (though often chronologically inaccurate) accounts of his work aimed chiefly at the art student and at lovers of art in general, and this is all to the good. But what of Goya the man? And what of Goya as a product of civilization, reflecting in microcosm all the faults, dilemmas, and contradictions of his turbulent times?

One aim of this book is to present an historian's view from this perspective. Goya's message to humanity is a profound one, conveyed through forms of the very greatest art but in such a way that they mirror a deeper landscape than the context of their subject. They mirror of course his development as well, and as this is an important part of this study, his art is seen from a biographical rather than from a technical standpoint. But one reinforces the other. The more that is known about the sequence of events in his life, the better his individual art works can be understood.

So many gaps and mysteries remain about his life that where no cast-iron evidence exists, freely admitted conjectures have been

made in an attempt to close or solve them. What kind of man, for example, was Goya at the best and worst of times? What was his attitude to his wife and family, and indeed to women in general—chauvinistic or considerate? And from his contact with so many social classes, what exactly were his views about the social order? Did he reflect its shaky structure with a satire that was incidental, using imagination as a playful release, or did he sense the shocking truths of society all along, until his imagination could no longer conceal its disgust? In other words, at what point did he abandon the whimsical and become a serious critic? And what of religion? Did he retain the seeds of a genuine mysticism which his spiritual heritage had nurtured in him from his school days, or did he use religion, with not a little anticlericalism in passing, chiefly as a medium for his outrage?

None of these questions can be treated with certainty even where primary evidence does exist, because except towards the end of his life, Goya's views were in a state of continual flux. In many cases the answers can be both. But insofar as there are points of fixedness in his restless shifting life, these have been emphasized so as to strip away some of the misconceptions surrounding him and thus advance the 'peeling process' a little further.

All these considerations, important as they are however, are subordinate to the central theme in this book concerning the man Goya: his struggle with civilization. For this purpose the present work has been divided for convenience into three parts. The first part concerns his efforts to win recognition at the court of Charles III. His struggle here has to do largely with attempts to overcome obstacles that stood in his path—and a long hard path at that— before he finally reached the summit of his dreams. His struggle was thus with a civilization he more or less accepted and from which he considered he was being excluded. Having achieved his ambition, which continued into the reign of Charles IV, he slowly experienced an anticlimax as the pressures of work overcame him. The second part concerns a complete metamorphosis occasioned by a terrible illness in 1792-3, which transformed his way of thinking to the point where, as the faults and mounting decadence of his contemporary society became revealed to him, his opposition to its existing norms slowly began to take root. The last part begins

from about 1800. This concerns his long descent into disillusion, thence across the valley of death and destruction during the Napoleonic invasion of 1808–13, till outrage filled his soul which Ferdinand VII's 'liberation' only made far worse. And self-imposed exile was the inevitable end.

These somewhat arbitrary divisions of his life may sound too facile. The fact is that Goya's phenomenon is far from easy to explain. It is made more complex by the Spain that produced him, with its historical antecedents rooted in many cultures and its boundaries lying virtually at the meeting-place of three continents. Aragon, for example, was rich in Moorish remains even in Goya's day (he himself as an Aragonese came from distant Basque origins), while its bullfight language was still using Andalucian terms inherited from the Arabs. But Andalucía's main port of Cadiz had an almost Atlantic-American flavor with its rich stake in colonial trade with the Indies. Elsewhere, then as now, there was economic and linguistic rivalry between Castile and Catalonia. Aragon was caught in the middle and prided itself on having Saragossa as a rival to both land-locked Madrid and Mediterranean Barcelona. Spain's overlapping diversity held together well in the eighteenth century, climaxed by the splendidly successful reign of Charles III; but its fragile composition crumbled in the nineteenth century from the shattering impact of the French Revolution and Napoleon. From then on there was truth in the wry comment that Spain did not have one king, or two kings, but four million among its male population.

Goya is seen caught up in this crumbling process in the later part of the book. But the big difference is that while his country could find no respite nor solve its riddles, Goya in between the twists and turns of his crowded life achieved order out of his own chaos. Society's disintegration, even as he struggled against it, provided material for some of his greatest works. It was thus a fulfillment wrested from the tragedy of struggle.

Granted that Goya's fulfillment most likely would have been achieved even if there had been no struggle, the very nature of its barbarism so sharpened Goya's perception of the world that he was able to universalize from the particulars of subliminal experience which his imagination could somehow intensify,

because he had witnessed so much. The gravity of the times completed this process within him. For the conflict was both internal and external, impinging on Goya at all points.

Apart from the catastrophe of Napoleon's invasion, this stemmed from the failure of Spain's power structure—the nobility and powerful business interests—to present a solid front in response to the decline of the strong legacy of centralization bequeathed by Charles III to his weak Bourbon successors. The power structure, to which can be added a small but rising middle class, became torn by conflict—between those reformist elements that sought to continue Charles III's enlightenment minus the French Revolution's values that seemed to threaten it, and those reformist elements that accepted the revolution's values but without surrendering to domination by Napoleon. Compounding the issue were many absolutists among nobles, clergy, and peasants, who did not want enlightenment at all. Ranged against all these was a collaborationist minority supporting a Napoleonic, instead of a Bourbon, dynasty (but likewise without surrendering to Napoleon's truncation of Spain), which it saw as a better alternative than continued allegiance to a line of decadent kings.

The original power structure thus became split among a multitude of factions. The patriot majority fought against the French and collaborationist minority with some cohesion once the invasion had started, but once the liberation was achieved by 1814, the old confusion returned—victorious absolutists personified in Ferdinand confronted reformist liberal-radicals who became the new victims. And along with this, came regional and class confusion as well. By 1828 at the time of Goya's death, Spain was simply not ready for a constitutional and economic uniformity which a strong cohesive middle class, if there had been one, could have helped to ferment. The centralizing mandate that had been structured so patiently in the previous century was brought to nought, and the way prepared for a series of military interventions that figured so prominently in Spanish political life during the subsequent decades.

But if it is true that history unmakes nations, as in Spain's tragic case, it is also true that history makes the man, and Goya rises like a giant among men.

Many people generously helped to make this book possible. To these the author is extremely grateful. In Spain itself, Dr. Francisco Oliván Baile, fellow of the Royal Aragonese Academy and of the Royal Academy of Madrid, advised me graciously on how to proceed in Saragossa; as did Dr. Cándido Pérez Gállego, professor of English at the University of Saragossa, along with the personnel of the Institute of Ferdinand the Catholic in this city. Published by the latter is the *Diplomatario*, dealing with Goya's correspondence prepared by Dr. Ángel Canellas López, professor of Paleography and Diplomacy at the University of Saragossa. It is my deepest regret that I just missed meeting Dr. Xavier de Salas, director of the Prado at the time of his sudden death in June 1982. One of the greatest art scholars in the Spanish-speaking world (as Pierre Gassier is to the French-speaking world), he had recently completed his edition of Goya's letters to Martín Zapater, published as *Cartas a Martín Zapater* and edited jointly with Dra. Mercedes Agueda. But I did have the good fortune to meet with Dra. Agueda in the deep recesses of the Prado two years later. This most helpful scholar made me aware of what a veritable mine of information the above work is, made possible from the nineteenth-century collection of these letters by Zapater's nephew and heir, Francisco Zapater y Gómez, and which has considerably sharpened my own interpretation. Needless to add were the many courtesies extended by the staff of the Prado. I was permitted to research the Goya manuscripts themselves, as well as some of his drawings at first hand not normally on view to the general public at this time. And the same courtesy I received from the staff of the Biblioteca Nacional in Madrid and its manuscript director, Dr. Sánchez Mariana, when I researched the cryptic diary of Goya's friend, Leandro Fernández de Moratín.

In England I am indebted to Nigel Glendinning, professor of Spanish at Queen Mary College, University of London, who put me in touch with works by Xavier de Salas in the first place. Generous assistance given me by the Anglo-Spanish Society and the London Library goes without saying. I am also indebted to Mr. William Wells, retired keeper of the famed Burrell Collection in Scotland, without whose kind attentions other works and sources on Goya would not have come to light.

Here in the United States, another 'keeper' is indeed worthy of mention. I refer to Eleanor A. Sayre, curator emeritus of the Boston Museum of Fine Arts, who graciously permitted me the use of her most valuable private collection of books on Goya. Dr. Robert L. Bartolli, president emeritus of the Massachusetts College of Art, gave me precious criticism and guidance, especially on the Italian background, as did also Dr. John Staulo, professor of Spanish at the University of Lowell. And my wife Elizabeth (to whom should be added my mother Katherine writing across the Atlantic) has proved an adept reader, smoothing out rough passages in the text and surely making this interpretation of Goya more palatable to English-speaking readers in general. Finally, who could deny praise to his typist? Mr. Herculano Fecteau is a joy to any writer for his competence, which extends also to highly finished work in the field of genealogy and the graphic arts.

Sherborn, Massachusetts, U.S.A.
April, 1986

I

THE LONG ROAD TO ROYALTY

And I kissed their hand which I never had the good fortune to do before...

Goya to Zapater, January 9, 1779

ONE
Frustrated Youth

In the reign of Philip V of Spain and his strong-willed wife Isabella Farnese, at a time of recovery under these Spanish Bourbons when southern Italy had passed into their sphere, and more to the point, inflation had been curbed at home, there took place in 1736 a humble marriage between master gilder José Goya and Gracia Lucientes. The scene was in the Saragossa region of Aragon. They had two daughters—Rita, their immediate first born, and Jacinta, who came nearly a decade later. There were four boys—Tomás, who followed Rita, and Francisco Goya himself, born on March 30, 1746; their two youngest sons, Mariano and Camilo, entered the world in the middle of the century. It is of passing interest that Francisco Goya's birth almost coincided with King Philip's death, and none could guess that this stubby infant would one day become closely involved with Philip's crowned descendants.

The little cottage at Fuendetodos where Goya was born, nearly thirty miles south of Saragossa, was tucked along Alhóndiga Street in the lower part of the village. Its thick walls of stone gave welcome shelter to the struggling family. This kept them cool in summer, and warm in winter, especially when the terrible northeasters blew across the plains. There were no oil stoves in these

3

parts—hearth and warming-pan had to make do, the hearth in this cottage being set in a little nook not far from the door. Here cooking was done, as along the paved floor an occasional chicken might stray, destined either for warmth or the pot. There was an upstairs floor where some of their sparse furniture would be ornately decorated by the family's master hands. Narrow barred windows looked out across the bleak hills.

Storks then as now nested on the higher ground by the church tower, whose bell, incidentally, became so warped and cracked with time that many years later a girder hung from a tree was banged resoundingly instead to summon the worshipers. The whole village especially in summer looked like a molluscan mass of deadness buckled by the heat of the sun. Ice was stored in wells. In the poorer sections, rickety humps of baked adobe were fighting a losing battle to keep their shape. The streams at times were as dry and parched as the clay hovels that leaned ominously toward them, as if wanting to tumble in. There could not have been many more than one hundred and twenty people living there.[1]

Francisco Goya's parents were not peasants. His mother's side of the family possessed some local land and boasted of *hidalgo* stock, or minor nobility, whose coats of arms still clung to door-ways in the village. His father's side also claimed *hidalgo* distinc-tion, but it lay further back in time, emanating from the Basque province of Guipúzcoa in northern Spain. Francisco many years later went to great lengths to prove the latter point; and the fact that he did so shows that the paternal side of the family had come down in the world to the lowly rank of artisan. While this gave its members an honorable means of living, it also bore the scarcely hidden stigma that its fortunes didn't enable them to dispense with manual work altogether. In any event Spain was full of aspiring claimants to nobility, and Francisco was no exception. Further back in time, one thinks of both Cervantes and Shakespeare poring over coats of arms to boost their family status.

Of his early childhood we know next to nothing. Precocious, daring and imaginative would probably be accurate terms to des-cribe him; and the story of him enticing pigs along by means of a cabbage stuck on the end of a stick has a ring of authenticity to it. No doubt other mischievous deeds could be attributed to

the boy, and without much stretch of the imagination one could see him scribbling figures of animals and men on village walls.

Neither do we know with certainty at what age he moved with his family to Saragossa. Most likely his parents decided to come to the great city when Francisco was anywhere from three to five years old, so that the father could improve their fortunes by practicing his trade as a gilder. Here the family lived in Morería Cerrada Street, the maternal home at Fuendetodos being eventually abandoned. Soon the young boy found himself attending the local church school run by the Piarist Fathers for the poor. Latin, and later the classics, were drummed into him. This is evidenced by his use of Latin in the titles to some of his drawings many years later and by his familiarity with Virgil. It was this same school, run by a Father Joaquín, that his great friend Martín Zapater had also attended, and who was to become his *alter ego*.

The many stories about Goya gilding doors and decorating churches, while largely fictitious in their details, are certainly true in their broad outline. And he loved to wander. We can envisage the young Goya on holidays daring the long trek back to Fuendetodos, as well as to other places in the area. The landscape was different in those days. There were no paved highways (beyond some grading and trenching along the Royal Highway to Madrid), no large brick factories, and certainly fewer of the vine plants that today abound in the scrubby soil. He may have been lucky enough to share the cost of a donkey, but more likely he would walk much of the way and by the shortest route across the hills. He might recall with fond memories the tales of his godmother Francisca Grasa about the secret caves visited by the Devil when the wind and the moon were high; and in times of searing cold or scorching heat he must have been glad to reach the sheltered tree-lined streams that coursed to the main river flowing into Saragossa. This part of the Ebro is today covered over and runs under the street that passes by the Goya Institute in the city. It was a proud city, full of schools and institutes even in those days, the name Saragossa being a corruption of Caesar Augustus, in whose name an archway still stands here.

When he had just turned fourteen, shortly after Philip's son Charles III arrived in Madrid from Naples as Spain's new king,

Goya was placed in the training school of José Luzán y Martínez to study drawing and engraving. Luzán had once been a court painter to Philip V and had visited Naples, becoming familiar there with such artists as Francesco Solimena and Luca Giordano; and under this master's hand Goya was soon busy with oils and frescoes, some of the oils having once decorated a reliquary cabinet (long since destroyed) in the parish church at Fuendetodos.

Luzán is an important link in Goya's development. Not only did he train him well, but through him Goya got to know Ramón Bayeu, and more importantly his elder brother Francisco Bayeu, who had trained in the school earlier. A native of Saragossa born in 1734, Francisco Bayeu at the time had just returned from his art studies in Madrid and was well acquainted with the work of both Luca Giordano and Corrado Giaquinto, especially the latter's delicate liquid style; indeed these two Italian masters had a great influence on Goya's subsequent technique. Goya meanwhile clung to the elder Bayeu's sleeve, and it is of interest that both of them moved to Madrid in the same year, 1763. Saragossa may have attracted artists because of its wealthy noble patronage—its Roman and Moorish associations alone were appealing—but the capital city of Madrid was a much richer prize for the young.[2]

And a lively young man Goya certainly was. In all probability he parted company with Bayeu much of the time, especially as the latter had been here before, and went off on his own. He liked to observe with his discerning eye, and the snow-capped Pyrenees just visible on clear days in Saragossa were now transformed into the Guadarrama. But distant landscapes never really inspired him—he preferred things at closer range. As an Aragonese familiar with the *jota* step, he loved to dance and sing. Madrid was the perfect city, with its theatres and bullfights, its dice games and carousing. Indeed his boisterous behavior must have got him into several scrapes. Like any keen young Spaniard, however, he would doubtless make amends by attending religious processions; and mixing with the crowds during the Ash Wednesday carnival or watching the fireworks during Corpus Christi week and at other festivals Madrid was famous for, increasingly he sketched his recollections.

But Goya was also ambitious. And what could be more chal-

lenging for him than to compete for a scholarship to study art, which the city's renowned San Fernando Royal Academy of Fine Arts offered to winning candidates every three years. Here, however, he suffered two big setbacks. For neither in 1763 nor three years later, when he tried again, did he get the votes to qualify. Whether his moral character which might have made him enemies, was a factor in his rejection is difficult to say. As it happened, his idol Francisco Bayeu, on the panel of judges in 1766, voted a gold medal for his brother Ramón who had been admitted into the Academy[3]—a blatant case of nepotism in Goya's view, though it is probable that at this stage the latter was no less mediocre than anyone else. What is certain is the disgust he felt. He was now twenty years old with nothing to show for it; and while he resolved to continue serious study, the picture he presents is one of increasing disillusion about his own prospects.

History does not record what his family thought about this. No doubt they would have rejoiced if he had won his spurs at the Academy; but having failed to do so, he must have been under strong pressure to return to Saragossa in order to help out with family expenses, as brother Tomás, a gilder-decorator like his father, was dutifully doing. There is no evidence that Goya was disloyal to his family—quite the contrary—but from his point of view continuing his life in the capital offered the best chances of advancement, dim as these were; and he could always send money from a distance.

There were many reasons for his wanting to stay here. Madrid under its new king, Charles III, was undergoing a drastic change institutionally and artistically. The royal aim was to mold the capital in the image of a new Naples, where Charles had reigned for many happy years, and he had brought over with him a team of Italian experts. These included treasurer Leopoldo Squillace, architect Francesco Sabatini, and the famous Venetian painter Giambattista Tiepolo, along with his two sons Giandomenico and Lorenzo.

There was also Antón Rafael Mengs, a true cosmopolitan. Born in Bohemia in 1728 of German-Danish-Jewish origins, he had studied in Naples like so many others, and by the mid-1760s had become the most brilliant exponent of the neoclassical ideal

advanced by Johann Winkelmann. The King favored this style; and among the many frescoes adorning palatial rooms from the Buen Retiro to the Pardo, what pleased him most were Mengs's ceiling paintings in the Royal Palace state apartments, with their figures placed in a frieze above the cornice.[4] But Charles also liked Mengs's canvas paintings, including the royal portrait done at this time—so much so that in the case of Mengs's *Nativity* he ordered it immediately to be covered with glass.

As for the Venetian master Tiepolo, now in his seventies, he was hard put to compete with the triumphant Mengs, in whom he incited jealousy with his brilliant rococo style of frescoes. Tiepolo's ceiling masterpiece, *The Glory of the Spanish Monarchy*, is in the throne room of the Royal Palace. It is striking for its fluid allegorical symbolism pointing toward heaven.[5] Among the motifs featured in human form is a draped figure suggestive of the greatness of such Spanish-born Roman emperors as Trajan or Hadrian, with whom the aspiring Charles III liked to be identified. But despite his success, Tiepolo (admirer of Veronese) lost the battle of the styles with Mengs (admirer of Correggio), whose well-modeled if emotionless dignification of monarchy was more in keeping with the formal neoclassic spirit of the eighteenth century.

Where Goya fits into all this is not hard to see. Francisco Bayeu befriended Mengs and came under his influence. By the same token Goya befriended Bayeu and came under his, clinging to his circle in the hopes of wider contacts. But Bayeu had much greater luck than Goya. He was a grant recipient of the Academy and by now was one of its distinguished officials. It was a short step from there to attract the attention of the King himself. Charles in fact was soon employing Bayeu in the Pardo, at the royal residence of Aranjuez and in various churches, raising him to the coveted rank of chamber painter (or *pintor de cámara*) by 1767. And among his other distinctions, incidentally, was his finding the right kind of pedigree dogs to suit the King's taste! It was largely through Mengs, with his profitable advice, that Bayeu got where he did. Goya meanwhile was aiming for the same end, however tenuous it seemed, and evidence suggests he was a keen and frequent visitor to the studios of Mengs, Tiepolo, and Bayeu, who

viewed the aspiring young man with sympathy.

But sympathy was all it was. Success thus far eluded him. Could it be that his restless shifting eye, the rough hair that never went with the wig, his coarse stocky appearance—almost bull-like with an unpredictable behavior to match—presented a challenge to men in comfortable academic positions? Possibly. They had judged him and found him wanting. He had come to Madrid full of expectations but as a hanger-on nevertheless who still had a lot to learn; and he was surely viewed in this light by many. His rustic manners clashed with form and etiquette. Spaniards were punctilious, especially those of the nobility and in Castile. Goya was a man of modest origins who sometimes acted as if the world belonged to him; and he was Aragonese. He had staked all on his talents but had left out conformity in the process. Dazzled by the success of others—the Bayeu brothers, Tiepolo's sons, and men of their ilk—and no less by the city he had come to love, with its splendid palaces, its lively street scenes, its coaches trundling up and down the Calle de Alcalá, he was confounded and confused by his own failure.

Madrid was a magnet offering more to ambitious men than just the glitter of street lamps, which Charles incidentally had instructed Sabatini to install. But soon in 1766 convulsions were to rock Spain, shaking the nobility, the Church, the artists Goya envied, the King himself. Above all they jolted the royal treasurer Squillace, against whom the mass riots were directed. They had the additional effect of obscuring Goya's movements. Indeed between 1766 and 1771, nothing is known about him with certainty, and this time-span might be termed his missing years.

.

TWO
The Missing Years

T he Squillace riots, as they are called, have no direct bearing on Goya's rise to prominence. But they are summarized here for the possible effect they had on his attitude, which in the absence of any clear record must remain purely speculative until his work decisively appears in Parma five years later. The riots in question were a severe setback to Charles III whose reign had begun with so much promise. Briefly, his reform plans included the promotion of arable farming and new settlements, the expansion of trade and industry, and the curbing of the Church's temporal power, all of which in one way or another were designed to curb poverty itself. More royal factories were to be founded, taxes made more uniform, and society was to be broadened by opening up new posts in government, universities, and guilds. It was this concept of promotion by merit within the government structure that upset some of the traditional nobility, thus adding a deeper dimension to the explosion when it came.

Already there were rumblings of discontent at Charles's poor showing against England in the Seven Years War (1756–1763). Prodded by his Bourbon cousin Louis XV who had suffered enormous losses at the hands of England, Charles came into the war on France's side in 1761. Here Spain's inability to defend her sea

lanes against the stronger British fleet ended with the temporary loss of Florida when the peace was signed at Paris two years later. But this was only the beginning of Charles's troubles. More importantly the war brought havoc at home from the inflation it had caused, as held-up supplies of gold and silver from Mexico began to flood the market afterwards. Attempts by treasurer Squillace to deal with this problem by fixing corn prices satisfied neither farmer nor consumer; and his own extravagance as a foreigner made him dangerously unpopular.

But there were other causes that ignited the fuse. Charles wanted to clean up Madrid by paving the streets, installing drainage, and erecting streetlights, in order to make the city of 150,000 inhabitants a capital worthy of a great empire. But the people wanted to stay as they were. "They're like children," the King grumbled, "they cry when you wash them." The crisis came with another attempt at tidyness, when he issued decrees banning the wearing of the wide-brimmed slouch hat (somewhat like a French or Italian curate's), and the traditional long black cloak so dear to Spanish males (where a weapon to commit a felony could be easily concealed). Already inflamed by the unpopularity of Italians in the administration and of foreign troops stationed in Madrid, the crowds erupted in a mass mutiny on March 23, 1766.

Soon the entire kingdom was in turmoil. Spurred on additionally by bad harvests that had led to bread riots—important factors in the mutiny to begin with—the people shared a common hatred for Squillace, who despite his ability became the scapegoat for the national ills; and they demanded his ouster. As the crowds in the capital surged round the Royal Palace, so cherished by Charles who had hastened its construction to commemorate his deceased wife María Amalia, the King had no option but to sign his assent then and there to the people's demands. He then wisely fled to Aranjuez where he could deal with the rebels from a safe distance—an action that probably saved his throne.

Returning to Madrid later in the year after granting an amnesty, Charles slowly won over most classes of society that saw in his person a symbol of compromise and sovereignty now that most of the popular demands, including the firing of Squillace, had been satisfied. It was left to an able soldier and diplomat from Aragon,

the Conde de Pedro Aranda, to restore order. As Charles's new president of the Council of Castile—the most important agency of the King's rule—Aranda carried out a number of wise reforms, such as local municipal elections to ensure an adequate food supply, as well as other measures to enforce the new laws.[1]

After the executioner had donned the old style of dress—the wide slouch hat and long ruffled cloak—to behead one or two of the worst ringleaders and frighten the spectators, few Spaniards dared to protest the new dress code. The new ruling required the narrow-brimmed hat or else the cocked three-cornered hat worn in the rest of Europe, along with a shorter jacket. Men were thus obliged to expose themselves to the sun. But slowly Madrid took on a new look. Its lively street boys and their girl friends—the *majos* and *majas* of the populace—began to fill the clean-swept thoroughfares in new-fangled attire of every shape and hue (barring of course the prohibited style). 'Half-cheese' Córdoba hats in vogue among dandified men, along with hair nets and hair queues, surmounted a battery of bright-colored cloaks and jackets, illumined with filigree and braid and silvery loops. Indeed the fine tight jacket and breeches are still worn by the bullfighter today. Spaniards, among the poorest in Western Europe, were becoming Europe's best dressed people. Even the rich began to ape the style of the poor, in startling contrast to neighboring countries where it was usually the other way round. And this included women as well, who despite their finery of embroidered bodice, mantilla and fan, and narrow-waisted multifolded skirt with sharp pointed shoes peeping out below, would often don simple *maja* costume.

Such spontaneity in fashion on the part of both sexes, like fancy dress at a masquerade, was an inspiration to the Bayeu brothers and to Tiepolo's sons. Above all it would inspire Goya, himself as dress-conscious as anyone, and whose genre scenes were to make him famous. There was even a new democratic spirit in the air, superficially at least, that people's brighter dress habits made possible. And Charles meanwhile was winning his battle for the modernization of Spain.

But now was the time for retribution. Instead of blaming the people for the riots, which would have brought on revolution,

the King's special council blamed the Jesuits, who were viewed as being hand-in-glove with the conservative noble faction opposed to Charles's reforms. Indeed it was probably certain nobles more than Jesuits who were guilty of spurring the riots on. But to blame the nobles would equally invite revolution. Hence the Jesuits became convenient scapegoats. In the witch-hunt atmosphere of 1767 and 1768, absurdity was reached when they were falsely accused of spreading the rumor that the King was going to ban hair nets—and, as one humorist put it, ban hats and jackets altogether.

As with Squillace, so now with the Jesuits. Long-standing criticism from many sources swelled the rising tide against them. The last straw where Charles personally was concerned was the unfounded rumor (doubtless criculated by their enemies) that their Father-General in Rome possessed proof that the king was illegitimate and was threatening to publish it. If this were done, then Charles would have to abdicate in favor of his brother Luis, Cardinal-Archibishop of Toledo. Since Charles had no intention of allowing this to happen, he decided to strike first before the issue got out of hand. Accordingly on February 27, 1767, the hapless Jesuits were ordered to be expelled from Spain and subsequently from its overseas dominions, while Spanish representatives in Rome were instructed to persuade the Pope to dissolve the Order entirely. In this latter aim Charles had the support of virtually the whole of Catholic Europe—France, Portugal, Naples, Parma and Austria. In these countries, rival orders of Jansenist leanings, along with secular merchants, had convinced their governments that the Jesuits were autocratic and elitist, in effect running a state within a state. Everyone in fact was ganging up against them. But it was not until August 17, 1773, that the ailing Pope Clement XIV gave way at last and decreed the Order's total dissolution.

Goya's reaction to all of this is unknown. But a few pointers tell us he was aware of the issues at stake. He was in Madrid, for example in 1766, having failed to get his scholarship there. Indeed the turmoil prevailing at the time may partly explain his failure to get one. And it is almost certain he saw the rioting, or at least heard about it from others; for there exist paintings by

him showing a Franciscan with raised crucifix trying to pacify the crowds, while a companion scene shows Charles proclaiming the edict for the Jesuits' expulsion, both of which belong to a private collection in Paris.[2]

The lack of records concerning Goya's involvement in these upheavals can partly be explained by the nature of the upheavals themselves. There was of course a breakdown of ordinary communications, which would have held up any letters he may have intended to write, with the added difficulty of finding good couriers for the four-day trek from Madrid to Saragossa. More likely, he simply stood aside and let the storm pass over his head. Goya was not an activist at this stage of his life, and he usually kept calm if things got completely out of hand. For what was the use of an artist taking sides? In these cases discretion was the better part of valor; portrayal of events could safely wait till later. And when we consider the dangerous riots going on at the time in Saragossa itself (where Goya might have returned), as well as in Huesca, Tarragona, and Cuenca where there was some sympathy for the Jesuits' plight, his silence becomes all the more understandable.

Then there was the deterrent power of the Inquisition. This was always kept busy in times of crisis, and its lurking presence was felt in every corner. Founded in the mid-thirteenth century, it was later introduced to Spain under Dominican influence, and served as an important branch of the Holy Office. Though waning by the eighteenth century, its powers were still formidable, not only for its legal autos-de-fe but through the secret censorship which it exercised as well. In this capacity it was assisted by the Spanish Index, nominally responsible to its headquarters in Rome. The Inquisition in Spain contained a tribunal under an inquisitor-general with at least five councillors, along with secretaries, a procurator, a constable, receivers, and examiners. Centered in Madrid, it had a network of consultants, agents and spies spread all over Spain. The last victim on record to be burnt at the stake— by this time an extremely rare occurrence—was an old woman from Seville accused of witchcraft in 1780 for having had intercourse with the Devil. Painted eggs with mysterious symbols were found in her possession. Goya would have reveled in the affair had he been there, not from conformity but outrage. Nor was

such a sight confined to Spain. England, for example, was quite happily burning its women under the normal processes of criminal law for simpler cases involving the murder of their husbands, and in the same proportion as Spain during this final period—about one every ten years.

Awesome as the Inquisition's powers still were, the lack of any recorded comment by Goya is more likely due to the sheer confusion of the moment and the atmosphere of purge that went with it. In any case it would be premature to ascribe to him any anticlerical feelings at this time. Like many people he was probably ambivalent. Yet the seeds of his hatred for both ignorance and elitism, which burst forth much later in life with a vengeance, could well have been sown subconsciously from what he had seen or heard. This of course would be distinct from his love of the Church or his respect for individual Jesuits he might have known. But already there were undercurrents of radical criticism going on around him. It was even possible in higher places to criticize the Inquisition, now that the special council under Aranda had secretly proposed to curb its oppressive power. Goya might have taken kindly to this criticism had he been aware of it. Charles himself however, rejected the idea. He was too clever a monarch to dispense with an age-old institution that in a more limited way could serve his national program of reforms with its convenient censorship.

In the meantime Goya was getting nowhere. Much as he had studied Titian and the Venetians, Velázquez and Rembrandt, Ribera and Murillo, recognition continued to evade him. Neither did praise from the illustrious bring him the grant he craved for. And thus there is another angle to the effects that these troubled times had upon him; unable to make any headway at home and running out of money, what could be more desirable than to get away from the tense atmosphere altogether and study abroad?

The chances are that in 1768 or 1769 he went to Rome. Whether he received support from Bayeu (anxious to get him out of the way?) or Mengs, who was believed to be in Italy at the time, is unclear. He may have earned his passage across Spain by taking part in bullfights, though Goya himself in referring to these later was unclear about the details. Knowing Goya, one

could guess he borrowed money and earned it at the same time. He was a man of energy and determination. And he had made friends. For Bayeu's father-in-law was a German named Andreas Merklein, and it might well be that the latter gave him an introduction to a Polish-German artist living in Rome. This artist was Taddeo Kuntze, and Goya was reputed to have stayed with him at least for part of the time he spent in this city.[3]

Stories about him climbing St. Peter's and carving his name at a height never before scaled by the public, as well as climbing other churches like San Andrea della Valle, are surely apocryphal. But it is more difficult to doubt stories of his sickness after his sea voyage (possibly from Antibes) and of being nursed back to health; about Goya the wild one getting into trouble with the law; or even about José Nicolás de Azara, Spanish procurator to the papal court and a fellow Aragonese, interceding for him on a number of occasions.

Azara played a big part in the beatification cause of Juan Palafox, bishop of Puebla in Mexico—a pet project of Charles and opposed by the Jesuits, whom Azara hated as much as did the king. Along with his friend Manuel de Roda, justice minister in Madrid, he can be counted among Spain's secret 'radicals' of the period. They were both severely critical of certain practices in the Roman Catholic Church, voicing their dislike behind Charles's back while praising their king whenever his views on reform coincided with their own. Whether Azara fed Goya with anticlerical bias is doubtful, however. As government agent and diplomatic host to the Spanish community in Rome, he would be more likely to pour oil on troubled waters, not wanting to disturb his other main interest which was collecting classical statues. Many years later in 1805, incidentally, Goya was to paint his brother, the naturalist Félix de Azara.

One prominent member of this Spanish community was a certain Manuel de Vargas Machuca, who had also been to Naples. His is among Goya's earliest portraits, and it bears the artist's tiny signature, along with the date of 1771.[4] Signing such work was a practice he would increasingly adopt. It shows Goya as a conscientious craftsman, far removed from the mere prankster he was once taken for. Rome had done him good, and its priceless attrac-

tions, not to mention the modest cost of living, explain why he stayed here for some time.

But the important point is that after five years of obscurity, he has stepped back into the pages of history.

THREE
Not Yet the King's Painter

A work by Goya appeared in Parma during the summer of 1771, where at last he met with a positive success. "Bayeu's disciple," as he described himself, won virtual second place in a contest the Parma Academy of Arts was offering. That his work appeared here at all was not merely because of Mengs's probable suggestion when the latter was in Rome, with the support of their mutual friend José Nicolás de Azara, but also because of the close ties between Spain and this Italian realm. Its reigning duke, Ferdinand, for example, was Charles III's nephew. Spaniards were generally welcome. Indeed Charles had once been the Duke here himself. It was widely understood that Parma, like Naples, belonged to the Spanish sphere of influence, upheld at this time by Charles's ambassador, the Marqués de Llano.

It cannot be assumed, however, that Goya was physically present in this duchy. Anyone legally qualified could enter the contest from a distance, especially from such a prestigious city as Rome; and one of Goya's earliest recorded letters contains a statement to the Academy secretary declaring his intention to compete for first prize and informing him that his painting had duly

been sent off to the examining panel. He quoted a line from Virgil: "Iam tandem Italiae fugientes prendimus oras (Now we in flight at length touch upon the shores of Italy)."[1] Though he failed to win first prize—this distinction went to Paul Borroni—he did win very high praise for his *Hannibal Looking over the Alps* (alas, since disappeared), and was so informed by the Academy on June 27, to his great joy. After many arduous months he had at last made his mark in Italy; now he was ready to make his mark in Spain.

Back in Saragossa that autumn, Goya became the pride of the city. His parents greeted him fondly. He had won his spurs in a distant land. And he promptly received his first big commission—to fresco a choir ceiling over the main chancel vault in the Cathedral of Pilar, the title of the painting to be *Adoration in the Name of God*. Working at a fast pace, Goya completed it by June the following year. For this he received a fee of 15,000 copper reales (worth nearly 170 pounds sterling, or a theoretical equivalent of about 850 U.S. dollars), which was about a year's pay for an established official of those times. In doing this work he had underbid a distinguished painter named Antonio González Velázquez, who had tutored Bayeu.[2] Such a senior man must have felt a bit put out by this upstart from Saragossa, and no doubt would later join the hidden ranks of Goya's critics.

The Cathedral of Our Lady of Pilar commemorates the Virgin's supposed appearance on a pillar of jasper which had been erected in honor of St. James—the same whose shrine is at Compostela. This stone with its image forms the centerpiece of the cathedral's sanctuary, built over a former chapel. Goya was thoroughly familiar with the story, for he had painted the Virgin of Pilar's appearance to St. James even before he had gone to Italy. Indeed, the Virgin, Patron of all Spain, features prominently in his works up to this time (along with portrayals of the Holy Family in Heaven), and among those that have survived is one showing her flight to Egypt, and there are various versions of her weeping by the dead Christ.

Famous for its dedication to Hispanicism and proudly termed the Basilica of Pilar, the huge centuries-old building flanked by four towers encloses a neoclassical interior, divided into a number

of partitioned aisles beneath stately domes, and it has a rich col-
lection of canonical vestments, pearls, and diamonds. In addi-
tion, there are surviving sketches done by Goya himself. Some
of his sketches can also be found in an older temple next to the
Pilar, namely, La Seo, or Chair of the Saviour. Site of an early
Christian church and then of a mosque, its Gothic-plateresque
structure holds a treasure trove of gold and silver chalices, jewel-
encrusted monstrances and Chinese porcelain; and along with
some priceless works by Andrea del Sarto, Ribera, and others,
such a place must have been as impressive to Goya as it is to us.
Ferdinand of Aragon, husband of the famous Isabel of Castile and
joint sovereign of Spain, figures prominently among donors to
both churches in an age of triumphant Catholicism. Yet around
Saragossa Moorish relics strikingly survive, among them the
Christianized castle of Aljafería where Goya most likely roamed.

Meanwhile he felt very much at home in Saragossa, where
he now lived in Noah's Ark Street. Next to Madrid in fact, the
city with its stately homes, its wide handsome avenues, was
perhaps the most prestigious in all Spain, and its closely knit
Aragonese society had powerful connections with the government.
For these reasons Goya began to attract families in higher circles,
and one of the first instances of noble patronage was his com-
mission in about 1772 to decorate a nearby oratory chapel belong-
ing to the Conde de Sobradiel, in which he portrayed two saints
(Joachim and Cayetano) after whom the Count was named. And
soon in Madrid he was to paint the Conde de Miranda, one of
his earliest portraits of nobility. Intermittently at this time he con-
tinued his fresco work in and around Saragossa, reflecting the
baroque-rococo style, among others, of the distinguished Tiepolo
who had recently died in Madrid.

Now in his later twenties and with some money behind him,
Goya felt the urge to marry. It would be irreverent to suggest that
his brilliant mural frescoes depicting the marriage of Mary and
Joseph, along with the adoration of the Magi, for the Carthusian
monastery of Aula Dei outside Saragossa gave him the idea.
Reaching full flower by 1774 and reflecting the influence of Luca
Giordano, these sublime Nativity scenes already show a man
capable of passionate humanism which his experience in Italy had

done much to shape. But Goya was not a monk. And what could be a better step than forming an alliance with the family of the one man who could help him realize his dream—not in the bosom of the Church but of the court—namely, Francisco Bayeu himself. Bayeu at this time stood in for Mengs as keeper of the royal palaces and churches, but Mengs was due to return soon from Rome and quite possibly Goya decided to strike while the iron was hot.

Francisco Bayeu with his younger brothers Ramón and Fray Manuel had two attractive sisters, Josefa and María. And it was the former whom Goya courted. Here was the prize, whose sterling qualities as a marriage partner could be combined with useful connections at court. Josefa Bayeu was the daughter of Ramón Bayeu senior and María Subias. We can guess that it was Goya's persistence more than her brothers' enthusiasm that overcame her parents' initial objections. Both parents warmed eventually to the idea of a marriage with the promising young artist. It meant keeping the same skill in the family, for all three brothers as well as the father were gilders of one sort or another. Francisco Bayeu himself was more cautious—he had the most to answer for—but he was willing to stand in as witness when Goya and Josefa were married in the parish church of Santa María in Madrid on July 25, 1773.[3]

What Goya looked like can be seen from his self-portrait of this year; but Josefa's personality and features are not known with certainty. She is a rather shadowy figure in Goya's life. Born in May 1747, and hence of nearly the same age as her husband, she became his physical companion in the role of buried obscurity beneath a gleaming throne. But precisely because she is obscure, having the possible misfortune to be married to a genius, does not imply an acceptance at face value of all the preconceived notions about her. She has been implicitly presented as a meek and colorless housewife—a sort of Mrs. Charles Dickens in a Spanish context. She was indeed a housewife—with at least three servants to help her—but she was certainly not drab or colorless, for she loved dressing up in the latest fashion. And on one occasion her husband, it seemed, complained resignedly that she preferred working on a stylish dress to sewing a ruffled shirt for him![4] True, we have Goya's comment that "home is a women's sepulcher";[5]

but the comment was hers rather than his, in the sense that he was surely quoting what she herself had just told him. Yet despite her flair for stylish living she was extremely loyal to Goya (whose fiery temperament extended to having rows with her elder brother) and helped him patiently with his career. Overall, one gets the impression that she was a forbearing woman yet strong enough to hold her own, and that her resourceful qualities complemented his erratic ones.

What is certain is that she suffered much of her life. But this is not because her husband abused her. The tragedy of Josefa was in her limitless confinements—twenty so it is said, though probably this is exaggerated—from which only one child survived, Francisco Javier, born in 1784. She had one miscarrage after another. And these were not without post-complications. In addition, Goya himself was often ill despite his enormous strength, becoming deaf in later years, so that Josefa, having passed the age of childbearing, then had to spend the rest of her life living with a deaf man. Yet the two appeared to get along together in relative harmony. There was little choice in those stoical days: the lack of freedom to divorce made marriages work. And if Goya at times could be unfaithful—possibly to Josefa's relief- he would soon be chastened by advice from professional friends. Dr. Ruperto de Ortigosa of Seville is a case in point. "Every sheep should keep to its own mate," the good doctor reminded him.

Despite his occasional straying, Goya loved her in his way, as she did him within the narrow confines of her life. He called her "La Pepa," a diminutive of her name. And wanting lots of children by her was part of his normal existence. "La Pepa has given birth to a fine boy, thanks be to God," he would write to his friends many times before the child would die. Such a fate was common everywhere. One has to look at Goya through the eyes of his society. With all the smallpox, tuberculosis, and rampant fevers taking their toll, the aim was to have as large a family as possible. Its surviving members could then give something back to their parents for all the care they had received, could help them in old age or infirmity, and generally pay for the privilege of being born into the world at all. Neither was this aim to have children limited to any particular class. One has only to think of Queen

Anne of England and Prince George in their urge to produce heirs and who between them had a zero survival rate among their multitudinous offspring. J. S. Bach with his two marriages was luckier; he had twenty children, of whom nine actually survived.

Whatever disappointments he felt on this score, Goya always looked after Josefa's welfare, and by 1780 settled on her a life annuity of six reales a day—the equivalent of a well-paid artisan's wage.[6] As his earnings grew, Josefa was able to share his life more openly, sometimes joining him on visits to patrons; and ten years later we see the couple sauntering along like any other, drinking in the sea breezes of Valencia.

Yet such supreme happiness was rare. It was a fragile mid-point in their lives—a relaxed companionship after her illnesses had passed and before his most serious illness was to come. But the couple somehow held fast. In 1798 Goya painted one of the most intriguing women in his long career. She is intriguing not only on account of her mysterious beauty, but also because she is unknown. Yet she is considered by many to be Josefa herself. With auburn reddish hair done up in a circular plait behind, with hazel eyes, attractive mouth, rounded chin, and silk shawl surmounting the embroidered sleeves against a dark background, the whole figure is cast in a brownish tinted glow. It is the portrait of a youngish woman—luminous, melancholy, but compelling. Could Goya have wanted to impart to the world some hint of her freshness and vigor as he once knew her, before a quarter of a century had done its work? But this is still a mystery. Not so his late drawing of her done about 1805. This shows a woman with life in her still, a bit crushed maybe, yet strong, proud, and sensual. The years have given her a plump and earthy persistence, though alas, not in terms of having produced a crop of surviving children. To breed and multiply in order to fill up the empty spaces of the universe was, after all, a duty incumbent on everyone.

The population of Western Europe at this time was barely a hundred million (about a quarter of its present strength), of which about eight million lived in Spain. The country in the past had suffered depopulation through soil neglect, inefficient land ownership, and emigration, though serious attempts were being made by Charles's government to recolonize and revive the

economy. But hampering progress was a high rate of inflation driving up the price of new arable land—a trend in common with the rest of Europe in the later eighteenth century. Tenant evictions followed, which swelled the unskilled population in the cities; and in Madrid at least, the price of labor was cheap. This formed a contrast, incidentally, with the booming cities of Valencia and Catalonia, for there a textile revolution was in full swing by the later 1770s, in which even a domestic could earn a wage nearly double the national average.

Where Goya was concerned, this meant that once he got settled in his career in the capital, he could afford to provide his wife with such amenities as two maids and a cook, thus relieving her of many chores. But this did not come without a struggle beforehand. Evidence suggests that after their marriage they lived for a time in Bayeu's house before renting quarters first in Reloj, then in Espejo Street, the latter in a house belonging to a José Vargas. Goya would still visit Saragossa to do more frescoes; but by 1779, following a short lease of premises in a Madrid house belonging to the Marquesa de Campollano on San Jerónimo Avenue, he and Josefa moved at last to a permanent home. This was at 1 Desengaño Street, and here they lived in the capital for more than twenty years.

* * * * * * *

With his income steadily rising meanwhile, Goya not surprisingly was pressed for money by family and friends. To these requests he usually responded generously. As we have seen, he was solicitous for his wife's financial needs, and he frequently helped his mother Gracia Lucientes in Saragossa, along with his brothers and sisters. But he could be cunning about the methods he employed. An amusing story concerns his brother Tomás, who wanted to borrow the sum of thirty escudos. Goya asked his friend Zapater to make this loan instead, reimbursing him later, since in this way his brother would be sure to pay the money back.[7] Goya well knew the liberties Tomás would take if he knew the money came from himself—the richer side of the family. A subtle piece of brotherly psychology!

Where Goya went wrong, though this was part of his very

25

nature, was in his reckless indulgence. "We must enjoy the things of this world," he said many times. There was nothing wrong with this hedonism, but in addition he was inclined to a *machismo* that was impressive even by Spanish standards. He was a participant not a spectator. His restless energy made him so. To his natural love of blood sports can be added material pleasures that surely put a strain on his health. Long after his death his old gardener Isidro is supposed to have confided to an enquirer that his master once had two main obsessions—bullfighting and cavorting with the daughters of Eve.[8] He might have added cavorting with the Devil as well. For along with his hunting and wenching as a younger man, Goya was quick to start a quarrel or at least lay faults in others, even granted he was capable of seeing his own. And he could be vain, petty-minded over detail and scornful in adversity. Many of these traits are discernible in his street scenes of rowdy processions, where the soul of the people reflects the soul of Goya himself.

Yet overriding these vices—impulses would be a better word—was a brave uncompromising sincerity not merely toward family and friends, but in respect of his art. In this dimension he was a totally different person. He had a deep religious feeling, as we have seen in his work for the Pilar and Aula Dei churches, though this was not exactly an end in itself but rather an outlet for the pent-up forces in his being. Of the early Christian fathers, he painted Saints such as Ambrose, Augustine of Hippo, Gregory and Jerome, whose murals adorned Saragossan churches at Muel and Remolinos in the 1770s. In his intense moments over these years and beyond, he saw figures of prophets like Moses, painting many of his miracles. And there was the sacrifice of Isaac, Lot confronting his daughters. His range was wide, from pagan scenes to the baptism of Christ, from a superb St. Luke to the death of St. Xavier. Among women there was Iphigenia, sacrificed by her father to Artemis, or the goddess-queen Omphale standing by Hercules, even as he saw beauty in the wandering St. Anne, or the vision of the martyred St. Barbara. And there were his incomparable studies of the Virgin of Pilar. He limned them as figures of mood and passion, whose ornate forms were extensions of what he had carefully studied. His baroque and

neoclassical training had of course fully done its work. And in the meantime he wanted to reap its rewards.

Goya's first step toward a more tangible destiny was at the end of 1774, when having finished the Aula Dei paintings, he was summoned to Madrid by Mengs. He was to join a team of painters preparing sketches for tapestry reproduction at the royal factory of Santa Barbara in Atocha. Colleagues included Ramón Bayeu and José del Castillo, the latter having studied Giaquinto's technique in Rome, as others had done before him. Both Giaquinto and Mengs were successively the overall directors of this factory, which like those for porcelain, glass, silk, woolens and carpets had been founded by the Spanish Bourbon kings. In contrast to the Habsburg practice of relying on foreign imports, Philip V and his sons Ferdinand VI and Charles III each sought to develop a native industry, initially under foreign managers but to be slowly replaced by nationals as soon as the necessary talent could be found. Thus the Santa Barbara factory, dating from 1720 and employing Flemish weavers, became increasingly Spanish in tone by Charles's time, though a family from Antwerp named Van der Goten still played a major role in its supervision. Here the original director Jacob was succeeded by Cornelio 'Vandergotten' (painted by Goya in 1782); he in turn was succeeded by Livinio Vander gotten in 1786. The factory, incidentally, was funded by the treasury, whose ministers were successively Múzquiz and Lerena.

Mengs was doubtless prodded by Bayeu into giving Goya this important post. But Mengs was also impressed on his own, having probably heard about Goya's work in Rome, from which he had just returned. Whatever the reasons, it was a wise choice. Over the next sixteen years Goya realized about sixty tapestry sketches (or cartoons as they are rather erroneously called), designed mainly for the Escorial and the Pardo Palace that lie north of Madrid, and executed, if approved, by the factory weavers.

Goya was delighted with his new assignment at first, for it brought him closer to his cherished goal of the court. In a galaxy of settings he could depict the sporting and street life he knew so well, in many ways comprising the warp and woof of his own. Initially reflecting Mengs's influence as that of Tiepolo receded,

he began to develop a distinctive style, partly from his study of others. To Giordano and Giaquinto can be added Titian, Tintoretto, Raphael, Van Dyck and Rubens. But his chief masters were the great Diego Velázquez and Rembrandt with their light-and-shade realism, besides nature itself. Indeed his new contacts with the court enabled him to etch some of Velázquez' works in the royal collection by 1778, while Rembrandt's own etchings were a source of inspiration to him in his later drawings. Goya in fact became as much of an engraver as a draughtsman. In this regard, his Velázquez etchings caught the eye of a Habsburg diplomat named P. Giusti who had helped Charles III bring in Bavarian settlers for his colonization project in the Sierra Morena region.[9] That Giusti eventually put in a good word to the King on Goya's behalf is highly possible.

The themes for the tapestry sketches were handled by Mengs as the King's chief painter and art director, who would pass down the line via Bayeu and Vandergotten what royalty was demanding. Apart from Charles III, this included his son and heir the Prince of Asturias (the future Charles IV) and his wife María Luisa of Parma, both of whom were to play an important part in Goya's life. Among the first forty of Goya's finished sketches, nearly all were screened as possible tapestry hangings, especially for the princely couple's residence. This meant mainly the Escorial, where part of their suite was used as a dining room. And on its walls the first Goya tapestries were hung. These were delivered in two batches in May and October 1775, and looked down impressively upon their table. They were hunting or fishing scenes, eight of them in all, and reduced in size because of the limited hanging space. The King himself only saw them in the autumn, when he would regularly visit the Escorial for the hunting season. Boars, quails, red owls, hunting dogs and anglers were the themes portrayed. Perhaps this was the first time that he took serious note of Goya's work. Charles, after all, was a hunting addict like the artist, whose obedient commendable performance must have notched him up a few points in His Majesty's estimation.

But it was mere passing praise, if at all. Goya's reputation was still only by hearsay. And despite Mengs allowing him some latitude with sketch designs, he was certainly expected as a mere

factory artisan to do what he was told in regard to the themes themselves. Neither was there any guarantee, as his sketches passed from their rough preliminary stage to finer detail, that these would necessarily end up as finished tapestries; and even when they did, they were often taken down from the palace walls during the hot summer months. There is an unsubstantiated story that Goya once growled back when it was suggested that these might also be used for carpets—as if he were expected to dedicate himself to an art for feet to tread upon! And while he was paid according to output, he was not allowed to undertake any outside work without permission. Bayeu and Vandergotten of course, would see that these restrictions were rigidly observed.

As Goya wrestled with the cloth canvas taut on its stretcher, coating it with glue to bind the web, coating it with tempera and oil to give a smooth surface, laying on the baked red clay which mixed with white gave a pinkish neutral prime, then would he dabble with greys and cobalt blue, perhaps a little black, to achieve the effect of a high finish. He repeated the process over and over. Each time he came a little nearer to what still eluded him—with here a mellow tree, a wisp of cloud, or there a curve of swing, a curve of *maja* skirt. Yet each time he knew he would reach a new plateau, placing him higher than his colleagues and surely earning the praise of Bayeu, whose icy features would at last dissove into a smile with perhaps a beaming Mengs beside him. Surely promotion would come soon.

Partially blocking his hopes in this direction of course, was Bayeu himself. With his conservative taste, like Mengs's, he had no intention of letting the cocky young artist bypass his authority. In bureaucratic Spain even with Charles at the helm, one had to wait one's turn. And this applied much more to artisan jobs than to posts in the government, where royal policy readily permitted merit to be the main yardstick in promotion. In this regard, Charles had many crises to confront both at home and abroad; and the time he had to spend in dealing with them combined with his own reluctance to take on new men unless he had personally known them a long time, were further reasons for Goya's slow rise to kingly favor.

<p style="text-align:center">* * * * * * *</p>

Compounding these problems was a conflict going on in the royal family itself. Briefly, this concerned a fractious opposition that threatened—abortively as it turned out—to shake the fabric of Charles's rule. And its leaders were none other than his own son and daughter-in-law. This was nothing new in royal history, but the factional spill into politics had some bearing on Goya's future direction.

The Prince of Asturias and his wife María Luisa by this time had become furtively hostile to practically everything Charles stood for. They disliked his stuffy ways, his austere piety, especially in regard to his dead queen whom grief could never bring back, and his inability to understand their needs. Both in their late twenties by 1775, the two had never really got along with Charles since their marriage ten years before. True, there was a mutual interest in hunting and the arts; but the son resented his father's insistence on learning and diplomacy—in both of which the son was conspicuously lacking—while María Luisa resented his insistence that women, even when they felt themselves to be intelligent, should stay firmly in the background. "Women are by nature weak, fickle, ill-informed and superficial, too easily beguiled by designing and ambitious flatterers," Charles intoned uncharitably to his son, though his words were to prove prophetic where these two personally were concerned.[10]

Widening the rift was their association with the noble faction discontented with Charles's policy of promotion based on merit. This especially applied to his new middle-class government appointments. To many nobles it seemed a threat to their power, and as we have seen there were undercurrents of this resentment during the Squillace riots. Powerful ducal names like Medina Sidonia and Sotomayor were rumored to be courting the Asturias couple in a common criticism of the King, whose policy of central direction at ministerial levels was at variance with rule by the traditional councils. Of these, the Council of Castile was still important and where the nobles competed for influence. It was Aranda himself as the council's aristocratic president and the one man Charles relied on in the wake of the Squillace riots, who coming from Aragon, became the spokesman for this so-called 'Aragonese' faction. And while a keen reformer in his own right,

Aranda inevitably drew closer to the Asturias couple.

Opposed to this faction were the humbler middle-class men in government who had risen by sheer ability, though some nobles had joined them. Nearer to the King's views, they supported the idea of a centralized direction of policy, and at the expense of big monopoly interests whenever these stood in the way of modernizing and strengthening the state. Strongly represented in the ministerial juntas and committees, they tended to downgrade such traditional councils as that of Castile or the Indies where 'Aragonese' interests exerted their lobbying tactics. These triumphant men in power were dubbed *golillas* by their enemies on account of the white collar they wore in office.

This rivalry between *Aragoneses* and *golillas* would have been healthy in a legislative country like England, where 'Whigs' and 'Tories' were common parlance. But Spain didn't have a legislature; and the consequence was a greater resort to secret intrigue in which the Asturias household played no small part. To do Charles justice, he did reserve to the councils considerable powers to deliberate, which was in keeping with Spain's traditional processes in lieu of the Cortes, which was in abeyance at this time. And he did seek to strike a just balance between the two factions in his appointments to office. But what incensed him was his own family's intrusion into politics. In his view, they had no business promoting 'Aragonese' interests as if these were some kind of opposition. And he was increasingly irritated by Aranda. As their unofficial spokesman, he was getting querulous and overbearing. It was only a matter of time before he would overplay his hand. Already he was making enemies among the *golilla* faction. These included Secretary of State Grimaldi (one of the few Italian administrators to survive the Squillace riots), and Secretary of Justice Roda, along with Campomanes and Floridablanca. These last two served on the Council of Castile, and had already acquired much experience as rising lawyers.

The showdown came over a crisis involving the Falkland Islands, claimed by both England and Spain. Termed Las Malvinas by the Spaniards, these were seized by Charles's government in the early 1770s, which prompted England to respond by sending a fleet. The outcome of this complex issue was a kind of com-

promise whereby England continued to claim the islands, while Spain was permitted to send a few settlers in a de facto situation which continued for the rest of the century. But the main casualty in all of this was Aranda himself. Having tactlessly annoyed the King by criticizing his attempts at a peaceful settlement— Charles well knew that diplomacy was better than war in dealing with England single-handed—he was fired from the Council of Castile presidency in June 1773 and packed off to France as ambassador to that country. Charles rarely lost his temper, but this was an exception. Aranda, incidentally, who had close ties with Saragossa, was one major figure whom Goya never painted, though while the minister was banished to France, his nephew the Duke of Hijar did have financial dealings with the artist.[11] Poor Aranda didn't return to Spain till 1792, having been thoroughly punished for his hawkishness.

As for the aging Grimaldi, Aranda's *golilla* rival, his fall from power came next. Following a disastrous Spanish attack on Algiers in 1775, Charles suggested forcefully enough that he retire; and his place was taken by the Conde de Floridablanca mentioned above, who as José Moñino came from modest origins in Murcia. An able diplomat, Moñino had played a large part in extracting from a reluctant pope the decree dissolving the Jesuit Order, and this was enough to win him his title from Charles's grateful hand. Whatever the merits of this issue, he was an extremely intelligent statesman. Discerning and persistent, he virtually formed a team with his sovereign for carrying out the royal plan of reforms that lasted till the end of the reign.

Floridablanca played an important part in Goya's eventual rise to prominence. But equally so did María Luisa and her husband, whose power base received growing support from the Aragonese faction in the absence of Aranda at Versailles. Goya thus had a foot on two ladders so to speak, up which he climbed precariously with many pitfalls ahead. And it was María Luisa who gave him his initial lifts. Far more than her husband, she was the one dictating the themes Goya was to sketch. No doubt she demanded a wider range of genre scenes—away with dull repeats of the hunt and down to more embracing subjects. One senses a converging of interests between herself and Goya on this

issue; for him it meant more freedom to experiment with style. There would be no personal contact, however, between the wife of the heir apparent and a humble factory craftsman at this stage, regardless of how much she liked his work.

Beginning in 1776, his sketches for the Pardo Palace dining room used by the Asturias couple included a *Dance by the Manzanares River Bank,* along with picnics and children picking fruit. Kites, balloons, and parasols interlace the series with singular beauty. But raucous themes like tavern brawlers, drunkards, and card sharpers show that Goya was not limiting himself to passive genteel adornments. His scenes may have reflected courtly taste for popular boy-and-girl, or *majo-maja,* types at a time when the social classes under Charles's enlightened rule were feeling a sense of unity to a surprising degree. Yet his scenes also show a subtler face—the *majo* types can be real *majos* proper to their class, and not just nobility dressing up and playing a peasant role.

Among the finished tapestries is a striking scene showing a coy gypsy girl surrounded by her admirers like a sort of early Carmen, titled the *Paseo,* or *Promenade.* The lusty men have thrown the right fold of their capes over the left shoulder, and they are wearing black 'chimney pot' hats. Such a scene was typical of Andalucía, forming an exception to the other tapestries which mostly related to Madrid. Since we know that Goya in 1776 corresponded with friends in Seville—Dr. Ruperto de Ortigosa is a case in point—evidence suggests that he visited southern Spain at this time. It foreshadowed more dramatic turns in later years, when following his near death he was to trace the footsteps of the Duchess of Alba.

This series seems to have pleased the Asturias couple, for larger tapestries soon arrived in the Pardo Palace to adorn their bedroom and hall. Sometimes however, Goya's themes were too intricate for the tapestry weavers, as with *The Blind Guitar Player* for example, which had to be modified. Goya was angry at this, apparently, as he played the guitar himself, and he afterwards made an engraving of the scene which he had witnessed. But the majority of the work passed muster. Dish- and fruit-sellers, a doctor and a tobacco guard, drinkers at a fountain, wood-cutters and washerwomen, are the kinds of theme he portrayed; and while

some of them still reflect Mengs's vertical perspective (such as *The Crockery Vendor* and *Fair of Madrid*), he was clearly aiming at new dimensions. *The Appointment* and *The Soldier and the Lady* suggest the theme of expectant love and carefree love respectively—appropriate, perhaps, for María Luisa's bedroom if one thinks of its occupant's capricious moods.

But the themes Goya loved to draw most were children, as if to invent more of what he wanted himself. Children playing soldiers, ball, or leapfrog, children pushing carts, children swinging, bird-nesting, mock bullfighting or just plain fighting, reflect his own mischief more than twenty years before. And such treatment of youth was new for an artist, coming at a time when social writers like Rousseau (and Pestalozzi later) were beginning to impress the fashionable with an understanding for the young.[12] Tragically for him and Josefa, they lost both their infant sons at this time—Eusebio and Vicente, born in 1775 and 1777 respectively when they were living in Espejo Street. Possibly Goya's own fever contracted in the spring of 1777 has something to do with Vicente's death, which may have been from typhoid.

Nothing could be brighter in a material sense, however. On Mengs's recommendation in the summer of 1776, his new annual salary was now 8,000 reales (about ninety pounds sterling)—far below Bayeu's salary of 30,000 reales, but Goya wasn't complaining. For his actual income was fast catching up to Bayeu's with all his approved tapestry designs, which carried extra remuneration. Goya's *Dance by the Manzanares River Bank*, for example, showing an attractive group of young men and girls circling by the water's edge to the rhythm of guitar players, fetched his annual salary figure alone; and this along with others won enough favor in high places for him to gain access to the royal collection. Here in 1778 following his illness of the previous year, he worked on his thirteen Velázquez etchings, most of the prints being sold that summer.[13] By 1779 Sabatini, the chief royal architect, revealed in a note to treasurer Miguel de Múzquiz that of some twenty-four paintings done by Goya and three others for the tapestry factory and valued at 43,370 reales, Goya's contribution of six paintings alone accounted for nearly half this figure.[14] A sure sign of his worth and promise.

The King himself liked some of the works in question. For these six tapestry cartoons, having passed through the hands of the factory director, Cornelio Vandergotten, were then submitted to the proper quarter at the palace; and Goya in January 1779 reached the first pinnacle of his career in being formally introduced to the royal family itself. Things were going his way at last. He had always craved for the glamor of the palace and now his goal seemed near. In a tone of mounting ecstacy he described the encounter in a letter to his friend Martín Zapater; but not without first criticizing the results of his collaboration with Bayeu in the matter of a sketch they had completed (with Bayeu the inventor and himself the craftsman, possibly a tedious variant of the successful *Dance by the Manzanares River Bank* mentioned above, which Goya deemed in his blunt language to be not worth a horn):

"If I could go slower I could tell you how the king, prince and princess honored me by the grace of God in bestowing on me the favor of letting me show them four pictures, and I kissed their hand which I had never had the good fortune to do before. I can tell you I couldn't wish for more in regard to how much they liked my works, judging by the pleasure they took in viewing them and the satisfaction I achieved with the King, and still more with their Highnesses... As for possessing land and leading the good life, my friend, no one can take away my opinion in this respect, and now more than ever I'll begin to make enemies with a lot more malice."[15]

Goya's optimism was soon dashed, fulfilling the premonition of malice he seemed to sense. Six months later he applied for a position as court painter—a much more prestigious post than merely being a factory artisan in the royal service. Mengs had just died in Rome, and the resulting vacancy would pass down the line. He set great store on getting the job. There was surely a place for him near the regal splendor of the King, he reasoned, whose benevolence would embrace men of genius like himself, and not simply men of mediocrity.

But they gave the job to Mariano Salvador Maella—Bayeu's friend from Valencia.

It was a bitter disappointment. His worth already exceeded 100,000 reales in the last few years alone, earned by the skill of

his brush, by sheer hard work, by dogged persistence in laying out his terms. He had come a long way since he was a humble student in the workshop of Luzán back in his early days at Saragossa, sweating over plaster casts, learning new techniques, learning from Bayeu. Had Bayeu let him down? And where were all his colleagues? Was this the malice he had foreseen? Vile men somewhere were saying bad things about him.

What Goya was yet to fully realize was that seniority weighed heavily in the academic Spain of Charles III, and that talent alone could not buy its way in—at least not where royal appointments of this type were concerned. And they had to be voted on first. In October 1779, the King's personal secretary, the Duke of Losada, was writing to Justice Minister Manuel de Roda that despite Mengs's past good words about Goya, there was no shortage of painters, and that he should improve himself by continuing to work for the royal tapestry factory.[16]

FOUR
"Those Vile Men"

Charles III was now more remote from Goya than ever. Burning for revenge after defeats suffered in the Seven Years War, the King again declared war on England at the end of 1779, having joined France in support of the American colonists' revolt for independence from the mother country. It was a risky step requiring the most careful strategy, for Spain had huge colonies of its own. But with Floridablanca at his side, Charles resolved the colonial dilemma by not actually sending troops to help George Washington directly, while giving his government every other sort of assistance. And as it turned out the war went not at all badly for Spain, especially in the Gulf of Texas region. Close to home, only Gibraltar could not be taken, and this had to be overlooked when a successful peace came nearly four years later.

Goya in the meantime was fighting a war of his own. However deferentially he treated them, his 'enemies' were his own rival colleagues—Antonio González Velázquez, Andrés de Calleja, and Francisco Bayeu, who had stepped into the coveted shoes of Mengs. Now Maella was among them. Goya resented their higher status of court painter which he was not; and his grievance mounted when, after being posted to Saragossa in 1780, he became involved in a bitter dispute with Bayeu as his director. After five

years of proximity to the court, he was to take a decidedly downward step, and the dispute left deep wounds.

At first he was in an exultant mood. Before his move to Saragossa he had won a signal honor in July, when he presented a magnificent rendering of the Crucifixion to the Royal Academy of San Fernando and was promptly elected a member. He had won his laurels at the age of thirty-four and was not going to let the world forget it. But in the light of subsequent events this year, it was to prove rather a hollow victory.

Bayeu in the summer asked him to paint the interior of a 'half-orange' cupola, or dome, in the Pilar cathedral depicting the Virgin as *Queen of Martyrs*, along with some adjoining pendentives. Goya had left a good impression here with his former fresco work and was delighted to accept. He looked forward especially to the following May when it would be bright and warm for his new colors. "I won't need much furniture," he wrote excitedly to his friend Zapater, who along with another friend named Goicoechea was to make arrangements for his stay, "just a print image of Our Lady of Pilar, a table, five chairs, a frying pan, wine bag, guitar, cooker and lamp—anything else would be superfluous."[1] Presumably a bed would take care of itself. He proposed renting quarters from the Duke of Medinaceli-Aytona, who later became one of his many patrons. And as he worked on some designs for Bayeu to look at, like all good Spaniards he was following Charles's English war with keen interest.

There had been a significant Spanish victory in August 1780, when two large British convoys had been captured off the Azores and the entire contingent paraded with great ceremony in Cadiz harbor, which Goya had read about in the *Madrid Gazette*. Patriotically he relayed the news to Zapater, adding that "La Pepa" had given birth to a fine boy so that he would see his friend sooner than expected. The child, like three others already, never survived. It was poor La Pepa once more.

Moving to Saragossa by October, trunks stuffed with blankets and curtains, Goya was joined by the Bayeu brothers (Francisco and Ramón), and set about preparing sketches for his Pilar cupola. Since Ramón fell ill, Goya was now solely in charge—or so he thought. He felt proud and independent. Before

long however, Francisco Bayeu became dissatisfied with Goya's designs and coloring which he stubbornly refused to correct. Bayeu no doubt was acting from the best motives in commissioning Goya in the first place; but the upshot was one of the greatest humiliations the latter suffered in his life, and it caused a long-lasting rift between them.

At the instigation of his disgruntled brother-in-law, Goya in March 1781 was hauled before the cathedral canon, Matías Allué, and the cathedral works committee (Junta de Fábrica del Pilar), and asked to give an explanation. This Goya did with lengthy gusto. He pointed out that despite family ties with Bayeu he had come to Saragossa as no menial dependent, denying the charge that he had been arrogant in his conduct, and further, that the designs in question had been earlier submitted to Bayeu in Madrid who made no objection to them at the time. Since the designs were essentially the same, why all the fuss? But if the objections were sustained, then let Velázquez and Maella come and give a formal opinion at Goya's own expense.[2]

Invoking the aid of those who, after all, were Bayeu's colleagues was a tactical mistake. Bayeu was the boss over all the royal art works in the churches and monasteries in Saragossa, and it was likely that his will would prevail. Moreover, in an age when the Church itself in Spain was fully under regal control, it would have been foolhardy for any ecclesiastical official to appear on the side of defiance. The last time this had happened was thirteen years before, when some pious clerics had incurred the royal displeasure by asking for certain reimbursements from Charles III and had been promptly banished from court.

On March 30, 1781, Goya received a kind but firmly worded missive from the Prior of the Aula Dei monastery, Father Félix Salcedo, who had been asked to mediate in the dispute. The worthy monk preached Christian charity, upheld Goya's gifts, but stated in no uncertain terms that Goya not only was to resubmit the designs for Bayeu's approval, but was to do nothing further without Bayeu's express permission in writing.[3] It was a shattering blow to the aspiring artist. In Goya's eyes, his condescending and superior brother-in-law was like some tin god ruling his life; and by July he was describing him as "Bayeu el grande"—probably

a sarcastic pun with the double meaning of Bayeu the elder and Bayeu the Great and a far cry from the days when he boasted of being his disciple.[4]

It was the daring tones of his brushwork that had upset the traditionalists. His magnificent Virgin finally passed muster for the dome, but among the pendentives that included depictions of *Faith, Patience,* and *Fortitude,* it was his *Charity* that caused most criticism. Indeed this had to be changed before the cathedral committee would accept it. Wounded to the quick he finished the work with considerable ill grace; and hastening back to Madrid with a confused Josefa, wrote to Zapater concerning another work, pouring out in injured tones exactly what he felt. "I'll do that picture for you as soon as possible after our arrangement, but I consider it's your friendship alone that makes me do it, because thinking of Saragossa and painting burns me up."[5]

His attitude reflects a feature common to many aspiring artists. Some, of course, are cooperative, modest and quiet, but others are not. Goya belonged to the latter. He was querulous and impatient, largely because he knew he stood head and shoulders above his fellows. In a society like Spain's, where bureaucratic niceties were perhaps more rigidly observed than elsewhere, such an atmosphere lent itself to wrangling and explosions among its members. It had much to do with personal honor, the integrity and purity of which it was the duty of everyone to uphold. In Goya's case, he displayed his wrath not so much when he was criticizing others, which he often did, but when others were criticizing him. This was the true stain upon his honor. In such a situation it was difficult to avoid appearing vain and egocentric, not from pure bombast but from sheer anger and frustration.

Aggravating his problem, as we have seen, was his natural ambition. Some artists of outstanding merit are content to remain aloof, either because their principles in art are too removed from what society accepts and they don't care, or else because society has already accepted them. Goya, far from aloof, was in neither category at this stage. Indeed, as an outsider he longed for society to acknowledge him; and because his instincts were pushing him to explore new horizons, this desire for recognition with all the rivalry it entailed, became all the more intense. His vanity

in a roundabout way was touched with sincerity, with an insistence that what he was trying to do had a validity as he saw it. The result was an effusiveness of manner, which was partly an appeal for attention, partly a showing-off of his disgust whenever attention eluded him. Effusiveness was part of his life, because this was part of his art. The whole fanfare of life was his canvas. It was like an obsession with him. And the more he cast off art's moribund techniques, with its passé baroque and passing neoclassicism in favor of new pictorial styles, the harder he found it to identify with his contemporaries. A genius or a prophet, whether gregarious like Goya or lonely like Leonardo, has always to pay an intolerable price.

It was his quality of mixing with ordinary people that eased Goya's pain. Here he could be himself, not from superiority or neurotic escape, but to "burn himself up," in which outrage could mix with relaxation. He had many friends, and names like Francisco Pirán, Josef Yoldi, Pallas and Ceán, abound in his correspondence. The traveling Pirán especially, served as a go-between in various financial dealings between Goya and Zapater, as each entrusted money to Pirán for the other to make purchases in Saragossa and Madrid respectively. There was also Zapater's aunt Joaquina Alduy, whose requests for Madrid finery Goya was especially concerned about. And there was Juan Martin Goicoechea, the same who had helped him get quarters in Saragossa. A founding member of the Aragonese branch of the Friends of the Nation economic society—an organization of Basque origin linked with other regions designed to promote agriculture and industry by means of private enterprise—Juan Martín was a man of wide interests, and his support of a local arts school in Saragossa which burgeoned into the Academy of San Luis by 1792, led to his becoming its vice-protector.

But it was Martín Zapater himself who was Goya's greatest delight. Their strange relationship is the most remarkable in the whole of the artist's life. A wealthy self-made merchant in the contracting business who never married, a treasurer of the same economic society mentioned above and ardent promoter of the Academy of San Luis, Zapater was created a noble of Aragon in 1789, partly because of his financial help during a grain short-

age in Saragossa of which he was a council member. He leased much land and his assets therefrom were considerable. He had a great interest in the arts which included theatre construction, and his generous character made him likeable to many. Their friendship that stemmed from common experiences at the same school—as boys they had both attended the Pía school in Saragossa run by Father Joaquín—certainly grew closer when Goya returned to this city after his sojourn in Italy. Whether they were in the same class under Father Joaquín's headmastership, however, or even of approximately the same age remains uncertain, since Zapater's birthdate is unknown.

It was this success story achieved by an attractive personality that drew Goya irresistibly to him, and by the same token made him the butt of Goya's envy and frustration. But this was accompanied by a good-natured love, not spite. And while their relationship was a deeply spiritual one—homophile, not homosexual, at least where the artist was concerned, perhaps like David with his Jonathan—it also served a practical purpose, for Goya took his cue from what his friend said and did. In a letter of 1780 for example, he stated that he had only 5,000 pesos to spare (a little over a thousand pounds), and hoped that Zapater would advise him how to invest this sum to greater advantage.[6]

We know little else about Zapater beyond what he looked like and the fact that he responded warmly to the artist's friendship. Perhaps Zapater's dabbling in poetry was a dilettantish throwback to his youth, in which he craved for criticism from the master as much as Goya craved company from him. Music and dancing too were mutual interests. But we know much more about the artist's motive for the friendship. For Goya, Zapater was the perfect target for all the slings and arrows of mood an Aragonese was capable of unleashing. He poured out his thoughts to him like a child. Goya loved him not only because he was Zapater, but because he saw traits that complemented his own. And he used subjectively colorful epithets to describe him. Zapater was his "cannibal," his "big nose," his "face of a bear," his "drone," "little demon," "idle wastrel," "dirty rascal," and for good measure, his "pile of excrement" as well. But Zapater didn't mind. The more he was caressingly insulted, the more he understood

Goya's deep need of him. Goya, after all, would use terms of endearment equally insulting to himself. "Your Paco the Plump," he once ended a letter with, while often making fun of his own flattened nose.[7] And there was genuine companionship whenever the two could be together in Madrid or Saragossa.

Zapater was an important figure in Goya's life for the rest of the century. Because of him we get a glimpse of Goya's bitterness, ecstacies, and triumphs poured out with feverish haste. The spite against "vile men" turns to exultation at his own success, expressed in a whirl of images colorful even by Aragonese standards. The words are frequently misspelled, though his mischievous resort to a trill of 'r's and 'l's delights us (as in "turrrrrronas" and "tordelllllaaas," which are kinds of pie or pastry).[8] We see him concerned for friends and relatives, sending toy dolls and coaches to children, money to his family in Saragossa, along with silks and gowns. Zapater of course gets the pick of the crop. He sends him a light-sleeved overcoat of the kind just coming into fashion, goatskin wine bags, mended guns and English clasp knives (which at a hundred reales a pair replete with whetstone, Goya trusted, was a bargain compared with London prices). And he sends stuffed pork sausages by the dozen — a Madrid delicacy apparently — as he begs Zapater for Aragonese chocolate and nougat in exchange. He would savor each sip of brazier-warmed chocolate as if it were manna from Aragon; and as for those bars of almond nougat folded and cooked in pastry, such a pie made a special treat at Christmastime, reminding him of home. Even the maize from Saragossa was to be meticulously packed in glass jars to keep out the rain.[9] In between his cigars and snuff, he would enumerate in writing all his favorite tastes.

We see Goya obsessed with hunting, be it duck, partridge, quail, thrush or rabbit, and savoring the meat that went with it. And he also loved his hunting dogs which he used as 'draggers'. In reclaiming one dog loaned to a friend, he expressed grief when it suffered in transit, or if any suffered from mange. Indeed, taking them to the vet for delousing and purgatives was a ritual with him. And one thinks of that supremely tragic study done in later life, of the dog half suffocating in a raging sandstorm. We see his growing interest in nature generally, from birds to crawling

insects, with all the bare anatomies of life lying at his feet. But it was dogs he loved the most. At times, it seemed, he loved the canine kingdom more than man.

* * * * * * *

Though full of bitterness toward the world upon his return from Saragossa in June 1781, he did get paid for his *Queen of Martyrs* painting and other work in Pilar cathedral to the tune of 45,000 reales, and his fame was spreading. A great opportunity moreover came this same month, which considerably lifted his spirits. He received a royal commission to paint the largest of seven altar canvases for the new Madrid church of St. Francis the Great, designed by F. Sabatini. This was approved by Floridablanca, who had been impressed by some Goya drawings shown him by his subordinate Vicente Bermúdez, a friend of the artist from Saragossa. The other six artists engaged in the project were Francisco Bayeu, Antonio González Valázquez, Andrés de Calleja, Salvador Maella, and two junior court painters, José del Castillo and Gregorio Ferro.

Goya once more was in an ecstatic mood. He asked Zapater and Goicoechea to spread the news throughout Saragossa, so that all those "vile men" who had denigrated his work would get a sharp rebuff. There was every reason, moreover, to cut the ground beneath his rivals in Madrid, for "Bayeu the Great," Maella and the others were vying in what amounted to a competition for promotion, in which he, Goya, would emerge the most favored.[10] His theme for the largest of the altar canvases was of St. Bernardino of Siena preaching before Alfonso V of Aragon (with Goya making himself appear in the crowd); and this *tour de force* took him two years to complete. In the process, incidentally, he purchased a nine percent annuity in the new National Bank of San Carlos with 30,000 reales from the money he had earned in Saragossa, and hoped—quite forlornly as it turned out—that he would receive this same amount for the work he was now doing.[11] He hadn't yet reckoned with Floridablanca.

By October meanwhile, anxious to redeem his reputation in Saragossa, Goya reversed tactics and instead asked Zapater to play down the altar work's progress so as to avoid any criticism

from his rivals. "Now that we're united in this matter let's keep silent about what we must," he wrote. For enemies were always lurking. In his superior mood, he saw very clearly the distance between himself and all those court flunkeys around him. Enjoying the simple pleasures of this world was very different from the world in high places, where petty malice abounded. "I shan't forget the thrush-shooting season is coming," he went on a few days later, "and if it weren't for the St. Francis picture I wouldn't have to pay heed to all the caterwauling gossip and formal respects here, for I like doing what I like. To hell with those who are concerned only with fortunes at court and with mundane affairs, for I see clearly that ambitious men neither live nor know where to live."[12] He intoned all this, of course, with not a little ambition himself.

But the barbs against his rivals lost some of their sting shortly before Christmas of 1781, when the death of Zapater's sister Manuela was followed by that of his own father on December 17. Such events affected him deeply as his family duly informed him of José Goya's last hours. "I am consoled by the opinion I've made that she was a very good person," he wrote to Zapater in November about his sister, which summed up the quality he would see in his own father, "and she will have found a good bit of glory which we who've been so dissolute also need in order to correct our own lives in the time remaining to us."[13] The remorse he felt, perhaps, was beginning to make its mark. And his main concern was now chiefly directed at completing his St. Francis church canvas, a sketch of which he later sent to his friend.

As he labored away, he eagerly awaited news of praise from Charles III. Surely the King, via Floridablanca, would approve of what he was doing, as every Christmas His Majesty passed through Madrid with the court. But Goya had to wait a long time; and he was scarcely assuaged the following Christmas of 1782, when Floridablanca tossed him a paltry 6,000 reales as if it were charity. It was praise from the King he craved, not money alone.

In this connection an amusing story concerned Francisco Bayeu, whose praise from Charles III received a suprise ending. One cold January day in 1783, Bayeu deposited in the Royal Palace uninvited what is believed was his Christ and Virgin painting for

the St. Francis church, and then left abruptly. It was a presumptuous act, though pardonable in view of Bayeu's status and the fact that his canvas was destined for the church's high altar. Fortunately, it won Charles III's approval. Hating formality and frequently relaxed, he usually backed his subordinates to the hilt if they were loyal, and his verdict on any Bayeu painting, however bad, was always his proverbial "good, good, good." But when the royal architect Juan de Villanueva expressed the same approval to the Prince of Asturias, the latter came down on him like a ton of bricks. "You're a beast," he grated to the astounded architect, as he decried the picture as totally lacking the proper light and shade and any merit whatever, "And you can tell Bayeu he's a beast as well!"[14]

Backed no doubt by his wife, the Prince made it quite clear where he stood. It was Goya, moreover, they both preferred—and here the future Charles IV was right for once. In the end, Bayeu's picture proved such a farce that before the altar pictures were finally unveiled two years later, it is believed that a piece of sculpture had to be submitted instead.

The tables had at last been turned on Bayeu. But Goya's revengeful feelings were tempered by a little compassion he might not have shown earlier, perhaps for Josefa's sake. In relating the incident to Zapater, he expressed pain over this slur to his brother-in-law, despite their altercation, and hoped that with a little help from friends like Goicoechea, the whole matter could be discreetly hushed up. And to do Bayeu justice, he did have many administrative problems which took him away from his work. Deep inside, however, Goya felt his point had been made. The coterie of second-rate court painters whom he despised was as shallow as the Prince himself, who despite his kindness to him didn't really understand anything about art. It was not until 1786 that Goya buried the hatchet with Bayeu by painting his portrait for the first time since 1780, and in that staid academic style he knew his brother-in-law would approve of.

Bayeu's gaffe certainly lifted the shadow over Goya; and any insinuation that there were aftereffects from his own rebuff at Saragossa could only, as he put it, "make me laugh."[15] Despite pitfalls ahead, he was still clinging to his twin ladders—the one

leading to Floridablanca and the King, the other to the Prince of Asturias and his friends. And now it was Floridablanca who took the initiative, possibly prompted by Sabatini, in asking Goya to do his personal portrait in January, 1783.

It was a signal honor, for Floridablanca next to the King was the most powerful man in Spain. The war with England had gone well (outside the context of Gibraltar), and now that England and the United States had agreed to separate, peace was near at hand. Having Goya to paint him would relieve the tension after organizing a war effort on a world scale. He knew the artist's work by this time; indeed he had recommended him to join the team for the St. Francis church canvases in the first place. The huge work was coming along nicely. And the minister now expected a similar result.

Floridablanca treated him with courtesy during the portrait's preparation. A friendly discussion took place late one afternoon in January after Floridablanca had come up to Madrid from the Escorial, where the court was residing. It was to be kept a secret from everyone except Josefa and Zapater;[16] if news leaked out that the artist had the ear of the all-powerful minister, "vile men" in Goya's view would certainly be up to their tricks again. But the portrait proceeded without incident, and along with a second one was finished by the spring.

Goya imbued the picture with an allegorical message as the enlightened minister stands next to a drafted project on the Imperial Canal of Aragon to symbolize Progress. It is not among his greatest works, however. The minister betokens magisterial power no doubt; but it is tempting to consider whether Goya's critics might have cast their barbs at the surrounding underlings of whom Goya was one, as he holds up a canvas to the minister in a subservient posture to symbolize Art, Charles III's head staring vacuously on the wall behind, a clock ticking approvingly in the background. The whole effect seems rather out of perspective—the underlings are too short, the minister too tall. Even granted the style of the period, could Goya's rivals have convinced the sitter of the portrait's defects, accusing it of crude satire? One can imagine Bayeu, albeit no evidence exists, feeling satisfaction at someone else besides himself stumbling at court, thus vindicating his own stand

against the flamboyant miscreant in Saragossa.

Whatever the facts, something made Floridablanca markedly distant toward Goya in the course of the next twelve months. Floridablanca was no fool. He was a keen judge of men; and it is just possible that in listening to criticism, he resolved to proceed cautiously in furthering the artist's acquaintance with his sovereign Charles III.

There was also renewed pressure of work at the highest level in arranging the final peace terms with England, France and the United States, in which Charles's insistence on Gibraltar's recovery took a great deal of the minister's time. In this respect Aranda, long exiled to Paris as Spanish ambassador and cursing Floridablanca for his senior position, was told to cooperate with the French minister Vergennes; and the final treaty was signed at last in Versailles on September 3, 1783. Though Gibraltar had to be relinquished, Spain did recover from England both Floridas (i.e., southern Alabama and present-day Florida), all of Central America except for a small enclave around Belize, as well as Minorca in Europe. It was obvious that Spain as a victor had come off considerably better than France. Indeed it was Charles's finest hour, as fireworks lit the sky all over the nation and special Masses were said.

Goya meanwhile treated Floridablanca's coolness philosophically. No news was good news. On the advice of friends he was learning diplomacy by not pestering him. But he must have seen in Floridablanca an obstacle to further patronage, eager for promotion as he was and still awaiting praise for his St. Francis canvas which never seemed to come. And in his darkest hours he no doubt added to his list of professional enemies the King's chief minister himself.

* * * * * * *

For his part, Floridablanca was further irritated by Goya's popularity with patrons who were not exactly in the royal favor. As we have seen, María Luisa as the King's daughter-in-law was a dangerous pull in this direction. Her reckless frivolity beside her husband's indifference was forcing a wider breach between Charles and his heir, and Floridablanca had been at odds with

her on a number of occasions. But there were other royal family members apart from the Asturias couple who were acquiring Goya as if he were their own. The King had a brother Luis, the former Cardinal-Archbishop of Toledo—the same who had posed a threat to his throne during the Jesuit crisis. Charles still kept him at arm's length, and it is possible that the Asturias couple, always scheming to score a point, encouraged Goya to move into his circle. If this was so, then the artist willy-nilly was becoming a pawn, and a valuable one at that, in the royal game of favorites. More tangibly, Luis had an architect, Ventura Rodríguez, whom Goya had known at Saragossa, and this architect might have made the first move in introducing Goya to so distinguished a patron. It was also a fact that the brother-in-law of the younger Bayeu sister María, named del Campo, held a post with Luis, and through this brother-in-law Goya almost certainly profited from the connection.[17]

Luis was a lover of music—he had known Scarlatti, Soler, and Boccherini—but he loved sensual pleasure even more. Released from his vows after the death of his father Philip V, but without permission to marry, he became so frustrated that he had been brought before his brother Charles III on a charge of misconduct committed in a tempting forest setting—in other words, rape. Charles didn't really know what to do with him. But as he now posed no danger to his throne, Charles lifted the ban on his celibacy with the approval of the Church, and proposed that he marry his own daughter, María Josefa. Such a union between uncle and niece was not unknown. But the horrified niece was not at all interested, and Luis settled for María Teresa Vallabriga of the Torresecas family—minor Aragonese nobility. They had first met in Madrid, but it was the hobby of catching butterflies that finally brought them together. Luis was a sporty fellow. And this morganatic marriage duly took place in the summer of 1776.

Charles was shocked and disgusted. It was a violation of his high ideal of monarchy, which as a matter of course meant keeping ordinary nobility in its place. And he banished Luis and his bride from the court. They were given the modest title of Condes de Chinchón, and to rub salt into the wound, their children were to be addresseed as the equivalent of plain 'Mr.' and 'Miss' Vallabriga. In the children's case Charles's decree proved unavail-

ing, while his brother in practice was addressed as the Infante Don Luis de Borbón. Much as he loved his brother—he had made an excellent hunting companion in earlier times—the King felt constrained to put duty before kinship; but in the process his high moral standards, finicky as they were, only brought trouble from his entire family.

Luis had his residence at Arenas de San Pedro near Ávila (along with other seats at Boadilla and Chinchón). It was here that Goya got to know the couple well; in fact it was probably Luis's Aragonese wife as much as her husband who furthered their relationship, and who was to retire to Saragossa itself in later years. Evidence also points to Goya's wife being included in the group, and to both them being shown the pleasant sights of Arenas.

Their stay here was a great success that summer of 1783. Goya was in his element as he went shooting with Luis, bagging partridges and other game. He painted his illustrious hosts, each portrait done in the space of an hour with loose and rapid brushstrokes, along with their children Luis and María, aged nearly seven and three respectively; and he painted Luis's wife, María Teresa, separately on horseback. The Infante household group is perhaps the best known of these works. The husband sits at cards, the wife has her hair dressed, other members are standing near the table. Goya here improves on the Floridablanca portrait as he bends with palette and brushes—not quite so cringing this time and recalling Velázquez' *Maids of Honor*. And despite a cunningly drawn figure smiling bravely with a bandaged head, the whole effect is one of harmony and joy.

Goya wrote boastfully to Zapater after his return in mid-September. The Infante Luis ranked him above other artists as well as other marksmen, commenting when Goya shot a rabbit that "this paint-dauber is even more dedicated than I am."[18] Luis gave him a thousand pesos (silver dollars worth more than 200 pounds sterling), along with an expensive dressing-gown for Josefa. He begged Goya to come again, and put a coach at his disposal when Goya eagerly joined the distinguished couple the next year. This time he made copies of some of the previous portraits, and painted Luis's architect Ventura Rodríguez, based on

a previous sketch. And as a final happy outcome among the many compliments the artist received, Luis as token of his esteem conferred the chaplaincy of Chinchón on Goya's brother Camilo, who had taken the cloth.

Goya was ebullient with his success, as if he had breached the royal defenses once more. Each high-born hand he kissed meant one less hand of malice capable of harming him. Petulant, rebellious, at times cynical and coarse—yet genial and humble when he wanted to be—Goya in his exuberance now wrestled with the enemy inside himself. The threshold of glory was looming nearer. But even as the glory beckoned to him, it was still not quite within reach, and the shadow of Floridablanca seemed to stand in the way. "Everyone's astonished at my getting nothing from the minister of state after all I've done to please him," he wrote disgustedly to Zapater. "If there's nothing to be gained, there's nothing left to hope for, and after expecting so much from my merit, I've become all that more mistrustful."[19] Yet he knew he must suppress the malice within him, be like those others who rained down their power above him. Thus the moment of recognition for his St. Francis church painting would in due course arrive, with the promotion and triumph that went with it. Floridablanca, Bayeu and Sabatini, each must be deferred to in his own way. He must learn their rules, move with skill as they did, gracefully and silently, and with no more asides, no more tantrums, no more scenes at home. But these resolutions were not so easy to carry out.

There were brief happy times even for Josefa, a loving woman in her modest fussy way, who was making the best of a difficult situation. Endless miscarriages, tension, and family feuds, were part of her life. The quarrel between her husband and her brother had taken its toll. But there was always the chance of another trip to Arenas—a change of scenery that was a welcome respite from their Madrid home in Desengaño Street, where Goya would rant on about artists and politicians, as if he were the chief minister himself.

At times he would join her on trips to the local cloth shops and markets, and satisfy her craving for gowns and finery, which was every Spanish woman's right. We get a glimpse of her visiting

the market of San Luis, long since vanished, with its bread, vegetables and fruit going at bargain prices—her husband no doubt joining in with the bargaining. (How he loved to haggle!) And we get a glimpse of her at home listening to a *tirana*—a Spanish song accompanied by the guitar and dancing—wafting up from the street below, while her husband begs Zapater in a letter to come and visit them. For him especially a room was always ready. "You can eat and mess things up," Goya wrote to him on another occasion, "dance and get drunk, do as you please, cry, yawn, say your prayers, shave, rave, and jump till you fornicate."[20] Yet one suspects that Zapater was the one person Josefa wouldn't mind coping with. It was Goya, after all, rather than his guest who did these terrible things. Such a visit would relieve the monotony. And Zapater when he came up to Madrid would often give them introductions to friends for use on vacations.

But if Goya reasserted his self-control at the expense of his impulses, thus relieving Josefa's frequent anguish, his stormy artistic world with all its bustle was proving too much for his mother, Gracia Lucientes, who had come to Madrid from her home on Rufus Street in Saragossa to stay with her son. There had been a happy family reunion with Goya's siblings, Rita and Camilo, after his triumphant return from Arenas in September 1783; but a year later, feeling the strain, the mother asked to go back to Saragossa. Goya generously settled on her an income of about five reales a day (partly from his 30,000 reales investment in the new National Bank), as he had done with his wife. Zapater as usual, or Goicoechea, was to handle her affairs in Saragossa via Pirán, and help both her and Rita should either of them fall into arrears with the rent.

The family was grateful to Goya; but their boy prodigy was extremely finicky about expenses—in his brother Tomás's case, for example, demanding exact receipts for money lent via Zapater, while insisting that everyone get wind of the generous assistance he was giving. A combination of pettiness, prudence, and vanity! But this was typically Goya with his many contradictions— unpredictable rustic, thrifty bourgeois, and compulsive spender all in one. Tight-lipped about his income, lying about it even to

his friend Zapater, he considered he had to act in this way to avoid being badgered for money. And with so many poor friends and relations around him, perhaps we cannot blame him.

His mother's departure in October 1784 was a kind of relief for Josefa, who while grateful for her help was once more in the later stages of confinement. But a supreme blessing came on December 2, when a robust boy was born at her home in Desengaño Street and duly baptized. His name was Francisco Javier. He was their only child to survive—they had already lost two sons and a daughter— and he was to live till 1854. The father was proud of him, the mother in the long term even prouder. The son's love, however, was scantily returned to the father for reasons that later developed, and in any case the price of genius is often to be distanced from one's own flesh and blood.

At the time of his mother's departure, meanwhile, Goya was in a buoyant mood for other reasons. He had just finished painting an Immaculate Conception and three saints (destroyed, alas, during the Napoleonic invasion) for the church at Calatrava College, which was part of Spain's distinguished University of Salamanca. His efforts earned him 400 doubloons, or nearly three hundred pounds sterling, which he once more invested in the new National Bank. He received this payment from an illustrious figure of the period, Gaspar Melchor de Jovellanos, who having been rewarded with a portrait sitting, probably arranged the commission in the first place.[21] Playwright, great thinker, and a patron of the arts who had long admired Goya's Velázquez etchings, Jovellanos as a lawyer and friend of Floridablanca was now secretary to the Council of Knighthood Orders, of which Calatrava was one. Since Floridablanca himself had studied law at Salamanca and remained in close touch with Jovellanos, the Calatrava paintings so successfully achieved seemed to put Goya right back into the chief minister's good books.

At last the great moment came, the event that Goya had been waiting for all this time which had become something of an obsession—the unveiling of the St. Francis church altar pictures. Toward Christmas of 1784, a solemn Mass was celebrated in the church by Father Joaquín Eleta, the King's confessor, and within a month all its paintings were formally inaugurated. Surely the

King would send for him now.

But the result was rather an anti-climax. Goya wrote excitedly to Zapater on December 11, as Josefa lay in a sweat of fever after giving birth to Javier, that his St. Francis church picture was certainly liked by all the public—there was no doubt everyone was for him—but that so far, he knew nothing about what would transpire in high places; they'd soon see when the King returned to Madrid from his local court residence...[22] When the King did finally arrive however, much as Goya's work was generally recognized as the best, officialdom under Floridablanca seemed to dampen the whole enthusiasm. "There isn't anything to report about my affairs in the highest circles, and I don't think there will be," Goya wrote rather disconsolately in the New Year, "though I couldn't be happier about the outcome...[23] Doubtless while dwelling on the public's approval of his St. Francis church effort, he was also reveling in the fiasco of Bayeu's unpopular one. Meanwhile in the hushed expectant atmosphere, still nothing definite was announced. With Floridablanca, it was always caution and keeping people guessing.

As the artist's reputation waxed greater by the month, Floridablanca had only to whisper the right word to the King for Goya to become one of Charles's closest painters. But still he held back. Would Bayeu and Maella support him? What would the others say? And didn't Goya have too many points against him with his impetuosity and stubbornness, his support from María Luisa? Capriciousness in skilled hands could easily lead to satire, and this could include monarchy itself. But the minister had to do something. He could scarcely oppose a minimal promotion; and by March 18, 1785, Goya found himself appointed assistant director of painting instruction at the Academy—strictly under Bayeu—at a pittance of twenty-five doubloons a year. He had taken the place of Calleja who had just died and whose altar canvas for the St. Francis church, incidentally, portrayed St. Anthony of Padua.

Floridablanca's finesse did not fool Goya. Bayeu's shadow, moreover, always hung over him as well, as if the two were in league. And he must have felt compensating relief in the shadow of the generous Infante Luis when he kissed his hand for virtually

the last time outside the Prince's rooms in Madrid on March 29. That day was a brilliant occasion. For a royal procession took place at Atocha, where a hermitage in honor of the Virgin was yearly venerated when the court was in residence. Charles III and two of his children, Josefa and Antonio, were there in splendid coaches, followed by the Asturias couple with their daughter Carlota sitting with her back to the horses. Fireworks lit the sky as the King prepared to leave for Aranjuez, which was his custom in the spring. But Luis was not among them. He looked pale and exhausted, as Goya stood there before him half an hour before the royal departure.[24] And by August he was dead.

His passing deeply affected not only Goya but the reigning King, who had virtually pardoned his brother's forsaken ways. But the supreme irony came after Charles's own death, when Luis's daughter María married an upstart named Manuel Godoy and so became the wife of Spain's future premier—the same daughter, the beautiful and sad Condesa de Chinchón whom Goya was to paint again as an adult in the years ahead.

Meanwhile, Goya was not going to let Floridablanca browbeat him. After years of hard work on his St. Francis canvas and getting next to nothing for his efforts, he formed an alliance with his younger colleagues Ferro and Castillo (who had portrayed St. Joseph, and St. Francis greeting St. Dominic respectively), and presented a joint petition to Floridablanca in April 1785 demanding full remuneration. They had each received only 6,000 reales so far and there was a big shortfall. The wording was bold and could not be ignored. Responding in niggardly manner, Floridablanca assigned them each a paltry sum of 4,000 reales— still far short of what Goya expected to receive—noting in the process that "the pictures weren't anything much, though these were less bad than the others."[25]

As Goya prepared to go to Chinchón in the summer to unload before his brother Camilo all his grievances and triumphs, Floridablanca knew the battle was far from over. Already the Duke of Medinaceli, chief majordomo to Charles III and about the richest grandee in Spain, who had heard of Goya in Saragossa, had commissioned him to paint an altar Annunciation for the church of San Antonio del Prado (near where the Prado Museum

now stands). A welcome of sorts had been given to Goya as an instructor at the Academy. But Floridablanca, like Bayeu, knew he could not postpone for much longer an even bigger welcome from the King himself.

FIVE
The High-Riding Bourgeois

"My dear Martín. I'm now King's Painter at a salary of fifteen thousand reales, and though I haven't much time I can outline briefly how the King ordered Bayeu and Maella to search for the two best Painters to paint tapestry samples and anything needed in the Palace, whether fresco or oil. Bayeu proposed his brother, and Maella proposed me. The recommendation went up to the King, and the favor of the appointment was made without my knowing that it was given to me, or what would transpire.

I have thanked the King and the Prince, and the other Chiefs including Bayeu, who tells me he was responsible for Maella proposing me, and I have thanked Maella for his part in proposing me as well. Goodbye till I write further. Yours and yours again."[1]

Goya's new post was confirmed on June 25, 1786, and the good tidings expressed above were sent to Zapater twelve days later. The Santa Barbara factory had just been reshuffling its personnel, and Goya along with Ramón Bayeu were specially selected for work at the Royal Palace. Their joy can easily be imagined. Now at forty years of age, Goya had at last achieved an important goal—to be nearer to the presence of the King. Earlier, he

was the Lazarus who had to beg for favors; now he was the rich man of whom favors would be asked. He had of course to share the post with others, and was in fact to wait beyond Charles's death before he became a royal chamber painter, or *pintor de cámara*, with duties even then at the tapestry factory. But the coveted promotion meanwhile allowed him much more access to court patronage in general. Commissions would be greeting him on all sides. And there was the powerful Medinaceli at hand, along with all the others, to put in further good words on his behalf.

As he strolled along the narrow streets between his home and the factory, or crossed the Puerta del Sol on his way to the Royal Palace close by, wafted by the cool breezes from the adjacent hills, perhaps he might resolve this time to make no more blunders. In the intoxicating mood of his new position he knew the standards expected of him, whether at the King's side, at palace functions, in the presence of the Prince and his wife. He was a respected figure at last. But he longed at times to escape from the court's formality and be his Aragonese self. He had to act his part out like all the politicians around him whose profession he detested, and this dual role often brought on unbearable tension. Fortunately he served a king who, while demanding, was patient and relaxed and who also disliked the trappings of too much etiquette.

It was the Indian summer of the Spanish Empire, and despite family problems Charles III was basking in its glory. Increasingly withdrawn, feeling his work had been done, he was approached by diplomats from many countries seeking his advice, for he was now virtually the senior king in Western Europe. Thanks to his efforts the prestige of Spain as a great power had never been higher since the days of Philip II, and few could guess the primrose path to disaster the nation was to tread during the fateful epoch of the French Revolution and Napoleon.

In these last years of his reign Charles got to know Goya well. Two of the greatest Spaniards of the eighteenth century confronted one another at last. And whatever faults he discerned in the artist's character, Charles had to accord him his due for the latter had earned his promotion by sheer merit and this was in keeping with Charles's own principles. We can assume he put Goya at his ease. Indeed the artist's famous portraits of him suggest a warmth and

intimacy that was mutually shared. They would surely talk about hunting, though the King who once boasted that "rain breaks no bones" now found dampness creeping into them. He appears more than once in his cocked hat, gloves in one hand, gun in the other, pockets stuffed with impedimenta above his high gaiters, white hunting dog lying at his feet. Model and artist were in their element here, eternal marksmen as both men were and linked by a mutual attachment to the soil. Neither Charles nor his brother Luis, incidentally, were handsome—the King looks as if he is sniffing for the chase, the other as if pouncing on it—but between the humorous and the ugly Goya managed to bequeath an affable expression to the former, as he had already done to the latter.

He was careful to keep the King's trust; for that perpetual royal smile could be deceiving, as Goya well knew. Humor was one thing, familiarity another. And as he worked away along with Ramón Bayeu at those tapestry designs that would end up in the Escorial or Pardo Palace dining room, he also sought to make the heirs to the throne as contented as his king. A breach with any of the royal family at this stage would be highly impolitic.

These late designs for the Pardo in 1786–7 are among Goya's more famous. The Four Seasons are gems every one, from the flower girls of Spring and the threshing floor of Summer, to the grape harvest of Autumn and the snow scene of Winter with the wind and the cold stabbing at the three peasants in one of the few such settings Goya ever attempted. Such a rarity earned praise in a poem by an academician named José Tejada. And there are sketches of a huntsman and flageolet player, of poor people drawing water, of boys round a huge mastiff. Such scenes would be pleasing to Charles, for he always paid attention to the simple poor, and both men loved dogs.

But perhaps the most striking tapestry design is his *Injured Mason*. Reflecting a royal decree of 1778 requiring scaffolding to be made safe against accidents, it stresses a popular incident as much as it foreshadows the *Caprichos* (his first great series of drawings and etchings, discussed in a later context). Starkly realistic in its portrayal of suffering, the scene unfolds its drama casually in the course of daily life.[2] Here is Goya the true lover of the people of Madrid.

A parallel to this genre, written for the stage, are the *sainetes* of Ramón de la Cruz. These quick lively scenes stem from the farcical squabbles of bawdy street people, witnessed by Goya and de la Cruz alike. His plays had been in vogue since the 1770s (which continued until the writers' death in 1794), and Goya knew him, along with other writers like Nicolás de Moratín and José de Cadalso, in the famous La Fonda tavern in the Plaza del Ángel. Indeed, the influence of de la Cruz in shaping Goya's own satire may be greater than is generally supposed. At all events he once took Goya under his wing, and probably helped him with introductions to many distinguished patrons, for his plays, going back to Aranda's time, were often privately produced in wealthy houses.[3]

There was not much Charles with his family could do in any case to prevent their gifted servant Goya from meeting other patrons, for having stolen a march on Bayeu and Maella he was fast becoming the most sought-after painter in Spain. Even Floridablanca had mellowed somewhat as he lay ill in 1786, but pleased that his sister-in-law, the Marquesa de Pontejos, had been painted by him with great skill. It is a portrait of rococo brilliance set against a background of vaporous parkland—an attractive style that inspired him with other ladies in the years ahead.

But the King did try to keep his artist on as tight a leash as possible. A case in point occurred after the death of Zapater's father in December 1786, when Goya wrote to Martín that he would paint a picture of the Virgin for him, but that for the present he could not spare a single day as he was behind with all the works commissioned by his sovereign.[4] Indeed it was not till four years later that he actually painted his friend's portrait for the first time, soon after Goicoechea's, when Charles III had departed from the scene. And on another occasion the King proved so demanding that along with Ramón Bayeu, Goya had to ask the treasurer Pedro de Lerena to defray expenses incurred by the many royal commissions. Charles did agree, however, to provide Goya with a clerk for his letters and a grinder for his paints, to be paid from palace funds. The clerk, who had also worked for Bayeu, was nicknamed 'El Perico' (the periwigged parrot) and must have been a rather singular character on this account! He came from

Carabanchel, but no one seemed to know or care what his real name was.

As visitors from all walks of life were now knocking at his door—we get a glimpse of naval captain Luis Vallabriga (the late Infante's brother-in-law) accompanied by an attractive lady from Cadiz making a courtesy call in 1787—Goya must have felt a respite from the court, as well as from Bayeu's crusty circle and the tapestry factory. But the royal pressure was relentless. By the King's express command of April 12, 1787, he was ordered to portray four saints shown in three altarpiece paintings for the new Cistercian church of Santa Ana in Valladolid.[5] It had been designed by Sabatini who now supervised the commission. And as a dutiful Catholic subject Goya got down to work in his studio, taking pains to keep to the neoclassic style so dear to Charles and his architect. At this time also there were bank portraits required for the new National Bank of San Carlos, founded in June 1782 by Floridablanca and Charles's French financial wizard, Francisco de Cabarrús. The latter's portrait Goya concluded by 1787, along with those of other bank directors like the Conde de Altamira, besides one of Charles himself.[6]

Altamira and his wife were important patrons of Goya, and they had a huge collection of paintings. The Condesa posed with her daughter and two sons, Vicente and Manuel, forming a conventional group striking for its browns and reds, along with cats and spaniels that typified family atmosphere in the eighteenth century. The four-year-old Manuel in particular is one of the most fascinating studies of an aristocratic child that Goya yet attempted.

But the patrons with the strongest influence on Goya's development at this time were the Duke and Duchess of Osuna – Pedro Téllez and María Josefa, the latter also having the titles of Benavente and Peñafiel. The couple first met him about 1785, and their portraits followed soon after. They were disposed to give Goya free rein, and the charming family group of 1788 with their four children after the Duke succeeded to his father's title shows a Marie Antoinette style which is but a prelude to a deeper imaginative world of Goya's own choosing.

The Osunas had a country palace outside Madrid called La

Alameda, which lies on the way to Alcalá de Henares, close to what is now the city airport. Goya would travel there on horseback and go hunting with his hosts. He had already worked on seven scenes for one of their rooms, including a *cucaña* game (where boys climb up a greasy pole), a woman on an improvised swing, and the same woman fallen off her donkey. The latter figures could be the Duchess of Alba, who was a frequent guest at the Osuna home. Her elegant posture on the swing is set amid the gypsy-like gesturing of those around her, and perhaps Goya was using her as a model to the delight of his distinguished company.[7]

Totally contrasting with his *maja* frivolity is another scene among the seven depicting a highway robbery. Dramatic in its bloodshed, it marks a step toward Goya's later world of violence and satire. In all of this the Osuna couple with their own taste for the bizarre shared his increasingly avant-garde perspective. Already he was mastering the dynamics of movement. And his famous *St. Francis of Borgia before an Unrepentant Dying Man* (commissioned by the Duke for his chapel in the Valencia cathedral by 1788, together with a companion farewell scene) shows a monster appearing for the first time. Here his *Caprichos* were foreshadowed once more as portrayals of witches began to loom in the Osunas' hallway. The couple remained his closest patrons for the balance of the century, impressed as they were by the grotesque outrage at human folly and suffering which his works express; and to their vast collection of paintings, among the largest in Spain, Goya contributed in the end no less than two dozen.

Capturing the inexpressible amid the fame he was now enjoying gave Goya a great sense of power, and sometimes it went to his head. In his exuberance he could be vain and petty-minded as ever, and at the other extreme as generous—a reaction no doubt to the royal and noble company he was exposed to, into which his rustic self could never really fit. Yet he loved being cosseted and cajoled. It was as if his patrons were conduits to a deeper other-world whose strange shapes and patterns stemmed from a superficial reality. And he was impelled to grope there with or without society's approval. Full of laughter and song, he was also

expert at living with pain—the pain of street people around him, the pain of Josefa. He had learned compassion by stealth. For it was not only his wife and children and maidservants who were frequently ill, it was the world as a whole, whose secret corners only he could find. Surely this, he reasoned, entitled him to privilege and independence. And in the process he took swift measure of his own strength.

It was a mixture of pride, wealth, and bravado that would help him reach where he must. "Regarding my affairs," he wrote to Zapater on the eve of his king's painter appointment, "I need only tell you that I always work honorably but as it pleases me, without my having to deal with any enemy or be subordinate to anyone. I could never be servile, for I've enough means already and I'm not going to kill myself for anything."[8] And on another occasion following an accident (described below), he wrote: "Now that I've established an enviable way of life, I don't dance attendance on anyone, and whoever wants anything from me has got to find me. I've come to expect a great deal more, and unless it's someone very important or a favor for a friend, I wouldn't do a thing for anyone. . . ."[9]

Granted that letters quoted out of context do not necessarily convey the writer's true personality—despite his denial, for example, Goya could be extremely servile when he wanted—they do provide a glimpse of a mood, an inkling of what lies beneath, which juxtaposed with other comments brings that personality a few steps nearer into focus. And we can deduce that he could be as bombastic and self-centered as the men he criticized. "No one's going to ride my horse," he once boasted, implying he could quite happily ride roughshod over everyone else. He could also be rather slapdash with his classes of students, though not when teaching individuals. Yet underlying all his vanity and egoism was a tremendous strength of will, a boundless self-confidence, as if he knew he was a man marked by the gods to be one of their own.

His great joy was to ride around Madrid in a high open carriage. It ran on two wheels and it cost him ninety doubloons. It was a toy with him, like a sports car today, and it was English-made, very light, varnished and gilded. People would stop to admire it, as there were only three others like it in the whole of the city.

One day in the summer of 1786 he took it out for a spin, accompanied by the dealer who had sold him the horse. But Goya unwisely lent the man the reins, with the result that the horse broke into a breakneck gallop down the street, and at the next turn when the vehicle braked, it rolled over giving Goya a nasty jolt. He was treated by a palace surgeon for injury to his right leg, but there was no fracture or dislocation. He was as much pained by the blow to his pride as to his body, and what he said to the incompetent horse-dealer who had caused the accident can well be imagined! As the carriage later nearly killed a man into the bargain, Goya changed this for a four-wheeled landau, with two animals pulling it instead of one, which his handsome 30,000 reales-a-year income could now allow. "If I'm going to serve the public, I can well afford to maintain a landau," he boasted.

In this same letter to Zapater, he also revealed his impatience with his job of instructing, whereby as Academy assistant director of painting he was required to do one month's work, four days each week, conducting classes and correcting students' efforts. "I'm writing to you from the Academy," he began, "and not with the greatest calm, for I expect they'll call on me to correct at every moment . . . and let's speak frankly, for four days we have to live in this world, one must live according to one's taste . . ."[10]

Despite his wealth and prestige, he was petty enough to let his old rancor still haunt him. Thanks to his brother Tomás who was coming up to Madrid with his family and to whom he refers in this same letter, Goya acquired for ten doubloons a pair of tamer mules in lieu of horses to pull his new carriage. While grumbling about the price of barley feed he could easily afford— rising to between thirty and forty reales a fanega because of a bad harvest—he became extremely sensitive about the change to mules, lest the world get wind of it and make fun of him. Here we see his bourgeois instincts at their worst, or misplaced pride at best. For keeping up appearances when it was no longer necessary was part of his eternal showmanship, though perhaps Goya would argue that his role demanded this attitude to prevent anyone from undermining his position. "There are some people who will say they know the mules are for me," he wrote to Zapater anxiously a few days later, "it's as well to be apprehen-

sive, as I suspect it's already known in Bayeu's household through the matter having been written about; and though we haven't actually spoken about it and I'm on my guard, they'll find it out when they will . . ."[11]

Yet even Goya was becoming disgusted with his own pettiness, for in the same breath he wrote that he had better "change the subject." And in all of this he remained steadfast in his generosity to friends, from money to medicine—in the latter case in the form of quinine for Zapater's fever, which he was entitled to purchase from the royal pharmacy. The fact was that Goya was becoming acutely aware of these twists of mind, aware also of his own changing appearance. As he looked in the mirror he saw sunken eyes and wrinkled skin. "And I should like to know if you are *majo*, grave, noble or sad," he asked his friend as if seeking comparison, "or whether you have grown a beard, still have your teeth, enlarged your nose, wear glasses, or go about still narrow at the hips. . . What is certain is that I feel my forty-one years, while you perhaps will continue to look as young as you were in Father Joaquín's school."[12] With good-natured envy, he still saw in Zapater a hero from his childhood past in Saragossa.

But Goya was not alone in his moods. Charles III especially was feeling the weight of his years and with much more reason; for already turned seventy, he was to suffer the devastating blow of losing his favorite son Gabriel, whose wife and newborn infant had also just died. Smallpox had done its evil worst. "With Gabriel gone, I hardly want to live," he muttered, and events soon proved him right. Within a month, on December 14, 1788, he was dead and laid out with great ceremony in the tomb of the Escorial.

Among writings attributed to Goya is a whimsical poem, no doubt done mostly in El Perico's hand, addressed to a certain "Pablo"—a possible reference to the novel *Paul et Virginie* which was popular at the time. The middle of the verse loosely reads:

"Among the latest news I have something to tell:
the Infante named don Gabriel
has ascended into Heaven to look for his mate;
but there're so many up there, you can't elucidate . . ."[13]

The poem is dated November 19, 1788; and one can safely assume that despite all the ceremonious mourning for the prince and his wife, Goya was a bit more affected by the subsequent death of Gabriel's father Charles III, perhaps no longer amused by his little Spanish joke spelled out in flippant verse!

For Spain had just lost one of its greatest kings. Through a firm central government, he had made his country considerably stronger and more prosperous than before. He had diminished class antagonisms that had long bedeviled the nation—the old nobility of the Albas and Infantados, the Medinacelis and Medina Sidonias, having more or less accepted the new nobility of Charles's own choosing. The rivalry between Aragonese and golillas had softened, and the people reconciled to both. Through some degree of fiscal equalization, Castile had become reconciled with Catalonia, smaller merchants with the larger ones, producers with importers. And skilled labor was enjoying new openings in the private sector and the guilds. At the other extreme, as an observer might have put it, "even the beggars were happy because everyone else was." The many fiestas and pilgrimages certainly gave evidence of social harmony. As for the Church, while losing much of its jurisdiction, it too had become reconciled to Charles's regalist policies. The King, it seemed, had performed some kind of miracle in squaring everyone's circle. And if population pressures were causing inevitable inflation and more enclosures of arable land, compared to the rest of Europe it was an age that was not to be repeated for a long time in the history of Spain.

SIX
The Passing of an Age

The reign of Charles IV and María Luisa had begun; and all the good work of their predecessor was about to be reversed. It was on the eve of the French Revolution and few could guess the disasters that lay ahead for Spain. While not all of these could be attributed to the royal couple, there is no question of their mediocrity. The new king could be tactless and blundering in the extreme without any statesmanlike qualities to redeem him—kindly but ineffectual, paternal but prosaic. He loved his flintlocks and the gossip of the downstairs palace staff more than the cold steel of politics. The coming decline of his country was mirrored in his benign but static blue eyes, the weak mouth and puffy cheeks, the large fat body topped by a round and torpid head.

As for his consort, she was much brighter and was certainly brave—she once calmly engraved her name on her future tomb where other princesses would have fainted—but this was obscured by a bewildering mixture of ruthlessness and social charm, and not without a reckless abandon to the wrong kind of favorite. She was the real ruler, but she never really ruled. There was a kind of vacuum in the functioning of state; able men were denied any time to implement sound policy, while timeless men like Godoy implemented policy that was totally unsound. The rapid

changes in government were like games of musical chairs that made a mockery of the strong cabinet system evolved by Charles III and Floridablanca. Neither was there much counterbalance from conciliar mechanisms like the Council of Castile. The elite structure of Spain which could have held the nation together receded into powerlessness because it was denied the responsibility of any meaningful role. In a word, caprice not common sense guided the government. It did not take Goya long to sum up the royal pair, though he had not yet become disillusioned.

He had in fact good reason to be satisfied, for the Queen, he well knew, had been his admirer all along; and Floridablanca on April 15, 1789, was at last instructed to confirm his post as 'chamber' painter (several notches above a mere painter in the royal service). The swearing-in ceremony duly took place five days later at Aranjuez, when Goya kissed the hand of both sovereigns which was his special delight.[1] He shared the post with at least five others, namely, González Velázquez, the Bayeu brothers, Maella and J. Ramos, though it was not till ten years later that he became the most senior royal painter of all, with only Maella beside him. There were also distinguished women painters at the court—Francisca Meléndez being a case in point—which in part reflected Charles III's encouragement of women's right to work.

Because of his father's death, meanwhile, Charles IV ordered a cutback on tapestry reproduction. It was a welcome relief to Goya, long grown tired of doing 'cartoons'. Yet such finished sketches as he did prepare in 1788-9 are among his most beautiful. His *Meadow of San Isidro*, patron saint of Madrid, with its greys, greens, vermillions and blues, is supplemented by a scene of the saint's hermitage along with a picnic and a game of 'blind man's buff'—the latter being the only one converted to an actual tapestry. Conveying the merry chatter of Madrid society, they show touches of impressionism, and the Duke and Duchess of Osuna, with their taste for the unusual, later purchased some of them for their collection.

As the period of mourning receded, Goya got to work on the illustrious royal pair—illustrious that is, only in virtue of the enlightenment they inherited from Charles III and the fame Goya

was to bequeath to them on canvas. And he was not to disappoint them. From March 1789 onwards, their portraits were to hang in the Academy of History, while others of the King included one destined for his brother Ferdinand of Naples and one for the University of Santiago. On other occasions the King is painted in hunting outfit, while the Queen in her Academy of History portrait sports an enormous hat running with feathers and green ribbon that borders on comic satire. It is doubtful, however that Goya was doing this to amuse future generations. The style was his own invention through the use of thick impasto, ironically coming with the French Revolution, and in retrospect it looks like a flamboyant tribute to a passing age.

One saving grace the new sovereigns possessed was a genuine interest in the arts, and Charles IV (unlike his father) had a good taste for music. This was enough to hold Goya's loyalty, for he loved music also. On one occasion in June 1789, a huge concert of opera and playhouse melody was given at court by more than a hundred musicians, which he much enjoyed.[2] If the King liked playing the violin, however badly, Goya liked playing the guitar as well as singing and dancing to the folk rhythm of *seguidillas* and *fandangos,* and he would often recommend guitar players and singers to Zapater on their way to Saragossa, and send him the actual vocal scores.

Goya's recourse to music was partly an escape from the long tedious hours at the tapestry factory; but this did not save him from getting ill later in the summer—whether from overwork or overindulgence is difficult to say. He had bouts of trembling, like sinister forewarnings of worse to come. Moreover, his son 'Paco' (probably Javier's non surviving brother) came down with a bout of smallpox at the same time, so that in the general gloom his old rancor temporarily resurfaced. His absences from court were quickly noticed, and shortly before Christmas he found himself in the presence of the King. But after mentioning Paco's smallpox, the King merely pressed his hand and departed to play the violin. Charles IV's way of dealing with a problem was to pretend it didn't exist. But Goya fancied he detected an atmosphere. "Vile men" once more were trying to undermine his position, when in fact they were merely telling him he was neglecting his duties. As he

put it in a letter to Zapater, he felt more at home among the simple palace staff than among the high and mighty putting on airs before the Palace majordomo, the Marqués de Valdecarzano— the same at whose hands he had sworn his oath of office a few months before.[3] And all the while it was promotion and more money he was after, as if his station in life required him to hand out favors like a prince.

Whatever thoughts the King shared with Goya's superiors, the nearest he got to calling him to task was a few weeks later in February 1790, when looking at his royal portrait destined for Naples, he put his arm on Goya's shoulder, commended him highly, then proceeded to decry Saragossa and the Aragonese! Needless to say Goya was not amused, but doubtless had grown used to Charles's idiosyncrasies by now. Yet the King did appreciate Goya's work if only because his wife did, and may have been referring vaguely to the 'Aragonese' faction among his former political supporters. On one point he was adamant, however: he was not going to give way in the question of a higher salary, not even for the favored artist. At least not yet; Floridablanca would see to that.

"I can't do more than I intend to," Goya wrote in relating the above incident to Zapater, "my situation is very different from what many people may think, because I spend a lot, because I've already made my choice, and because I like it. There's also the circumstance of my being a man so well known that everyone from the King and Queen downwards knows me, and I can't reduce my inclinations so easily as others perhaps can. I'd like to claim more salary, but because of a bad situation and to await a better opportunity, I won't do so now..."[4] In other words, Goya is implying 'Let me carry on with my extravagance, this is the way I am for all the world to see, and they'd better pay me more for my being so.' In his unabashed conceit before Palace and tapestry factory officials, angered by his reluctance to churn out masses of cartoons since his chamber painter appointment, he could still revert to his primitive bombastic self. Yet no other artist could match his genius, and he knew it.

But he was not quite the perfect spendthrift all the time. In a more practical vein he could be prudent enough to ask Zapater's

advice about investments. His motive here was as much to parry the thrusts of constant money demands from friends and family alike (to whom, however, he always remained basically loyal), as to help himself. Investments, after all, were more difficult for his relatives to get at. And an example of his dodging tactics was to buy shares in the National Bank as soon as he got paid. He even underestimated his assets to Zapater, who was quick to note in 1786 that his declared annual earnings of 12,000 reales fell short of the actual figure. Though Goya corrected this by doubling the amount soon after, his total assets with all his commissions, including tapestry sketches, increased to 50,000 reales, then to over 100,000 reales, as he freely admitted to Zapater in 1789. By this time he had at least twenty-five shares in the Bank alone, each worth 2,000 reales on average, and he attended some of the bank meetings.

In a letter of May 23, 1789, he asked his friend whether to invest in more bank shares, in royal promissory notes, or shares in guilds.[5] Royal promissory notes, or *vales reales*, were negotiable paper bills initially bearing four percent interest, which were the brainchild of Cabarrús, the National Bank director previously mentioned. This scheme to raise government money was Cabarrús's device to avoid paying higher interest to the big five guilds of Madrid that enjoyed a huge monopoly in the cloth and silk trade, along with spices, medicines, jewelry, and precious metals. But as the need for money constantly increased, so did the number of promissory notes in circulation, soon reaching over a hundred thousand and worth about half a billion reales, with the result that their value sharply fell. By 1792, the government begged the guilds to bail it out, but this did not save the notes from further decline.

Zapater's reply to Goya's request is not recorded—few of his letters have survived—but evidence points to Goya's further interest in bank shares, as by 1794 he had settled a nine percent annuity on his surviving son Javier from the proceeds after selling some of them. He appears to have avoided the pitfalls of the fatal promissory notes, thanks no doubt to Zapater's good nose for business.

With the ring of money in his ears from his many commis-

sions and royal praise into the bargain, Goya could count the months of 1790 as among the happiest in his life. He felt carefree and independent. And during a portrait session with Pedro de Campomanes, president of the Council of Castile and Florida-blanca's friend, he was allowed by this distinguished sitter to forego morning dress and come in workaday clothes because Campomanes's wife was not at home.[6] A rare privilege accorded to the gifted Bohemian! By July he was granted leave to absent himself from Madrid, and was soon taking the baths at Trillo near Guadalajara. His health was now better; and by autumn he was at the gates of Valencia, his wife at his side.

After presenting some drawings to the San Carlos Academy in this city, with its rich collection of silk weavings and flower paintings, Goya was soon made an honorary member. The academy secretary was Mariano Ferrer, an old friend and sitter who had probably met Zapater here on business. And it was Zapater's company Goya chiefly missed as he went shooting and fishing by the health-giving salt waters of Lake Albufera nearby.[7] In other respects, he never felt in better spirits. In the course of his two-week visit, he collected the balance of his fee from the Osunas for the St. Francis de Borgia paintings he had done for the family chapel in Valencia. Moreover, as a happy outcome to a highly successful vacation, he apparently spent some time with Zapater at last shortly after his return to Madrid, and soon painted him in Saragossa, along with a canon of the Cathedral in the city, Ramón de Pignatelli. A delightful portrait followed by 1791—of a boy named Luis María de Cistué aged two and a half—which replete with dog, figures among Goya's favorite themes.

Just as Zapater and Goicoechea had done, he also joined the Aragonese branch of the Friends of the Nation society, a patriotic and profitable organization. The mood of the hour was one of enjoying the prosperity built up by Charles III, and Floridablanca did his best to conceal from the public the dire trend of events in France. Ironically, much of this prosperity stemmed from French capitalism itself. But already travellers were coming home with disturbing tales to tell. Most Spaniards, however, apart from discerning members of the clergy, carried on as if nothing was happening north of the Pyrenees—too often recalling the late

Voltaire as a harmless playwright and critic—while dandies still slavishly copied the French style of dress.

To this deceptive calm Goya the triumphant bourgeois was also drawn. In his grand manner of living he paid scant regard to social revolution, and at the other extreme, to the formal niceties of life which conservative wealth in Spain demanded. He could write in French to Zapater, as if it were *à la mode* to do so; and his work had already found praise in the writings of a Frenchman, Jean-François Bourgoing, whose *Nouvelle Voyage en Espagne* was all the rage.[8] Certainly pro-French friends from his tavern haunts, like Nicolás de Moratín and his son, influenced him with their avowed rationalism to accept certain values inherited from the new enlightenment coming from France. But none could guess that this same country would one day engulf Spain and destroy its very fabric, to the consternation of so many patriots of whom Goya would be one.

An example of his social pretensions was his arbitrary decision to add *'de'* to his name, so that the world would be obliged to address him as Francisco de Goya; and by 1792 he was trying to claim legal descent from minor nobility. Perhaps he was vying with Zapater who had recently been made a noble of Aragon His *hidalgo* antecedents however, were buried too far in time among the mists of the Basque country, though he did trace back his lineage three generations from his paternal grandfather when his ancestors were once masters of land in Cerain. The process was costly and confusing, and his case apparently had to be abandoned.[9]

More tangibly, as he still labored for the hated tapestry factory, his mind lunged daringly toward satire, as if by way of compensation, and by 1792 he had completed the final sketches for the royal offices in the Escorial. There were jibes at an arranged wedding, women with jars on their heads, men on stilts, and more familiarly, boys climbing trees or playing see-saw. Of special interest is the straw man or stuffed manikin being tossed in a sheet by courtly young ladies, which theme of 'feminine folly' appeared much later in his *Disparates*.

Yet their striking originality concealed the artist's real mood. Restless like his colleague Ramón Bayeu from having to turn out

cartoon sketches like so many products in a factory line, he became resentful and uncooperative, arguing he had done enough of them already. By far the majority had been his in any case. It is estimated that over sixty sketches considered for tapestry reproduction had been completed by him since 1775. But his grumblings about the monotony of his job fell on deaf ears. His attitude annoyed the factory director Livinio Vandergotten who had already complained to the King, even as it annoyed Francisco Bayeu who charitably interceded for him.[10] The result was an unexpectedly contrite letter from Goya, with permission given him for a month's visit to Saragossa. Goya promised to be compliant—to spend more time with Zapater was a delightful prospect—but his excuses were running rather thin.

Perhaps the official rebuke he at last received is reflected in his letter to Zapater a few months later: "You have filled me with such a desire to live with you again that if it weren't for fear of my boss I would have marched off to bring you . . . the *seguidillas* which I enclose, and which will be your pleasure to hear. I haven't heard them and doubt that I will, because I've no place to go and hear them—and this is only because it's been put into my head to sustain a certain conceit and maintain a certain dignity which, I tell you, a man has to have, and which, as you can well believe, leaves me not very contented."[11]

As he drowned his sorrows in his cups—what else was left for an Aragonese who loved wine and song?—he would cast off the many roles he felt impelled to play. The palace showman, the hard-pressed artist kicking against the pricks, king-lover and critic, all those roles he had assumed in one way or another, were buried in his deepest moments, easing the despondency and ill will he felt surging within him. It was infuriating to be at the beck and call of duty when the creative Muses spoke to him, especially those of painting and music. Listening to them was like a ritual. It prepared him for the next assault on canvas. And after those crude and beautiful shapes were born again, the world, he knew, would be there asking for more, with its prim courtesies, its courtly wealth, its primitive passions. When he was being flattered for what he had done instead of being told what to do, then the world's values filled him with a raw exhilaration, intensifying his

vision. The world would be a dance, easing his vulgarity and excess, spurring him anew to capture more of humanity's laughter and pain. But increasingly the process would bring its aftereffects. Hauntings would come again more crude than beautiful, wherein some bizarre changeling seemed to beckon to him with flashes of still stranger art.

Such flights of fancy were, after all, but parts of his artistic mechanism. One has only to think of a host of artists to see the link between freedom from restraint and the creative impulse. It need not be this way, but in Goya's case the pressures were so great that he needed all the more liberation to drive himself forward, as if he were goaded by some other-world compulsion. And the price he paid was not a loss of perspective—on the contrary—but damage to other faculties both physical and psychological, which only his tremendous strength was able to counter.

But slowly the unbearable strain, the intolerable tedium of tapestry demand and his own indulgence, began to tell. His health deteriorated in 1792. He was still very much *compos mentis*, but the blackouts he had experienced earlier in life started to recur. He became more conscious of his changing physique—dilated eyes, hollow sunken cheeks, the bent shoulders; and he grew more irritable. He complained of a knife wound allegedly received in his youth. He was of course seeing assassins in the shadows, ghosts round hills in Saragossa, live skeletons with swords in their hands ready to strike at him. He saw more than the monsters and witches he had already drawn. He saw them this time because he was ill.

By November 1792, after he had given a report to the Academy, things suddenly took a turn for the worse. He had a severe attack of colic and was writhing in agony, his stomach gripped with pain. Fortunately, through Zapater he had made a new friend in Sebastián Martínez, whom he had already painted, probably in Madrid. Martínez was a wealthy merchant and treasurer of the Board of Trade in Cadiz, who invited him down for a visit. Goya was in Seville stricken with illness (minus his travel permit), before he hurried to Cadiz as the guest of Martínez, who now took him under his wing. Here he managed to paint two reclining ladies with delightful effect—one chatting with her

boyfriend, the other taking a siesta—on the overdoors (i.e., extra paneling for decoration, quite customary for the period) in the rooms where he was staying. But he became seriously ill again, and this time he nearly died. It was a gloomy time early the next year as he lay in bed, immobile and delirious. And worse was to come. Recovering, but only just, a few weeks later in March 1793, he suffered a relapse with painful pounding noises in his head. It was acute otitis, with severe danger to the Eustachian tube. He became permanently deaf. An attack of paralysis followed, and once again the end seemed near. But this proved temporary, which was extremely fortunate for Goya and the world. Only his pulsating will to live, his animal energy, had saved him.

So much has been made of his illnesses that little would be served by examining them all here. He is said to have contracted otosclerosis, Ménière's syndrome (or auditory vertigo), and a host of other diseases besides polio. But might not botulism be an added ingredient to his troubles? His obsession for pies and sweetmeats would be especially dangerous in his new environment of southern Spain, and this could have aggravated the symptoms with hepatitis, thus reducing resistance to the really virulent blows when they came.

Things could never be the same in any case. During those dreadful months when he had gone through the motions of living, his whole being contorted in an endless nightmare of despair, he had seen things that not even his most private monsters could approach. It was as if hell and death were his bedfellows. Visions held him with a morbid fascination through all the twilight hours, wearing out his frayed nerves and stabbing him with terrors of remorse from which he would awake sweating and crying out in anguish. Yet he had survived. His zest for life had triumphed. But his way of life could not. The kiss of near death with the disability it brought, had come too near. And it had sharpened his vision of mortality.

If Goya had died at this point, he would still be an important figure. He had already achieved a great deal. Despite his faults, perhaps because of them, this grand innovator of style had already won a victory for the artist. For no longer was he a mere lackey of any king. Whereas before he was grouped with underlings to

serve imperial caprice, he now enjoyed a higher moral status and so could play a part in the broader process of enlightenment. In a word, art was becoming a means of contact with the people. And Goya was becoming a people's artist. He himself had said, albeit with a lot of vanity thrown in, that he could afford a four-wheeled carriage if he was to serve the public interest. This aspect of serving was a new concept in the mind of a court painter. In the process, Goya sought to free young artists from straight-jacketing formulas as taught in the academies, to encourage them to discover divine nature in all its manifestations. This appeal for artists' freedom was spelled out in a report he gave to the Academy on October 14, 1792. And he meant every word he said.[12]

Charles III and his mediocre son at least had this in common—they recognized Goya's genius despite his neoclassic tepidness that could slight absolute monarchy itself. But they were willing to take the risk. While not loving, they certainly respected his Aragonese ways. And as Goya bent to kings, himself an innovator and traditionalist, a democrat and a bit of a showman all at the same time, he impelled them with a subtle impishness to bend a little to him, and to all artists with the common touch:

II

METAMORPHOSIS

I can stand on my feet but so poorly I don't know if my head is on my shoulders...

Goya to Zapater, 1793

Enchantment in Andalucía

Goya's struggle to recover coincided with the darkest days of the new French Republic. Discussions about legislatures and constitutional freedoms in genteel drawing rooms in Madrid could no longer hide the gravity of the threat that was emerging from Paris. The Jacobin terror was only a step away. And Charles IV, for all his habitual vacillation and overreliance on his queen, was getting worried.

Already in 1792 when France and Austria declared war on each other, Spanish politics were thrown into utter confusion. Floridablanca, the mainstay of stability who yet had stooped to call upon the Inquisition to halt the flood of subversive literature pouring across the Pyrenees, had been dismissed that February. He was replaced by Aranda, who after imprisoning his old enemy in a fortress at Pamplona, only lasted a few months himself. Men like Campomanes, Cabarrús, and Jovellanos shared the same fate, or worse, the latter being banished to his native Asturias; and there was Mariano Luis de Urquijo, translator of Voltaire and detained by the Inquisition on Floridablanca's orders, then released through the help of Aranda. If not heads, then reputations were

rolling. It was like a French Revolution in reverse, played out in the name of reaction. Sadly, all these men were enlightened reformers and Spain was infinitely the loser.

An underlying motive for this reign of represssion was the attempt by Charles and his queen to contain the revolution after great French victories had been won over the Austrians, and save cousin Louis XVI from the scaffold. And there was only one man daring and unscrupulous enough to try and pull this off—Manuel Godoy, Duke of Alcudia, the Queen's intimate friend.

Born at Badajoz in 1767 of minor nobility, Godoy joined the brown-coated royal bodyguards before he was twenty. Being stationed at court, he found it easy to attract María Luisa's attention, including so it is said, a contrived fall from his horse. From then on his advancement was swift. Exploiting the long-standing rift between Floridablanca and the Queen, he soon joined Aranda's Council of State and by April 1792 was made a grandee with the above-mentioned ducal title. A much younger man than his colleagues, he played his cards with skill and won the absolute confidence of his sovereigns. Neither Floridablanca nor Aranda, both of whom detested Godoy as much as they detested each other, had been able to divert the course of the French Revolution; and Godoy's appointment as chief minister in November was a last-ditch attempt to save Louis's life.

Despite Charles IV's incompetence and the rigidity of an absolutism that unquestionably retarded Spanish development, any abler monarch would have reacted in much the same way where the horrors of this revolution were concerned. When the great blow fell with the French king's execution early in 1793, it sent shock waves throughout Europe, warning its governments that the old order was finished and that a new one could be imposed by force if necessary on the whole continent. Spain thus joined with Austria, Prussia, and England in a coalition to contain the republican tide. Nothing much came of it however, and Spain's ineffectiveness became ever more apparent. As for Godoy, the fact that he had failed in his mission was not enough to bring about his downfall because he was now not only the Queen's intimate friend but also her lover—a situation that apparently won grace in the King's eyes as well. 'The Trinity' as the three of them were

called, was a term coined by the Queen herself.

To do some justice to María Luisa, it was a custom among the upper crust of Spanish society for a married lady to have her *cortejo* or favorite, whose job was to entertain her with witty conversation. Whether the wit ended up in more discreet places was strictly their affair. But if high society permitted this, the rest of the Spanish public thought otherwise; and whatever merits Godoy had as a supporter of enlightenment, he soon became unpopular among growing numbers of people. Indeed his high and mighty airs soon earned him the nickname of *'El Bonducani'* or caliph. At the kissing-of-hands ceremony in the Royal Palace, for example, court ladies would often be held up in the outer chamber on their way to the Queen's apartment, because Godoy stood in the way playing with Her Majesty's dog; no lady thus dared to pass. When even the Queen grew impatient at the delay, the King would laugh benignly and remark, "They won't pass the *Bonducani!*"[1]

Less-inhibited Spaniards called him the 'sausage-maker.' The term had its merits, for vice and gluttony flourished under his rule; and in the process there is little doubt that he would cast lustful eyes on ladies other than the Queen, including the Duchess of Alba. It was this same lady, in fact, with whom Goya himself was to become so closely involved. She was to ease his pain, making him forget reality for a while, even as Godoy was to rekindle his awareness of it, rousing him later to a heightened sense of anger and disgust.

But this was not yet, for at this stage Goya was well out of the limelight. Cadiz, not Madrid, provided the setting, and it was a miracle he was alive at all. Sebastián Martínez, his wealthy amiable host to whom, along with his daughter Catalina, Goya owed so much, did everything to make his stay as comfortable as possible. The Martínez home was stuffed with portraits and prints of every description, and its Dutch and English reproductions of genre scenes, including those by Hogarth, may well have stored themselves in Goya's mind as topics for the future.

To many people, meanwhile, the patient seemed a spent force. As Martínez put it in a letter to court chamberlain Pedro Arascot, it was in Goya's head where all the trouble lay.[2] It was a true statement in more ways than one; for not only was his

trouble a recurrence of earlier breakdowns, for which reason his friends were now treating him with a compassion reserved for a mental case, but also unknown to them, his very condition provided the mainspring for a creative resurgence that was soon to lift him to even greater heights. His deafness was permanent, though Martínez joyfully informed Zapater that at least he could get about and climb the stairs.[3]

"My dear soul, I can stand on my feet," Goya wrote to Zapater soon after, "but so poorly that I don't know if my head is on my shoulders; I have no appetite or desire to do anything at all. It's your letters alone that cheer me up—yours alone. I don't know what will become of me now that I've completely lost sight of you; I who idolize you have given up hope that you'll ever glance at these blurred lines and derive consolation."[4]

A few strands of comfort, however, did lessen Goya's dismal plight. The buzzing noises in his head receded a little, but more importantly his deafness, critical as it was, had a slight redeeming feature in that he was not totally stone-deaf—practically so would be a better description. Neither is there evidence that he used a hearing aid much of the time. This was because, unable to distinguish every speech syllable, he had an uncanny knack of grasping speech patterns when he wanted to by using his imagination; and while he did not lip-read each word, as a substitute he was good at picking up sign language. A Swedish diplomat, Jacob de la Gardie, probably put it accurately when he said as late as 1815 that Goya was *almost* stone-deaf;[5] and it would be interesting if it were possible, to compare his degree of deafness with Beethoven's.

Slowly regaining his balance, by the early summer of 1793 Goya returned home at last to Desengaño Street where Josefa anxiously stood by. He was a changed man now, more humble, less truculent. He kept in touch with his benefactor Martínez, greeting old faces and meeting new ones. A mutual friend was Juan Agustín Ceán Bermúdez, whom Goya had long known and painted eight years before. Art historian and critic who had once studied under Mengs, bank official who probably promoted Goya's National Bank commissions, Ceán had amassed a big art collection from his many visits to the markets in Seville and elsewhere, and like

Martínez was a lover of prints. Both Ceán and his Aragonese wife had again been painted by Goya, possibly the previous year in Seville, and their many contacts served to widen his circle among the lower ranks of society. Another sitter was Ramón Posada y Soto, related by marriage to Jovellanos, who had been in Mexico where he was on the governing board of the Academy of San Carlos, of which he was a founding member. Ceán, Posada, and Jovellanos all came from Asturias, and Goya had every reason to be grateful to this coterie of friends for the many commissions they arranged on his behalf.

Yet another close friend was Leandro Fernández de Moratín, son of the writer Nicolás de Moratín and a wealthy jeweller. Poet and dramatist, he was also an expert translator from his knowledge of many languages acquired in the countries themselves—the Strand by Westminster Bridge being one of his favorite haunts in England. Indeed his cryptic diary that has survived is a polyglot mixture of Spanish, French, Italian, Latin and English. The widely traveled Moratín would take Goya sightseeing in Cadiz and Madrid, no doubt communicating to him somehow the latest news, especially about Aranda and Godoy whom he had personally met,[6] and in a general way he would make him aware of the reform movement influenced by France with its revolution and historic Declaration of the Rights of Man, that was demanding answers in the Spain of Charles IV.

But Goya's main interest at this stage was not politics but picking up the threads of his painting. By June 11, 1793, he was well enough to attend a meeting of the Academy; this soon dispelled any rumor that his life as a painter was over. And while acquaintances like Bayeu, Maella, Livinio Vandergotten and even Jovellanos were soon to point out that his resumed work lacked firmness and consistency, this was because they didn't understand his new directions. With his tremendous recuperative strength he was back to form but with a difference: his style became more original with its freedom from restraint, its capture of rapid movement, its daring thrusts into the unknown, often with grey and silvery overtones, which his breakdown in health had somehow only accentuated. Zapater as usual was the recipient of his new resolve, as well as his protestations of undying love. It was as

if Zapater was always there, in his rooms, lending him a lifeline up which he could climb to his fantastic heights.

He knew it would be a tough battle to put over his ideas to the Academy. But he had won over a few supporters there, among them its new secretary, Isidoro Bosarte (successor to Antonio Ponz) and the Marqués de Villaverde, who afterwards received his latest efforts. Then there was the Academy's assistant director, Bernardo de Iriarte, brother of the distinguished writer Tomás. Goya informed Bernardo in January 1794 that he had undertaken to paint some easel pictures "to occupy my imagination, mortified as I am by my misfortune," in which he had made observations not normally applied to conventional works where caprice and inventiveness could have no scope.[7] The result was a set of oils on tinplate which he presented to the Academy. Depicted were such scenes as wandering comedians paying tribute to the Athenian playwright Menander, a puppet seller, an attack on a coach, a shipwreck and a madhouse, along with a theatre fire in vivid colors which he had reputedly witnessed in Saragossa earlier.

But the main emphasis is on bullfighting. His interest in this art goes back to his youth; indeed it lasted throughout his life, as evidenced by his later depiction of village bullfights and his famous historical series of etchings in 1816. But unlike Zapater, his motive was mainly to record what he saw, though he always longed for Zapater to accompany him whenever he attended the ring. And as he worked at his scenes, he may well have recalled the heated discussions Zapater had had with Bayeu as to who was the best among the younger fighters, Pedro Romero or Costillares. The latter was preferred by Bayeu, it being a time when bullfighting was changing with new ground rules that allowed the champion to fight on foot, replacing the older style whereby gentlemen fought on horseback as if they were knights. Goya in any case may have witnessed the scenes he was now depicting at Ronda or Seville—the two main schools of Spanish bullfighting. He was certainly familiar with terms used in Andalucian dialect. Of special interest in this series is his terrifying yet somehow funny *Picador Caught by the Bull's Horn*. The fighter has fallen astride the animal, so that its horn penetrates right through the man's

buttocks. 'If you play with fire, you must pay the price,' the picture seems to be saying.

Goya's interest in the *corrida de toros* brought him into contact with famous bullfighters of the day. Among these was the handsome Pedro Romero himself, idol of the masses and product of the Ronda school, whom he was to paint in 1797 (along with his bullfighter brother José). It is a fine portrait, and for the occasion Pedro Romero was decked out in festive clothing loaned by the Duchess of Alba.

Another Alba protégé, incidentally, was the actress María del Rosario, whom Goya painted in 1794, and again five years later. She was called 'La Tirana' because her actor husband was good at playing tyrant roles; for her part, she had so popularized her version of the *fandango* on the stage that the dance became known as the *tirana*, probably so named after her. Thus does one thing lead to another. But where Goya was concerned, he most likely visited the theatre less often on account of his deafness, though evidence suggests that, besides applauding this much loved actress, he could still appreciate the *zarzuela* and *tonadilla* rhythms on the stage, as in a music hall, with all their visual gestures.

As the critics in the meantime continued to cast their barbs at his work, he longed for Zapater to give him comfort, as he probably did personally in 1794. But Zapater's motive in coming to Madrid was not exactly to serve as Goya's interpreter, nurse, and whipping-boy. He would come here on business, probably to include fund raising for the Friends of the Nation society, whose director in Saragossa was the Conde de Sostago.

Sostago had a fondness for collecting miniatures. Among these was a tiny reproduction from a portrait by Goya, excellently done by Agustín Esteve, the artist's personal copyist from Valencia, depicting the canon of Saragossa Cathedral, Ramón de Pignatelli. In April when Zapater was in this city, Goya wrote to him and asked if he had seen it. Goya had painted the canon as well as Zapater four years earlier, and in this letter Goya expressed the hope that Zapater's portrait would also emerge in miniature, perhaps for inclusion in his own snuff box.[8] One can assume that in addition to chocolate and cigars, Goya took to this habit pleasurably, and that his loss of hearing reinforced his other senses by way of compensation.

Where Zapater was concerned of course, it would seem as if Goya had never lost any of his faculties in the first place. Fully recovered in strength by now, he instructed Zapater in May how to assemble a curtained four-poster camp-bed he had helped him purchase.[9] He commented in a subsequent letter on the sweetness of memory and how he felt all five senses functioning for his friend, even though he had only four.[10] It was as if he could hear Zapater's voice in Saragossa, cursing and swearing as he fumbled with the post with its rods and rings in a vain effort to put it all together. And with his eternal impishness, no doubt he drew a little satisfaction that he could understand the directions, whereas his friend could not!

Professionally as well, he was back to his former pitch. The King and Queen were considerate, the Academy accommodating. He was at home with all types of society. And as he worked with a deceptively apparent haste which was a component of his great art, the result achieved its purpose. Among his sitters were General Antonio Ricardos, who had pushed the French back across the Pyrenees, and the young Doña Tadea de Enríquez, dressed in white muslin shot with pink, which recalled the style of parkland setting he had devised with earlier portraits. There was the Marqués de Sofraga, director of the Royal Academy of History, and the Marquesa de la Solana, whose untimely death occurred in 1795. Here Goya has struck a note of stirring pathos by combining her receding youth with approaching death, as if he knows what death is. With a pink rosette in her hair, with black embroidered skirt against a neutral background, she resignedly reflects in her eyes what Goya senses, but without her losing a trace of dignity or pride. The Marquesa was a lifelong friend of the Duchess of Alba, and it could be that she had a hand in furthering the artist's acquaintance with this lady.

* * * * * * *

Fate in any case was drawing Goya and the Duchess of Alba closer together. It is not known how or when they first met. It could have been through his late friend Ramón de Pignatelli, the distinguished canon of Saragossa mentioned above. A member of the San Luis Academy in this city and of the Royal Economic Society of Madrid, architect and engineer with whom Floridablanca

had patiently cooperated in the construction of the famous Aragonese canal, Pignatelli had been a man of wide connections among the 'Aragonese' faction of society and came from a family of diplomats. More importantly, his brother was Joaquín, Conde de Fuentes, who had married into the Alba family. This was back in 1775, when Pignatelli was known to be in Saragossa. Thus Goya, perhaps, got to know the Alba family via the Fuentes' home during the time he worked in the Pilar cathedral shortly after his marriage.

María del Pilar, Teresa Cayetana de Silva, was the thirteenth Duchess of Alba. While bad luck was hardly her lot during her life (she was to die at forty), she was nevertheless rather a problem from the beginning. Born in 1762, she was the daughter of the Duke of Huéscar, who was heir to the Alba inheritance. But he died before his parents, so the young girl was left mainly in the care of her grandfather, the incumbent Duke. Brought up at Piedrahíta in the Sierra de Gredos west of Madrid where her grandfather had built a palace on the ruins of a castle, she had no formal education, which was not untypical among children of the aristocracy. But she knew a great deal about Rousseau, for her grandfather had personally known him. Her chief companions were her servants, and these implanted in her a sympathetic outgoing personality which made her popular with all classes of people. The real problem was that her mother and grandfather didn't quite know what to do with her. Marriage seemed the only solution, and following her father's death before she was nine, they set about finding as propitious a match for her as possible. They settled on José Álvarez de Toledo, Marqués de Villafranca, brother-in-law, incidentally, of the Conde de Altamira, one of the subsequent directors at the National Bank. Thus in 1775, when the young Duchess was thoroughly nubile in her fourteenth year, a double wedding took place: she was married to the twenty-year-old Villafranca, while her mother took the Conde de Fuentes as her second husband. The latter thus became her stepfather.

As a vivacious young wife with independent means, the girl Duchess was free to enjoy the frivolities of society as much as her older sterner husband devoted himself to music and the arts.

He arranged concerts with the Infante Don Gabriel and corresponded with Haydn. While his wife also appreciated art—her family's huge collection included works by Raphael, Correggio and Velázquez—their marriage was not an ideal one. They were simply not compatible, but they kept up appearances as demanded by custom. Her grandfather's death, meanwhile, brought her even more wealth and titles, so that she was destined to become a luminary in the society of her day. The family palace at Piedrahíta near Ávila was an ideal setting away from the Duchess's smaller Madrid residences at Moncloa or in downtown Barquillo Street near the present Prado, and it is possible she knew the Infante Luis and his family, whose seat at Arenas de San Pedro was also near Ávila. Where Goya was concerned, he and his wife were reputed to have stayed with the Albas at Piedrahíta. It is even said that he had the Duchess in mind with his famous *Grape Harvest* scene, whose figures are not simple peasants this time but disguised landowners visiting their estates.

All this, however, is pure guesswork. What is certain is that once the Duchess was in full flower of her womanhood, taking part in popular fiestas and social functions in general, Goya like everyone else became fully aware of her existence. The Duchess of Osuna knew her, and tradition relates, this time more positively, that Goya met her when she was a guest at the Osuna palace of La Alameda.[11] The two duchesses were close friends at first, and Goya might well have gone on hunting trips and picnics with both of them. But the guest's stunning beauty soon made her a rival, especially in regard to bullfighter Pedro Romero whom both women coveted. Even more importantly, she became a rival to María Luisa herself. Where the Queen of Spain was concerned, it behooved the Duchess of Alba to tread warily.

And a 'stunning beauty' she certainly was. It was her raven hair as much as anything that drove men like Jean-Marie Fleuriot or the Marquis de Langle to declare in so many words that not a single tress falling down her body failed to arouse absolute desire. Nothing in the world was as lovely as she. People would watch her from the windows as she passed by, children would stop their games.[12] Her dark flashing eyes, her jollity and wit mixed with reserve at the right time, prompted Lady Elizabeth Holland

to write of her "beauty, popularity, grace, wealth and lineage"—
qualities that certainly rankled the Queen.[13] Yet however much
these qualities incited envy in women, they aroused even more
strongly a desire in men. And Goya was no exception.

The story goes that he accompanied her on a journey to
Sanlúcar, near Cadiz, following a row she had had with the Queen
who had made her a *persona non grata* at court, and that an axle
broke on the road to Seville which Goya helped to mend; but
he caught a fever in the rain, and this had led to his illness and
deafness. The row with the Queen may be authentic and
banishments from court were frequent, but there is no proof
positive to connect Goya with this journey, even granted he was
in Seville in 1792.[14]

There is no doubt, however, that he met her soon after his
convalescence. We have it in his own words. And important
words they are, for they show incontestably that he got to know
the Duchess well from 1794 onwards, when he was approaching
his fiftieth year and she was thirty-two. He wrote to Zapater: "It
would be well worth your coming to help me with the portrait
of the Alba lady, who yesterday thrust herself into my studio for
her face to be painted and she got her way; she certainly pleases
me more than my painting her on canvas, and I've also got to
portray her full-length for which she's coming to sit." He then
commented that he had barely finished with a rough sketch for
an equestrian picture of Godoy, the Duke of Alcudia; but as it
was taking longer than he thought, the minister was arranging
accommodation for him in the current royal residence (probably
the Escorial). All this was a most tiresome nuisance for any painter
to have to face, Goya went on, especially as it should have been
Bayeu's job in the first place.[15]

Goya shared with many professional artists the wish to be
left alone, where one could reflect in peace; and in a fit of whimsy
he ended the letter with a grotesque caricature of himself. But to
deal with the Duchess of Alba would be different. And what a
contrast in his rendering of the two subjects! The Duchess's por-
trait, which he may have completed in the breezy atmosphere of
Moncloa facing the Guadarrama, is one of sensual elegance. The
white embroidered dress, sweep of black hair, red bow, red

necklace, red knot across the bosom, red sash tight around the waist, form a rhythm of color as she points imperiously to the ground with her right forefinger, her left arm swathed in golden clasps. Here she is at the height of her triumphant beauty. A white Pekinese lies meekly at her feet. Godoy in comparison appears feebly on his horse which seems to dwarf him in grandeur. Despite happier portraits of him later, one senses that the artist did not have his heart in the work. Godoy, moreover, had the reputation of being a hard taskmaster, and once fumed at another artist for making his face too fat.

But Goya certainly had his heart in his work for the Duchess of Alba. As to love, he well knew the restraints he had to observe, and it was not till later that some of the drawings in his notebook known as Album A of Sanlúcar, suggest an intimacy that was more than just an artist's imagination.

His friendship at this stage had to be shared with other members of the Alba household. These included husband José Álvarez, mother-in-law Marquesa de Villafranca, and a nurse-attendant or *dueña* named La Beata, all of whom he painted in a close family setting, possibly at Moncloa. We see the violin-playing Duke standing wanly by a piano holding a Haydn score, a half-view of the Duchess teasing her attendant, the attendant teased as well by two children tugging at her skirts. But all the time it was the Duchess who spoke and laughed, only she who could reach him through the intolerable silence, alone among the scores of beautiful women who were already crowding his past. There were moments in his mind when he no longer felt afraid of being unfaithful to Zapater.

During this time, however, he was jolted by a blow that struck close to his family. It was as if death now greeted him from a reverse standpoint. It carried off Francisco Bayeu on August 4, 1795, as it had already carried off his delicate brother Ramón two years before. The elder Bayeu, whom Goya had often hated more than loved and treated ungratefully, had been ill for some time after having begged leave to go to Saragossa; fortunately, Goya had ended the feud once and for all by painting his portrait shortly before he died. It was his third attempt, and its silvery grey overtones against a green background seem like a peace offer-

ing in a final farewell. It also led to his taking Bayeu's place as director of painting at the Academy. As for Josefa, who had herself frequently been ill even during Goya's darkest hours, she was deeply affected by both her brothers' deaths, and her husband with his own affliction to contend with, could only console her as best as he could.

It must have been a relief for him to get away in May 1796 for another trip to Andalucía, this time with a happier result. For chance circumstances were bringing him nearer to the Duchess of Alba. His aim at first was not necessarily to meet with the Albas but probably his benefactor Sebastián Martínez in Cadiz, who had long wanted him to do some chapel work for one of the local parishes. Then, the following month, came news of the untimely death of the Duke. Goya was in Seville with Ceán Bermúdez when the Duke died, and the Duchess was within easy reach at her leased residence in Sanlúcar. He followed her there, however, not because of any passionately inspired rendezvous, but mainly to pay his respects. It is difficult to say at what point intimacy developed. But he certainly stayed away from Madrid longer than he had intended; indeed his absence between May 1796 and early April 1797 was frequently noted by colleagues at the Academy.[16]

Sanlúcar de Barrameda lies at the mouth of the Guadalquivir River, facing the Atlantic. It was here in the bracing atmosphere of this watering place that Goya found a new vitality that was fully matched by his companion. Restraints had to be observed— three years was the normal length for mourning—and under the circumstances no Spanish woman would throw easy embraces without a very good reason. Knowing Goya, one could suppose that he sought to provide her with one, namely, with a humble appeal to his genius. It was his one and only card. And he worked at it passionately, persistently, but with sincerity. The look in his powerful eyes told her this. She was attracted to him because she was so good at playing with attraction herself, while cautious and resisting at the same time.

But the most beautiful woman in Spain was human, after all, and must have welcomed the subtly contrived condolences from Spain's most famous artist. Her response was inevitable. It was friendship and understanding she needed most of all,

however, rather than the challenge of love. Yet in the cool summer breezes of the southern coast, tinged with a touch of Africa and with only the salty wilderness of cattle and seafowl behind him, it was Goya who desired to caress her, as one drawn to an enchanted island. She the condescending, still grieving aristocrat, was like a Muse to him, the ex-rustic who had but recently emerged from his own darkness. And as he led her through a world of sign and symbol she had never before experienced, his infatuation grew with every drawing of her, matched by a coquetry with which it was her pleasure to treat him. It livened the idyllic hours, but always stopping short of absolute permanent givingness for both of them. In the end, as she turned from her impassioned mentor, it was with a sense of exhilaration at his gifts, pity for his state, love for his giant solitary spirit. Each knew their meeting was transient, would blow away like sand the world would some day try to probe. They had met as equals in the manner of the time, with ephemeral feelings shared but with secrets kept, and so it would remain. She would call him her "Francho" to the end.

During all these weeks at Sanlúcar, his first album of drawings known as Album A began to take shape. They focus on her and her people, including a charming sketch of an adopted black girl, María de la Luz. Other girls are shown walking or dancing to the rhythm of the guitar. The sixteen drawings in pen and china ink wash, touched up with black pencil, convey a lively atmosphere on the bluish paper; but the Duchess herself often appears in isolated drawings, with hands upraised or sitting with a companion, presumably the artist himself.

We may pause to imagine what thoughts they shared during their visit to nearby Coto de Doñana. This large sanctuary of red deer and boars and birds of paradise adjoins the village of El Rocío, where homage is still paid at the Whitsun, or Pentecost, festival to a wooden image of the Virgin dating back to before the Middle Ages.[17] Amid the sandy reeds against a background of green pines dotting the landscape, perhaps their thoughts turned upon that other exquisite portrait Goya was to paint of her—the black mourning dress with high mantilla blending with red and gold as she once more points imperiously to the ground. But this time there is a difference. For in the sandy soil along the forefront

of the canvas, the words *Solo Goya* (Only Goya) are indelibly inscribed. The word 'Solo' was discovered many years later when the picture was cleaned, thus turning the signature into a message. And one of the rings on her fingers bears his name. By these signs their relationship is forever entwined in the *plein air* setting, woven like a tapestry the artist would know how to do so well. It is not surrender on her part but rather the other way round—a noble lady receiving tribute from a subject who in return has worked his spell of immortality on both.

It is not known precisely when the portrait was begun or where it was finished. The Duchess had to go to Madrid in the autumn for her husband's formal requiem, which took place on September 4, 1796. Goya in the meantime went to Cadiz, his original destination. Here he met Leandro de Moratín and Sebastián Martínez; and he may have fulfilled the latter's request at last in executing some paintings for a chapel attached to one of the churches dedicated to the Sacrament. In this oratory of Santa Cueva, Goya depicted such scenes as Christ's Miracle of the Loaves and Fishes, the Parable of the Wedding Guest, and the Last Supper, based on earlier sketches. The three friends doubtless exchanged ideas about art and the latest plays, but Moratín noted in his diary that Goya was ill when he visited him at his home that Christmas.[18] Moratín repeated his visits to the artist many times early in the following year, often accompanied by Martínez. Evidence suggests here that Goya was going through some sort of trauma after his emotional encounters with his duchess—lovesickness plays strange tricks even with the hardiest—and it is not known for sure if he returned to Sanlúcar. What is known is that the Duchess was back there by February, for she signed a will leaving money to Goya's son Javier upon her death in the amount of 3,500 reales per annum. Since the portrait is signed and dated 1797, it is assumed they met again, either at Sanlúcar or elsewhere among her estates.[19]

Upon his return to Madrid early in April 1797, Goya felt the fulfillment of an experience that was not to be repeated. She had given him a rationale for living with a realization of his dreams. But it was the end of the magic, a finishing chapter, a parting of the ways. Strong as his passion had been, it lacked the obses-

sion of a Romney for his Lady Hamilton. The commoner who had enticed the noble lady for so long was to greet her in the ordinary world, in the ordinary way, as she would greet him. He simply had too many commitments to sustain the intensity of his feelings. And erotic love, he knew, stood in the way of his fruition as an artist. As for the Duchess, instinctively she shared these thoughts, for to deny them would be to deny her own liberation.

Perhaps he wanted to have something to remember her by when he removed some pages from his Sanlúcar album.[20] He would keep these mementos in very special places, tucking the leaves of memory away in a manner that not even Josefa could divine. Less secretly he would put together other drawings—of Andalucian women he had seen, of witches he had pretended to see. They were like dust shaken off from his enchantment that yet came from an earlier part of his being. Here in the so-called Album B of Madrid with its seventy-four sketches that progress in captioned satire, the china ink and sepia unravel all the people and the Holy Week—the priests, doctors and lawyers that file past as at a masquerade. The Duchess of course had played her part in all of this, lending her beauty and condescension, and in whom he no doubt saw all the facets and the faults of an eternal Spain. But this was only part of the explanation for his art. Neither was this the only series he was working on. The *Caprichos* were brought nearer to realization, and these will now be discussed.

EIGHT
When Reason Sleeps and Wakes

Among the first things Goya wanted to do on returning home was a portrait of Zapater. It was a kind of expiation for his roman tic lapse in Andalucía, with all the exotic scenes he had lived through and the tensed-up emotions they demanded. Now he was among ordinary mortals again and all his friends. It brought him back to his former self.

But another part of his former self he had never really abandoned. He had been enchanted all along by a spell of his own finding his fascination with man—long before his visit to Sanlúcar and even before his illness. He had once written to Zapater: "Now I don't fear witches, hobgoblins, ghosts, giants, rogues and liars or any kind of body except human ones, and it's yours I love most."[1] The seeds of his fantasy had been implanted even then; and in between his declarations of love, his sentences were interspersed with symbols of eyes, ears, protruding tongues, guinea-fowls, rifles, jugs and watermelons, down to barbers' bowls and scissors. Bold, fanciful and analytical, he was relaying the world as perhaps Aristotle might have understood it, particularizing the universal; but the end result, as Goya himself could not

yet foresee, was to be the world of Plato, with a deeper sense of reality behind it.

A galaxy of writers and artists had long influenced his mind, which was always hyperreceptive to begin with. And illustrations of their works he had often seen or heard about. *Don Quixote* goes without saying—an edition came out in 1780 for which allegedly he had proposed some etchings—while Bosch he discovered while making an inventory of the royal collection nearly ten years later. Callot, Magnasco, Hogarth, and Piranesi he was at least familiar with. He studied the works of others, and was sensitive to new currents coming in from abroad. His contacts with the Osuna patrons and with Martínez in Cadiz have already been mentioned; and we see him groping for new expression almost immediately after his illness.

It is possible, then, that the first sketches that became known as the *Caprichos* were done in the earlier 1790s, even before the Sanlúcar and Madrid albums were completed; and that while they can be considered partly as products of his illness, their antecedents go back much further in time. All the print reproductions he had seen, from nudes to witchcraft, had slowly been steering him away from the fading idealizations à la Mengs toward a starker world of fantasy and the grotesque.

The term 'Capricho', according to the definition in the *Diccionario de la lengua castellana* published by the Royal Spanish Academy in 1729, stems from the Italian '*capriccio*', and means a concept outside the usual rules; while in a religious sense it refers to Calvinist heretical doctrines. Later editions in the 1780s up to 1791 give more emphasis to the term as applied to the arts—to poetry, music, and painting—in which a *capricho* relates to the force of creative ingenuity rather than to the observance of rules. Among various theories explaining Goya's choice of the term, incidentally, is one that refers to moral points made in Spanish comedies, sometimes featured during a musical interlude; since Goya loved the stage, the argument runs, it is not impossible he was inspired to call his drawings by this name.

There are over one hundred of these, mostly in sepia pen and china ink, some with hatched lines, gouache or sanguine wash, and they are accompanied by eighty etchings, including aquatints,

but with much less detail than in the drawings.[2] Each *capricho* has a terse caption or title, usually different from its corresponding drawing, with caustic commentary added later. Here Goya was probably helped by friends like Ceán Bermúdez and Leandro Fernández de Moratín. To what extent the latter inspired Goya's thematic treatment of witches that appear in his later *Caprichos*, on account of Moratín's great interest in a witch-hunting auto-de-fe celebrated at Logroño, Navarre, in 1610, is still a subject of debate; but Goya's manuscript commentary does bear some comparison with Moratín's caustic serious style. Goya moreover, was certainly aware himself of the descriptions of witches and witch-hunting given by others in a subsequent account of the Logroño episode.

The etchings are divided into two groups—numbers 1 to 36 followed by a kind of transition, then numbers 43 to 80. Each part begins with a figure of Goya himself. The first group is called 'Dreams' (merging into the series haphazardly because Goya subsequently changed the original order), and these etchings are harmless enough at first sight. Somewhat like a cross between Hogarth and Daumier, they are mainly outpourings of scathing fantasy with some emphasis on sex. Though a few figures seem to reflect the Duchess of Alba—*capricho* 27 shows a lady being courted, probably by Goya himself—the resemblance at this stage is subordinate to the general caricature intended; indeed the Duchess may have been party to some of the preparatory sketches and appreciated them with indulgent amusement.

In this event, Goya most likely would have used her servants as models for his satire. There are stabs at fickle women and fussy nurses with their 'nanny's boy', at marriages of convenience, at carefree prostitutes. One mother harshly spanks her child, while another, a beggar, is ignored by her own wealthy daughter. And there is that macabre vanity of vanities, *capricho* 12, showing a woman pulling out a hanged man's tooth for her own use.

As the *Caprichos* proceed, Goya's satire becomes more daring. Already in the first group, *capricho* 5 shows a woman being courted by a man while washerwomen grimace behind her back, which his later commentaries reveal as the Queen being courted by Godoy. And still in the first group, Inquisition scenes

depict women being hounded by heartless and ignorant men. Though attacks on this outdated institution were almost becoming fashionable—Godoy himself abolished auto-de-fe trials in the 1790s—it is hardly surprising that hackles were aroused among the establishment later. It was Goya's growing criticism of his country and the court (distinct from his loyalty as a good Catholic subject) that was prompting him to play perilously with fire.

In the transitional phase—*caprichos* 37 to 42—the approach becomes more political. Thus the donkey is used as a symbol of ignorance and social injustice, which was a device already evident in other countries, including England. Here, in *capricho* 39, Godoy is referred to in the later commentaries as an ass driving genealogists crazy—a sure jibe at his Duke of Alcudia title given him when he was a mere minor noble. And *capricho* 42 shows asses climbing on the backs of peasants, who must bear the asinine load of feudal dues and burdensome taxes. Disorder and mismanagement are seen to exist at all levels of society.

"Fantasy deserted by reason produces impossible monsters" goes the comment accompanying *capricho* 43 which opens the second group, "but united with it, fantasy is the mother of the arts and the source of all its wonders." And here Goya shows himself dreaming his nightmares. In his attacks on irrational vices, we see perhaps a mild reflection of his own past, and this would not exclude the Duchess herself for her continued riotous living. But more importantly, friends like Jovellanos and Leandro de Moratín were helping him see a world that was becoming disenchanted following Charles III's death, when rational policy had departed and irrationalism returned. Jovellanos in particular, who was later given a brief term of office by Godoy in 1797, most likely prompted him to continue his secret etchings of the *Caprichos* at this time. But despite Godoy's about-face in politics and the largesse of his patronage, Goya would spare nothing in his attacks on society itself. The temptation for a daring artist was too great. In essence, Goya has abandoned the "reason" mentioned above in order to uncover the "monsters," in other words, to expose the blatant evils existing at all levels in the Spain of his day.

In this second group then, symbols are used fiercely, distortedly, and with ruthless passion. Gone is the lightheartedness that

features the beginning. Abnormality becomes the norm, the tone more strident. And absurdity turns devilish as the harmless hags and prostitutes turn into witches and vampires. There are furry rodents like men, monks with branched limbs pressing their importance, parrots of the law uttering claptrap, parodies on lineage, women led astray on broomsticks by teachers of nonsense, and a couple—chiefly the woman—chained by marriage. Sexual situations abound in contortions of flight. And death looms also. There are naked men vainly holding back a slab as if getting sucked under, doom in the faces of hobgoblins and monks. "Now is the hour" scream the latter in a mock semblance of reform, with which the *Caprichos* end. It is as if the clerical monsters are mocking their own inanity.

Yet despite the ghoulish plasma of evil that seems to encompass Goya's dreams, it is perhaps the effects of evil in suffering that come nearer to his aims. His unnumbered etchings, for example, show a chained woman in jail, and women weeping over an injured dog. Goya well understood suffering, having gone through so much of it himself. But as to pointing up a remedy, he is skeptical not merely of the existing state to heal physical malaise, but of all those earthly institutions, including the professions, that either claim to know more than they do or else suppress knowledge in finding a cure. *Capricho* 58 ("Take it, you dog") illustrates the point. It shows priests going through the motions of 'curing' a man by means of a giant syringe. A veiled figure joins the group around him, a lustful horned monster in the background, the obscenity given approval by the Father Superior. The meaning is obvious: one cannot escape being injected with nonsense anywhere, because one cannot escape the vices of society; but it is up to society to educate itself and act responsibly in trying to treat its own ills.

A somewhat similar theme underlies capricho 50, *Los Chinchillas*, or furry rats. Here two aspiring noblemen with padlocks about their ears present pitiable figures of affected breeding and wisdom, as one of them is spoon-fed with nonsense from a cauldron by a man with ass's ears.[3] Vice is implied but made funny by monstrous fantasy of Goya's own choosing; and its satire is theatrical in origin, and hence social rather than pointedly

political.

Radical critics down to Marxists of our own century have claimed to see more in the *Caprichos* than Goya perhaps intended. He was not a revolutionary activist, hell-bent on bringing down the existing order and bringing in a people's paradise, but a revolutionary artist exposing with an incidental warning the sick society of Spain with all its false pretensions. He had no prejudice against any class or person. Peasants and the poor were as culpable in their way as the bourgeois or the aristocrat. Class in fact was not his main obsession, beyond wanting to move into higher circles himself. It was the vices of all the classes that drew his attention. For he had had enough experience to know what vice was. Neither was he anti-Church or even necessarily anti-clerical except in regard to the Inquisition and the Church's lazy monks. He felt rather that the Church, like society, simply had to change, and would have agreed with any good Catholic that it needed reforming all the time. And the same would apply to the monarchy he knew so well. As such, without in any sense being an academic intellectual, he was nearer in spirit at this stage to the philosophic writers of an earlier generation—more in tune with Feijóo or Montesquieu—than with some of the later Encyclopedic philosophers with their challenge to the accepted order. The warnings he gives us in any case are subordinate to his artistic impulse: he would have been a great draughtsman and painter even if society had been perfect. A moral awakening was not necessarily his purpose. Art for him was an imaginative issue, linked with social values because he was part of them, and because coincidentally there was so much to grieve about.[4]

Outrage, of course, is always a useful passion for any artist. With the *Caprichos*, however, the themes are ambiguous enough to bypass the polemics that would have turned him into a social hero. Instead, they reflect the posture of an ambivalent, almost cynical observer; and his articulate liberalism was yet to burgeon. Society at this stage was a convenient playground for him to make his moral points for basically artistic reasons. As he himself put it when the *Caprichos* were ready for sale by 1799, he was only exposing certain errors in society with no individuals in mind. The latter point was a white lie no doubt; but as he later showed

by his attitude, he meant no harm to the Queen or her chief minister in a personal sense. He could still approach them with dignity and a smile. It was simply that they were such easy targets for satire, though the satire was beginning to strike back at him with the truth.

* * * * * * *

Much was to happen before the *Caprichos* were actually ready for sale. And some idea of the swirling torrents of his mind in all the politics around him serves to put his conflicts at this time in proper perspective. Certainly the seeds of his disillusion had been sown; but after he finished the etchings in 1797, he had little time for personal invective. He was groping for new expression, not for individual digs at the stupid or the bad. As with the Duchess of Alba, so now with the *Caprichos*—they had had their time. One has only to think of the haunting power of his paintings, commissioned by the Osunas, to see that at this stage he had reverted to sheer fanciful imagination. There were witches in flight, a witches' Sabbath, witches' spells and brews like new *caprichos* done in color, along with scenes from the works of the Spanish dramatists Tirso de Molina and Antonio Zamora—in the latter case depicting a monstrous exorcism in which a priest pours oil on the Devil's lamp. And a charming contrast soon to emerge was his *Masquerade of Children* where the puppet-like figures have masks on their faces and angel wings about them.

All this suggests that Goya's foremost interest was imaginative experiment, be it with evil or innocence, and that his satire on foible and superstition, important as it was, was but a part of this experiment. Witches and ghosts were played up by him not because of anything evil about them, but because they were useful as symbols. Indeed witches were already becoming out of date in the popular mind. Many of the above paintings (possibly including his new portraits of the Osuna couple) are believed to have been exhibited at the Academy in the last years of the century; and any criticism he aroused came from his challenge to accepted standards in art rather than to popular superstitious beliefs. In other words, he was probably making enemies for treason to the profession, not for heresy in religion. He had already been

pressured to resign as director of painting at the Academy in April 1797 after his wayward absence in Andalucía, ostensibly on grounds of ill health.[5] Students in fact had been complaining that they couldn't get an answer out of him because he couldn't hear their questions! But the real reason was as much because he was regarded as an oddity, if a highly respected figure, who was better kept at a safe distance from the youth committed to his care.

Yet he remained in close contact with his Academy friends and other colleagues, painting Bernardo de Iriarte in that year; and this was followed by a portrait of Andrés del Peral, a gilder like his father and brothers. Peral had amassed a large art collection (including works by Mengs and Goya himself), and was now an avant-garde supporter like the Osunas. But as Goya felt his way through the labyrinths of power in his profession, there was always the intolerable strain between the demand for academic excellence and his fancy for experiment; and only his tremendous strength and versatility prevented a repetition of events back in that ghastly winter of 1792.

Once more it was Zapater who sustained him, to whom he always turned. Zapater was a tonic to him. He did his portrait at last, as already mentioned; and there is an ebullient letter to him written later on in the year, probably at Christmas time, 1797, following a banquet for which Zapater unexpectedly provided most of the liquor. Its ecstatic comments are not in Goya's hand—they are drafted more likely by a clerk or spokesman for the guests—but the following excerpts surely reflect his flamboyant style:

"Most powerful, generous and splendid Sr. Don Martín Zapater...Who would have grasped the thought that a knave and cannibal like you could have surprised our spirits with such gallantry, disposed as we were to celebrate and applaud our good fortune? No one; and thus we've rejoiced almost to the point of excess. What toasts! What repetition of bottles! What coffee and more good coffee! What bottles once again! What cups of wine we quaffed! Indeed the glasses in the banquet hall were barely replenished before could be heard the joyful acclaim of 'Long Life Zapater, what an excellent man and good friend. Long may he live and so continue to live and draw winning lottery tickets with

still more to come...' And just after our party ended with so much festivity, what another surprise greeted us at that moment! For an attendant brought us a hackney cab with a message from our host saying he'd arranged a balcony for us overlooking the city, where we could continue enjoying ourselves and relax from the rigors of our feast... We who are your most grateful and attentive servants kiss your hand. Like servants to ladies, not like rustic ill-bred clowns."

Then followed two columns of garbled signatures and slogans, with drunken greetings and references to dens of vice and the pleasures of the feast—from cakes the size of a coach-wheel to eel pies, with sketches to match. And below Josefa Bayeu's signature is a scatalogical end-piece pasted onto the page.[6]

Zapater's double winnings in the National Lottery, as this letter implies (albeit for a modest total of 7,500 reales), certainly helped to make the banquet festive. The lottery, incidentally, had been founded by Charles III at Squillace's suggestion, and Zapater doubtless was an addict like so many others. But he was an enterprising businessman, and fund raising as well as contracting for the army can be counted among his many pursuits. He would thus have ample reason for coming up to Madrid from Saragossa, where at this time he lived in the Coso district near the Conde de Sostago's house. Goya would be delighted to see him as Zapater plied between the two cities, and indeed their friendship remained steadfast to the end.

But Goya also had many commitments that so often separated him from his closest companion. This especially applied toward the end of the century when a burst of official commissions kept him very busy, and it was largely due to the circumstances of politics. The country's liberal swing in 1797-8, for example, which was a strategem on Godoy's part to protect himself from the Right, enabled Goya to come into closer contact with enlightened government figures of the day.

* * * * * * *

The words 'liberal' and 'Right,' while scarcely used as political definitions at this stage, are better understood in terms of the Spanish nation's attitude toward reforms and the Church. The

liberal position favored bringing Spain fully into the mainstream of the contemporary world and its enlightenment, and was generally sympathetic toward Jansenism, with its emphasis on the national interest taking precedence over the international interests of the Church. The 'Right,' on the other hand, and especially its ultra-conservative elements, opposed Jansenism and favored a 'pro-papal' or ultramontane concept of the Church, with its emphasis on the pope's role as supreme jurisdictional and international pastor. These rightist conservatives saw in the nationalism of their enemies, including clerical nationalism, a smokescreen for harboring dangerous revolutionary doctrines. Such nice sounding words as 'reform' and 'enlightenment,' it was held, could easily be applied to undermine morals, and bring about a Jacobin reign of terror. Their view was essentially defensive, for in the struggle between the establishment and progress, archconservatives had to reckon not only with the fact that most Spaniards with great minds favored liberal reforms fundamentally, but also with the fact of Napoleon himself, whose similar ideas, however imperious in scope, were soon to engulf all Europe. Nonetheless, the Right was a power to be reckoned with in Spain, and it had most of the establishment on its side.

There had been a conservative clerical plot against Godoy involving the Queen's confessor (foiled by Godoy's ally, Napoleon, who was busy in Italy at the time bullying the Pope); and this was followed by a further plot among ultra-conservatives entrenched in the Council of Castile. Thus Godoy persuaded Charles IV to appoint Jovellanos as minister of justice in November 1797, while Cabarrús was made ambassador to France. Other liberal-minded reformers were likewise given office. This recourse to enlightenment, however, tinged as it was with a Jansenist flavor and designed to check an ultramontane dominance of the Church in Spain, was to prove short-lived.

But in the ferment going on around him, Goya for his part breathed a little easier among his 'liberal' friends. There was Juan Meléndez Valdés who sat for him this year—a gifted philosopher and poet, and now appointed a fiscal officer in the royal court of Madrid. Meléndez Valdés was protected by Jovellanos who had once helped him win a chair at the University of Salamanca.

Jovellanos himself was painted by Goya in 1798. And two further political figures joined his list of sitters as incoming members of the government. These were Francisco de Saavedra the new treasurer, and Mariano de Urquijo—the latter recovering power through the help of Godoy's brother and who now headed the ministry of foreign affairs. Both men successively became first secretaries, or chief ministers, after Godoy's resignation in March 1798.

Goya went to see the "minister" (probably Jovellanos in this same month) to discuss one of these sittings. We have it in his own words in a letter to Zapater: "I arrived at Aranjuez the day before yesterday, and that's why I haven't replied. The Minister surpassed himself in entertaining me, taking me with him for a ride in his coach and expressing his friendship in the strongest possible terms. He allowed me to eat at table with my cloak on because it was very cold; he learned to communicate by hand, and left off dining to converse with me. He wanted me to stay till Easter and do a portrait of Saavedra (who is his friend), and I gladly would have done so but I had neither canvas nor change of shirt, and I left him displeased as I departed. Here is a letter confirming this; I don't know if you can read his writing, which is worse than mine. Don't show it or say anything about it and send it back again..."[7] Interestingly, Goya's letter was written on greenish paper this time, perhaps taken from special stationery at Aranjuez, which was a departure from the usual lighter texture of his correspondence.

The "minister" must have had his way, for Saavedra's portrait emerges at this time (and not to be confused with Juan de Saavedra whom Goya painted in 1795). Francisco de Saavedra had an interesting career, having been with the ministry of the Indies before he was captured by the British off Jamaica during the American revolutionary war. Now as treasurer, thanks to Jovellanos, he was responsible for endorsing Goya's salary as court painter during this brief enlightened interlude. But both ministers soon lost their jobs during the conservative reaction that followed—Jovellanos ending up in jail on Majorca island by 1801 because of Charles IV's personal hatred of him—and both men were to emerge as great patriots during the coming war of Independence against

Napoleon.

Their respective fall from power—Jovellanos in August 1798 and Saavedra soon after—was a tragic loss to the country, for they were the flower of their generation. Yet curiously, their ouster was not caused directly by Godoy despite his quarrels with them, for he himself as noted above had already resigned in March. In fact it was Saavedra who succeeded him as first secretary and treasurer during these months in 1798. Godoy's motive in conveniently withdrawing from the stage was largely due to his temporary estrangement from the Queen, who had allegedly taken on war minister Antonio Cornel as her new lover. And one of the Queen's ladies-in-waiting had married a leader of the 'pro-papal' arch-conservatives in the government, Antonio Caballero, who profiting from this connection, foisted an attack on his clerical-nationalist rivals led by Mariano de Urquijo. But Godoy was being pressured by Republican France as well, his new-found ally, whose government had objected to his refusal to expel French émigrés from Spain. In sidestepping these problems which thus came from both the Right and the Left, Godoy made a wise decision from his point of view. He was still in favor with the royal pair, and carefully bided his time for a recovery of power. This came three years later, when he was to ride the crest of an ultra-conservative reaction.[8]

Goya in the meantime must have been completely bewildered by these changes. Urquijo followed Saavedra as first secretary and whose term of office was to last from the end of 1798 to the end of 1800; but the reactionary Caballero emerged in the meantime as minister of justice, and he was an alternative even worse than Godoy. The artist's disillusion was growing; and not without some secret satisfaction he must have felt that his *Caprichos* exposing the sick society of Spain had been amply justified. But aroused as he was, he was probably able to relax in dealing with official commissions at humbler levels—his portrait of the royal embroiderer Juan de Roblero is a case in point—as he wandered among the Academy exhibitions in the last years of the century, keeping opinions discreetly to himself.[9]

Featuring prominently among these exhibitions was his striking portrait of the French ambassador, Ferdinand Guillemardet. He

poses in a chair at a curved angle, sword entwined with a tricolor sash, hat decked out in all its tricolor plumage, thrust upon a table. No one could now disparage the prestigious image of France. And at Goya's side would often appear the pro-French writer Leandro de Moratín, one of his closest companions next to Zapater, who in the course of his many plays and as many walks with the artist had impressed him well with the force of both character and caricature. Moratín sat for him in 1799; but not before he had personally accompanied Goya the previous May to view one of the greatest works in the whole of the artist's career.[10]

This was his fresco painting for the dome, apse and pendentives in the new little church of San Antonio de la Florida in the San Plácido outskirts of Madrid. The church had been designed by Juan de Villanueva, who was himself painted by Goya a few years later. Jovellanos most likely had a hand in arranging the fresco commission, and Goya completed it by the late summer of 1798. It focuses on the miracle of the Portuguese saint, Anthony of Padua. In legend he brought a murdered man back to life who uttered the truth of what had happened, thus acquitting the saint's own father who was falsely accused of the crime.

After much hasty experiment, Goya scrapped his first designs on the grey walls and focused the miracle in the dome itself, with the angels at the side among the lunettes and pendentives, instead of the other way around which would have been more traditional. Thus the saint and his people dot the circular rim of the dome with its simulated railing, and the effect is prodigious as the people gaze with wonder at what they have just witnessed. They are dressed in contemporary clothing like *majos* at a fiesta—St. Anthony's day was always a popular celebration in June—and the angels' faces are no less human. The impressionistic cast of feature in the crowd, from a white-shawled girl to a toothless shepherd, foreshadow French painters like Delacroix; but the secret of the work's greatness in addition relates to a mysterious blending of finite reality with an immanence from the divine that fully matches its humanly religious purpose.

The little church now made so famous lies close to the Puente Verde Bridge that crosses the shallow Manzanares River. Here Goya would stroll along its sandy banks. He would not necessarily

be alone, for apart from Moratín he might be accompanied by his chief assistant Asensio Juliá, a fisherman's son from Valencia who helped him with the decoration. Goya painted him in 1798, perhaps in recognition of his services, and again in 1814. During this time Goya got to know well the district across the river, and his association with it possibly influenced his choice of a new home a mile or so downstream in future years.

Elated by his success and the public acclaim that went with it, Goya at last heeded the attentions of Luis, the Cardinal-Archbishop of Toledo, son of his benevolent patron the late Infante Luis. The Archbishop, it is believed, urged him to portray Christ, passing on the wishes of his predecessor in his episcopal seat; and Goya got down to the ambitious oil-on-canvas project which proved a worthy sequel to the previous work.[11] The actual theme was *The Taking of Christ*, and it was completed by December, 1798. Before sending the life-size work to the cathedral sacristy at Toledo the following month, Goya showed it to the Academy, where it was praised for its sense of composition, color, and masterly technique. This was praise indeed, for everyone knew it was to hang near El Greco's *Disrobing of Christ*, with which it would necessarily be compared. But it passed the test, then and since. Its secret lay in its humanly neoclassic, as well as mystical, overtones, reflecting the style of John Flaxman and El Greco all in one. Goya successfully portrayed the human worth of Christ, not merely as a divine illumination but as a victim of bigotry. As a rational person, he is set against a background of spatial depth made possible by the play of light and shade on the figures in front that reflect the glint of weapons, and by the darkness ascending behind.

As for the Archbishop Luis himself, who probably had called for the picture in the first place, he rewardingly sat for Goya two years later, and the artist had a useful friend in this distinguished member of the Bourbon-Vallabriga family. More importantly, the Archbishop's sister, the beautiful and sad Condesa de Chinchón, was none other than Godoy's wife; and although the chief minister had resigned from office, he had no intention of staying out of power for long. But with time on his hands meanwhile, and impressed like everyone else by Goya's recent triumphs in fresco and

oil, Godoy gave him a number of important commissions. Thus there emerged two portraits of the Condesa de Chinchón (the second one in 1800 along with her brother mentioned above), in which Goya compassionately reflects what she was enduring. It was a sadness heightened by her husband's impertinent flaunting of his mistress Pepita in front of her very eyes, and Goya who was not above infidelity himself, was quick to notice its effects on others. In addition to a roving eye Godoy had an extravagant taste for art, and the seasoned painter could hardly pass over the opportunities he offered him. Commissions at this time included allegories depicting *Trade, Agriculture* and *Industry* for Godoy's palace staircase, *Poetry* for his library, along with *Truth, History* and *Time* in more discreet places where nude figures could appear—a subject that the minister no less than the artist were both well versed in. But with the latter, the nude figure was essentially an object not of lust but rather of glorification tinged with mischievous satire.

Now feeling safe from the assaults of church and state on account of his many contacts, Goya rather rashly decided to take the plunge and sell his *Caprichos* to the general public; and an announcement to this effect appeared in the *Diario de Madrid* on February 6, 1799. In it, Goya pleaded that the censuring of human errors and vices should be an aim of painting (hitherto peculiar to eloquence and poetry), and that he as artist had chosen from among the many extravagances, errors, and conceits sanctioned by polite society whether through custom, ignorance or self-interest, those themes that in his opinion were most apt for exposing to ridicule, and where fantasy could be resorted to on the part of the craftsman. After insisting that none of his works was aimed at exposing the faults of any individual, Goya went on:

"Painting (like poetry) selects from the universal that which it seems most fitting for its ends, and unites in a single fantastic person circumstances and characters which nature presents distributed among many; and from this ingenuously arranged combination springs that fortunate imitation through which a good craftsman wins the title of inventor rather than slavish copyist."[12]

Two weeks later, sets of the eighty *capricho* engravings went

111

on sale in the perfume and liquor shop below his studio at 1 Desengaño Street. The price was 320 reales per set, nearly thirty being sold in all, and the Duke and Duchess of Osuna were among the first purchasers. These two had long been loyal friends of Goya. The Duke, moreover, who had sat for him during the year, now enjoyed an army post at court where he could supervise payment for some of Goya's commissions—the portrait of Captain-General José Urrutía being a case in point. They had also purchased *The Four Seasons*, his *San Isidro* painting, and two country scenes. But they were lucky to get the *Caprichos* at all. For Goya's final announcement that appeared in the *Gaceta de Madrid* on February 19 only allowed two days for the public to buy them before the offer was suddenly withdrawn.

This about-face was almost certainly due to the Inquisition that was now assuredly stalking his path. Since this period from late 1798 onward coincides with the conservative clerical reaction led by Caballero, one can assume that a denunciation was pending, and that Caballero's rival Urquijo was the one who tipped Goya off. Whatever the facts, Goya was taking no chances. It behooved no one to confront such an awesome branch of officialdom, and hence the sale's cancellation.

The Inquisition authorities must have been perplexed by Goya in the extreme. On the one hand, there were his powerful religious works already referred to (along with a group of four early church fathers,[13] and an 1800 portrait of an old friend from Saragossa, Joaquín Company, Archbishop of Valencia and head of the Franciscan Order in Spain); on the other hand, here were his *Caprichos* that appeared to strike at the very vitals of the Church. The fact was that religion to Goya was both food for love and food for outrage—rational beauty and irrational ugliness alternating at opposite ends of his vision. But even if the Inquisition had struck at him, its officials would hardly have known what to do. For Goya had many protectors, not least of them the artful Godoy, patiently waiting in the wings of the political stage for his triumphant return. Above all there was the King (which meant the Queen), who in October 1799 appointed him to the highest art post in the land—that of senior chamber painter—at a handsome salary of 50,000 reales a year. The reason for this

promotion was a series of successful royal portraits which are discussed in a later context. Under these conditions, the *Caprichos* were at least safeguarded from the assults of censorship.

In an exultant mood, Goya relayed to Zapater the good news of his appointment, transmitted by the first secretary Urquijo from the Escorial at the end of the month. He bade Zapater tell everyone about it in Saragossa—Yoldi, Goicoechea, and the rest—and made it no secret that their royal Majesties were delighted with their portraits. He also commended his much-loved personal copyist, Agustín Esteve, with whose work on the portraits he was especially pleased.[14] But sadly Urquijo himself, Caballero's enemy and Goya's last friend left in the government, was to fall from power by December 1800. He had angered Napoleon (who now as First Consul of France was dragging Spain ever closer into his orbit) by allegedly ordering the Spanish fleet to be detached from French command, Urquijo had also fallen victim to the conservative ultramontane forces of reaction that were soon to embroil the artist himself. Caballero, in a word, had triumphed.

✦ ✦ ✦ ✦ ✦ ✦ ✦

Goya's final relationship with the Duchess of Alba, meanwhile, merits some comment for the light it sheds on his shifting attitude, as he moved inexorably into the gathering gloom of the nineteenth century. To what extent they kept in touch after his return from Andalucía is not exactly known. A close relation of the Albas was the Marquesa de la Merced y Santa Cruz, possessor of a big art collection, and whose own posture on the canvas done by his hand at this time in 1797-8 bears some resemblance to his enchanting Duchess. Indeed this lady may have brought the two together again. Another link was the Osuna couple, who most likely would greet them both at some of the Academy exhibitions. There was certainly a request for him to paint Ramón de Cabrera, librarian to the Alba household.

But the fire in their relationship had somehow cooled. Unnumbered among his *Caprichos* is a scene titled "Dream of Lies and Inconstancy," which seems to suggest her betrayal, though who first did the betraying—himself or the Duchess—must remain speculative. And number 61 of the *Caprichos* titled *"Volaverunt"*

or "The Birds Have Flown," mentions her by name in the subsequent commentaries. Here a remark suggests that three bullfighters (of whom the famous Pedro de Romero could be one) are filling her head with notions of grandeur. The Duchess, incidentally, was as fond of the bullfight as he was, whereas Charles IV and Godoy were against it and even resolved to ban it.

As old memories flickered here and there, a certain impishness left over from the embers of his grand passion could never quite desert him. He knew the shallowness of the life she was leading— this after all was what the *Caprichos* had partly been about from the beginning. Yet after a fashion he loved her still. But it was with a brittleness that matched her own. And one is tempted to attribute a certain prankishness to his two famous *Maja* paintings reputedly inspired by her—the nude one and the clothed one completed some time at the turn of the century. It is of course possible that she had nothing to do with them at all. Or she may have simply shared in the general enjoyment of an extravaganza. At all events, the hand of Godoy was behind them somewhere, as on the sidelines of power he cosseted Goya on the one hand and bullied the Duchess on the other, wheedling out of her as many works of art as he could lay hands on. Perhaps prankishness was the one common bond between the two men.

Godoy's involvement with the Duchess is made more probable by the fact that the *Maja* paintings themselves ended up in his palace by 1800, for the nude was seen by a visitor on November 12 of this year.[15] The face is certainly not that of the Duchess, but she may have done the posing with the face disguised so as to avoid scandal. It would have been highly impolitic for any of them to have revealed the identity despite Goya's popularity with the royal family, for the capricious Queen and the dedicated Inquisition could have struck them down at any moment. The chances are that the head was simply that of an ordinary model superimposed, as it were, on a more distinguished body, with a similar device used in the subsequent clothed painting. All this may have been Goya's idea in the first place, though they are not his greatest works.

One fact clearly emerges—the Duchess herself was fast losing her looks. By 1800 she was considerably thinner and shrinking into her barely more than five-feet frame. She who had made

herself an enemy of the Queen was "all skin and bones" and "still as crazy as in her first flush of youth," as María Luisa triumphantly commented after seeing her on two occasions.[16] She died on July 23, 1802, when she was barely forty; and the second *Maja* may have been clothed purposely out of respect for her advancing illness. The latter painting, incidentally, was placed over the original in Godoy's palace to screen it from view—even Charles IV was beginning to crack down on nudes—and both were confiscated by the Inquisition in 1808.

Rapaciously enough, many of the Duchess's effects were seized by the sovereigns upon her death (she left no immediate heirs), thus joining Godoy in this disgraceful act of piracy. The latter's huge art collection by this time included Velázquez' *Toilet of Venus*, which had long been in the Alba family and is now in the National Gallery of London. Godoy was following the Alba footsteps in collecting such nudes, so frowned upon by Spanish officialdom, in a tradition that goes back to Rubens, Correggio, and Titian. He had deftly stolen a march on his sovereigns. And the childless Duchess was left in her cold grave in the cemetery of San Isidro in Madrid.

That Goya was saddened by her passing is evidenced in the sepia-wash design he did for her tomb, though the plan was never carried out. Interestingly, there was an inquiry at the time to see if she had been poisoned. Rumors were abounding; but neither then nor in 1945–6 when her remains were exhumed, was any trace of poison found. She died of dengue, or break-bone fever, showing traces of tuberculosis. What was subsequently found, however, was the apparent resemblance between the *Majas*' anatomy proportions and those of the Duchess, strengthening the possibility that she had posed for the paintings after all.[17] Goya kept his secret well, above all the degree of intimacy he had shared with her. This was his world, inviolate and unbridgeable.

As he looked back over the crowded years of his century it was surely with a sense of nostalgia, especially in regard to all the many friends, both men and women, he had known. One thinks of his real love for Zapater, long past the butt of his every frustration, whom he was to lose soon after his Duchess. In different ways he and she and countless others like Martínez had nursed

him back to health, strengthened his art and sharpened his ability to see through the veil of the shallow society that enveloped him. Love had fortified his vision, but in a way that not even his friends quite understood. He saw the things that he did, not merely as an incentive to explore new horizons, but because they were the truth. He was close enough to the seat of power to grasp their meaning.

Beauty and distortion, character and caricature, realism and fantasy, serenity and violence—all these oscillations in his being were reactions to what had been revealed to him. And he used varied media to express it, whether oil or fresco, red water color or sepia, which formed the basis for his etchings. They could be flesh-and-blood portrayals or mere silhouettes, monstrously uninhibited. They could be gentle victims or grotesque perpetrators of ignorance and superstition. His life, lived out in silence like a silent movie, was a kaleidoscope of forms and visions which he somehow jumbled into a coherent whole. It was as if his mind had been split into a myriad of diverse, yet connected parts. Goya the conforming portraitist had become with his *Caprichos* the psychologist in a new dimension of art.

And through it all he had reached the topmost rung of the ladder. Incredibly unscathed, he had reached it because of his integrity, his detached experience which had guided him past all the pitfalls. He had become at last a rationalist in a crumbling edifice. His dreams had awakened him out of his slumber. There in his own house of cards, he had seen stranger signs, heard deeper voices than any of his fellows.

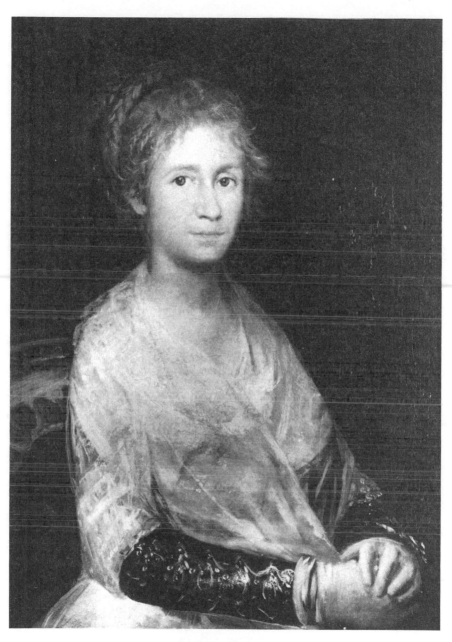

Josefa Bayeu

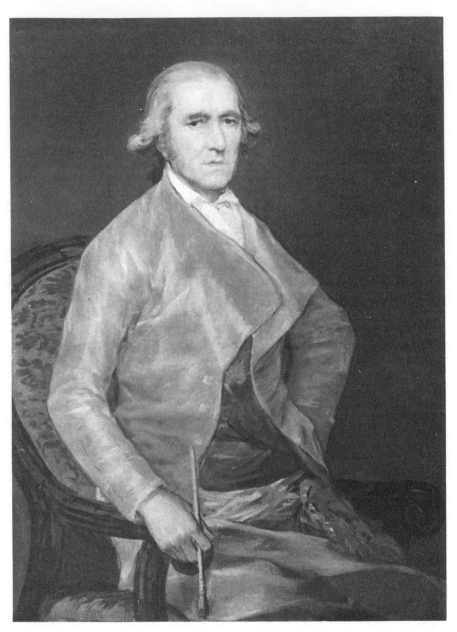

Francisco Bayeu

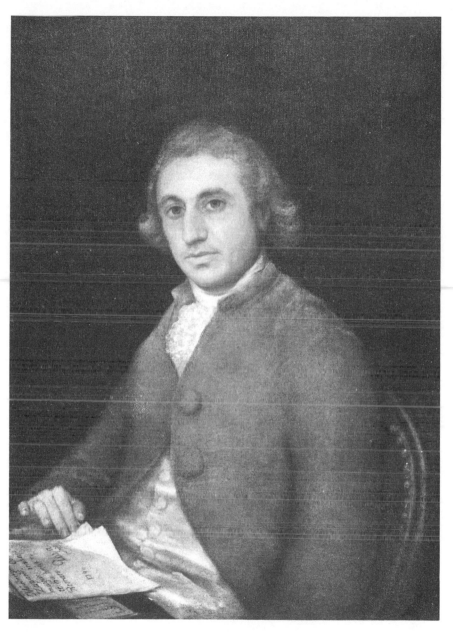

Martín Zapater

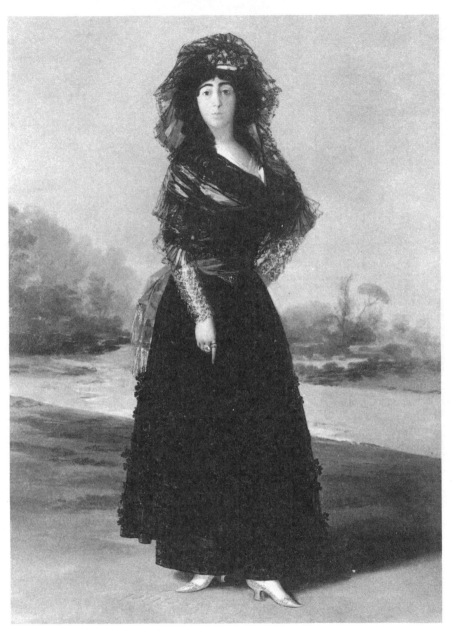

The Duchess of Alba

The Duchess of Alba Showing her Hair

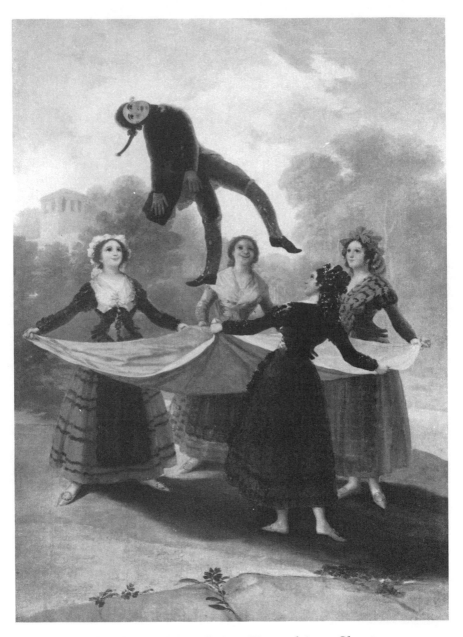

The Straw Man Being Tossed in a Sheet

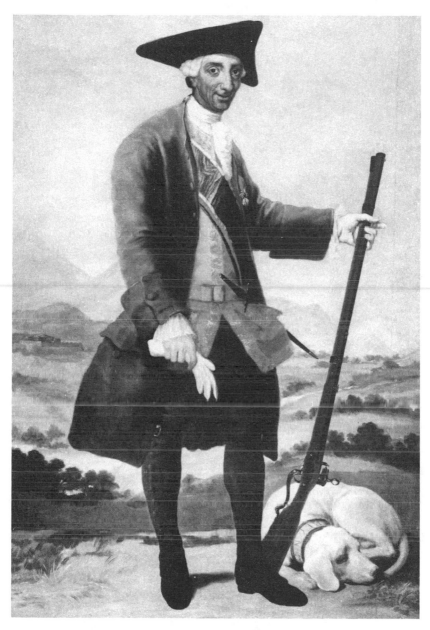

Charles III

Charles IV and Family

Courtesy of The Prado, Madrid, Spain

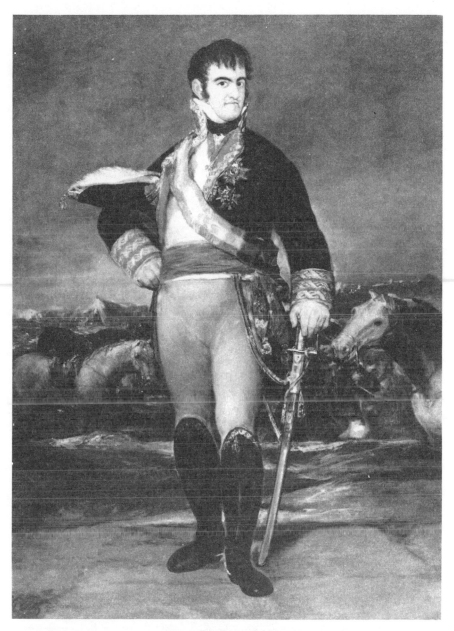

Ferdinand VII

The May 2, 1808, Uprising

Courtesy of The Prado, Madrid, Spain

The May 3, 1808, Executions

Courtesy of The Prado, Madrid, Spain

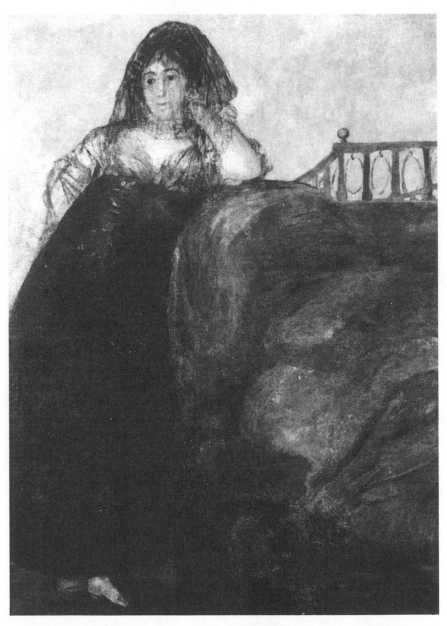

Leocadia Zorilla (from the Black Paintings)

III

THE ROAD TO DISILLUSION

Truth has died. But will She rise again?

<div align="right">

Captions to numbers 79 and 80,
The Disasters of War etchings

</div>

NINE
An Ill Wind From Austerlitz

G oya's disillusion really began when friends like Jovellanos disappeared from the government. It is interesting to note his self-portrait done in that year, 1798, at the age of fifty-two. It shows him as a man more changed than in any of his previous self-portraits, whether in 1783, 1790, or 1795. He wears engraver's glasses (perhaps for the final etchings of the *Caprichos*), his sideburns have lengthened, his hair become more grizzly, the mouth turned down at the edges. He has a quizzical skeptical look. 'Nothing surprises me,' he seems to be saying, anticipating the time when he had seen everything. Congenial yet fussy, he was alternately happy at his progress in art, depressed by the quandary of long-suffering man. And the starker the contradictions, the more daring and diffuse his reach became.

He was the perfect court painter, but only just concealing his satire of the court. He was the perfect religious painter, while hating the Church's stuffy ways. He was sincere with his sitters, but would have liked to avoid mere academic representation which his deeper instincts had rejected. And while accepting the validity of society as he knew it, he had already become a critic

of the social scene. Yet all the time he remained undeterred by his critics. He was made of sterner stuff than they, as he worked in solitude to expose people's vices and temptations that had long surpassed even his own. Art and anger were mixed up in him. Often he worked very fast, as if time were going to run out on him once more. And with one of his self-portraits, he ringed his hat with flaming candles so as not to lose any light!

There was certainly much to be concerned about. It didn't take great intelligence to see that something was rotten in the state of Castile. Indeed by the early nineteenth century Spain was sinking deeper into the mire from both internal causes and external pressures. It was a far cry from the days of Charles III. Reforms long past due had been forgotten or postponed under the disastrous *camarilla* regime of the Queen. And in the absence of a strong King, Spaniards still looked to Godoy if only because there seemed no other alternative. The latter had flirted with enlightenment in relaxing the censorship a little, trying to tax the nobility, and supporting badly needed agrarian reforms proposed by Jovellanos. But the drift to decadence seemed to have passed the point of no return. As a man of character moreover, Godoy struck a poor figure. We may forgive him his opportunism, but he was also greedy, unreliable, and pleasure-seeking. His principle was to have no principles. And as his erratic qualities infected the government, so society became rent into factions, in which the new clerical reaction only made things worse.

Of Spain's population of nearly ten million by 1800, about sixty percent were peasants, and of these the majority were landless and scarcely productive. As for the industrial work force, where in textiles for example, there had been a boom in Catalonia and Valencia only a decade before, these workers now only accounted for about fifteen percent of the population. The remainder were nobles, clergy, and the military, not to mention the large number of servants, none of whom contributed much to the economy. Out of five hundred noble families, a few grandees had huge estates, especially in the south, which did give some employment to casual day laborers but without much else in terms of efficient cultivation; while in the north, so many claimed to be minor nobles that it was a standing joke that there were more

nobles than beggars in Spain. In the country at large, some ten thousand towns and villages were still under seignorial jurisdiction, with as many estates tied up in entail. A decade later by Ferdinand VII's time, nobles still owned fifty percent of the land, the Church sixteen percent (with a revenue almost as large as the state revenue itself), while the remainder of the land was largely divided among generally impoverished communes. Only in the Basque lands and parts of eastern Spain were independent farmers prosperous. In a land of increasing drifters, moreover, from lease-ridden Galicia to depopulated La Mancha, barely ten percent of the children received an adequate education. Madrid itself was a bustling city of over 150,000 people, but its access to the nation was hampered by poor communications. As to the national debt, whereas this had been curbed by Charles III, it was escalating far beyond the state revenue of 1.4 billion reales, and with bankers and guilds increasingly reluctant to answer the national call, Spain was rapidly heading toward bankruptcy.

Compounding these problems was Godoy's disastrous foreign policy. He was called the 'Prince of Peace' after deserting the first coalition against Republican France by signing the Treaty of Basel with this country in June 1795; but discerning men knew his peacemaking was only another term for appeasement. He then joined France against England and got soundly defeated at sea by the preponderant British navy—a fitting reward for having deserted his allies in the first place. True, after his temporary eclipse in March 1798, he redeemed himself in the 'War of the Oranges' against Portugal in 1801, which resulted in the capture of Olivenza as well as his own recovery of power. But the swing to the Right that lasted till 1805, internal disunity, the loss of territory in the Caribbean, not to mention pressure from the United States, weighed heavily on Godoy's shoulders. When a truce was signed with England and France at Amiens in March 1802, which gave him a breathing space in terms of a brief economic recovery, Napoleon was virtual master of continental Europe. Spain lay in his shadow. Yet Godoy was not the man to deal with such a threat. Pressed as Spain was between England and France on the one hand while trying in vain to protect half of the American hemisphere on the other, the nation needed a man of Churchillian

vision to keep all the threats at bay.

Godoy aside, it was Charles IV more than anyone who had brought things to this sorry pass. Empty chatter and affability are not enough to lead a state. What was needed was a firm hand with capable ministers serving the royal will. But Charles seemed to lack a will altogether which at least should have preserved the stability of society in the way his father had done. Godoy's policies, after all, were his responsibility. And at a time when neutrality and a more astute diplomacy abroad were essential, Godoy's machinations with the Queen at home were bringing the crown itself into mounting disrepute. As government went through the motions of governing, and society went through the motions of socializing—fans wafting the perfumed air in make-believe as at a masquerade—Spain was like a calm before the storm. The threat from Napoleon was real. And Goya certainly was not deceived by appearances.

As the years wore on, as Spain's swift decline portended a series of disasters unmatched by any nation, Goya was to live through it all; and it is one of the trenchant ironies of his life that the more disillusioned he became, the better he was able to express himself in positive artistic terms.

His attitude, of course, had to be hidden from the King and Queen who were treating him well at the turn of the century. To celebrate the tenth year of the reign that summer of 1799 as the court moved to La Granja, the royal couple gave him a number of commissions. Posing before him in country dress, the King sports a hunting rifle, gun dog lying at his feet as in portraits of Charles III, while the Queen wears *maja* costume, with black mantilla like the Duchess of Alba. More portraits followed when the court moved to the Escorial in the autumn. Indeed this was the time when Goya at last received his senior painter appointment at a handsome salary of 50,000 reales a year. He was also given special quarters as well as a carriage allowance (along with Maella), his junior colleague Manuel Napoli standing next in line. Now he could comfortably paint his royal patrons on horseback in the equestrian style of a Velázquez, while other scenes show Charles IV in military uniform, María Luisa in court dress. Some of these portraits, thanks to copyist Agustín Esteve, were later

exported for Napoleon to admire with greedy eyes in Paris. The portraits in fact are brilliant and are among Goya's finest work, especially those depicting Charles IV.

María Luisa was well satisfied with Goya's performance at first. In a note to Godoy of October 9, 1799, she mentioned the popularity of his equestrian portrait of her—and Goya did try to capture some of her former attractiveness as she regally surveys her kingdom beneath her fashionable riding hat.[1] Godoy, incidentally, provided the horse named Marcial for this picture, anxious to redeem himself in Her Majesty's eyes and obliged in consequence to receive copies of the royal portrait in exhange. The unstoppable minister was relentless in his aim, and probably saw in Goya a convenient foil for his intrigues.

For indeed, Goya at the moment did stand high in the esteem of the royal family. He was already familiar with the principal features of its members, and Leandro Fernández de Moratín noted in his diary that on February 11, 1800, he went with Goya to see his portraits in the rooms of the Royal Palace. Among these was one of the Infante Don Antonio (Charles III's youngest son) which Moratín viewed with special interest six days later.' The two friends were very close at this time, and Moratín can easily be imagined discussing with Goya the merits of these portraits, no doubt pondering on the merits of monarchy itself.

But the crowning achievement of the royal commissions was Goya's superb study of Charles IV and his entire family, of which the above portraits formed the basis. It was begun at Aranjuez in the summer of 1800, probably in the Casa del Labrador, and continued over the next twelve months. María Luisa allowed him to finish his portrait of the Condesa de Chinchón (Godoy's wife) before he embarked on the ambitious project, but her graciousness was somewhat misplaced in that, despite her enthusiasm, María Luisa in the end emerges as perhaps the least flattered in all that glittering assemblage.

Yet Goya worked hard on the great oil painting, preparing sketches of each of the fifteen persons in turn. The result shows some reverence for Velázquez with his *Maids of Honor*. But there is a difference. The artist stands behind the group without the aid of mirrors, and he skillfully lends their grandeur such a light

touch of satire as to be almost undetectable. He has done this by subtly blending the neoclassic design in the groups of figures with fluid brush-strokes in their features. María Josefa is there—the diminutive daughter of Charles III who had wisely rejected the hand of her uncle Luis—as sour and aging she stares vacuously against a background of black and red, as if lost in exotic thoughts of what might have been. As for the Prince of Asturias (the future Ferdinand VII), he stands next to a lady with a featureless profile who is probably intended to be María Antonia of Sicily, whom he was to marry in 1802. Underlying the great work is a sense of easeful pageantry typified in the portly figure of the King, whose head and hand are magnificently done like a Titian; but the faces convey an almost mock solemnity as well, as if Goya had conceived them in the spirit of a grand *capricho*. When the painting was cleaned in 1967, a nude male figure appeared between two females on the salon wall behind the group, as if Goya the prankster was up to his tricks again.

Interestingly, his relations with the royal couple soon after began to cool. It could be that his patrons had second thoughts about the work—María Luisa for all her faults was no fool in dealing with men—especially when Goya allegedly refused to change the posture of the profiled lady mentioned above. Then there were the *Caprichos*. There is little doubt that the Queen had seen them by 1802, perhaps in Goya's presence, and might have guessed the meaning in *capricho* 5, which as the artist's later comments reveal, depicts María Luisa being courted by Godoy. Kings and queens were normally amused by satire, unless of course pointed at themselves; but in addition, the *Caprichos* fly perilously close in the face of the whole establishment, and not surprisingly in the reactionary mood of the time, enemies of Goya would make sure their resentment would reach the ears of the Queen. Among the gossipers was the Inquisition itself, still smarting from his anti-clerical attacks and doubtless now sharpening its weapons against him. To forestall possible arrest, Goya by the summer of 1803 hit upon the idea of offering the *Caprichos* to the King in exchange for a grant of 12,000 reales for his son Javier to travel abroad.

The offer was accepted, the royal couple being only too glad to control the *Caprichos'* distribution; and various etchings (in

aquafortis) were passed on to the royal calcography authorities for prints to be made and released for public sale.[3] It was an astute move on Goya's part, his official reason being that the *Caprichos* might otherwise fall into foreign hands. Lame as this excuse was, it had the effect of thwarting the Inquisition; but in other respects his isolation from the court continued, and rival painters saw their chance to profit in his stead. Among these was Vicente López, who was winning the favor especially of the King's son and heir, Prince Ferdinand. The latter hated Godoy and could never forget that Goya had been on close terms with the relentless scheming minister. In this regard, perhaps Goya's best portrait of Godoy shows him as a general conducting the victorious 'War of the Oranges' against Portugal in 1801—a sure stepping-stone to his full recovery of power—as he reclines in impressive yellow breeches before a triumphant flag. What Ferdinand thought of the portrait is not recorded, though the chances are his comments would be highly unflattering.

But there were other reasons for Goya's increasing isolation. Now well in to his fifties and seeking retirement, he wanted freedom for his own work and to live out his remaining years in peace. Fortunately he was still kept on the payroll as a court painter, while his considerable number of portraits brought him a substantial private income. On this score his family had no cause to complain. And at the turn of the century he and Josefa bought a new home at 15 Valverde Street, close to their old address. Fully moved into it by 1803, the couple with their nineteen-year-old son Javier found it a welcome change, with more space and less pokiness, and all could feel relaxed now that the tension from court politics had eased.

Sadly, 1803 was the year when Goya lost Zapater, whose death followed soon after that of Campomanes. With so many of his friends departing, Goya clung all the more closely to those remaining, like Ceán Bermúdez and Moratín, perhaps reminding himself of his own durability. Zapater had been a light in his life. Now the great light had gone out. His greatest friend of all had helped him in his lowest depths of despair, and Goya surely must have thought of him reflectively not merely as a man of great generosity but as one of practical wisdom in his own right which

stood him apart in an age of rampant dissipation.

In the meantime he had a great deal to get on with. Indeed, these years show no lessening of his feverish activity, as in the privacy of his studio he would potter among his albums of sketches in the early light, rounding out the hollowness of society with relentless ire. His drawings would keep him quiet for hours. Evolving from Albums A and B (the 'Sanlúcar' and 'Madrid' respectively), they emerged into Albums C (the 'Diary', 1803–24) and E (the 'Black-edged', 1803–12), which complement the *Caprichos*.[4] Album D (the 'Unfinished', 1801–3) he had already completed, presumably before he moved to his new home. Some lie outside any album framework altogether. There is a woman looking at her reflection in the form of a snake coiled round a scythe, and a huge rock that resembles the Titanic in its final death throes. Human-like frogs abound individually and in the albums. In the latter, his fantasies range from ordinary street scenes and sex to more animal symbolism, in which *caprichos*-like postures of foible and lust foreshadow a world of an apocalyptic reckoning.

He had come a long way since his sublime *Head of an Angel* was first sketched for a fresco in the Pilar cathedral. Now it was the dilemma of mankind that especially held him. He worked at this theme like a demon—pleasurably but with pain also, as if compelled to forewarn of his country's coming doom. To catalogue the message, he would paginate the albums, pore over each work's title. Order was coming into his life; he was no longer wrestling with the chaos in himself, but with the world outside. And while his titles with their caustic innuendos reflect the cool philosopher, they lack the sophistry of the philosopher's stock-in-trade. He has the eye of a plain observer who is humbly learning from others all the time.

As to his portraits, he completed no less than fifty between 1800 and 1808, which gave him a release, perhaps, from his deepest forebodings. Scores of patrons would call on him or invite him to their houses. His own studio was large and airy, but visitors would have to be quiet if his model's throne was filled while he worked away at his easel, artist's donkey long abandoned.[5] In such an atmosphere in his former studio, he had sketched the first outlines of his Duchess. Now others would come, impressed by

the furnishings in his new home—the cabinets and mirrors, the sofas of damask. He had also acquired a library and a great deal of jewelry, hidden of course, but he loved to display his priceless Correggios and Tiepolos, along with copies of Velázquez and prints of Rembrandt.

His patrons came from all walks of life. Among his sitters in the early 1800s were the Condesa de Haro and the young Marquesa de Santa Cruz (daughter of the Osunas), both of them related to the Alba family. The portrait of the Marquesa de Santa Cruz, whom Goya depicted in 1805 as the muse of music in the reclining pose of a *maja*, was of particular interest after 1983 when it became the subject of a legal dispute between Spain and England. It was purchased in London by the Spanish government in the early 1940s because General Franco intended to present it to Hitler; and an emblem on the lyre in the painting is said to resemble a swastika. It was later acquired by the Fernández Valdés family for a collection in Bilbao. From here it re-entered England via Madrid Airport and Zurich, having been bought in Switzerland by the Viscount Wimborne interests in 1983. But the Spanish Minister of Culture (Sr. J. Solana) wanted it back, on the ground that it had left Spain under false documentation.[6] Indeed, arrest warrants were issued through Interpol for two intermediaries allegedly involved in the picture's sale in Switzerland, Viscount Wimborne being the innocent third party in the transaction. Its auction at Christie's in London, meanwhile, scheduled for April 1986, attracted wide attention, and bidders reportedly were willing to offer a world record figure of nearly nine million pounds for it. In this same month, however, by an agreement between Viscount Wimborne and the Spanish Minister of Culture, the picture was to be sold back to Spain for 4.2 million pounds (about 6 million dollars) for its eventual home in the Prado. In any event, the dispute underscores the very high esteem with which the art world regards a Goya work today, and smugglers of his paintings are hard put to sell them at a profitable price on account of the well organized blacklisting and prosecution that confront them.

How Goya would have been astounded at the controversy! With his modest average fee of about 7,000 reales for a full-length

portrait (barely 150 pounds at the rate prevailing in 1804), with a third as much for a bust, he would have regarded such high figures as inconceivable. He must have felt a certain contentment in any case; for even before he painted the fabulous Marquesa, two other marquesas had already sat for him in 1804—Lazán and Villafranca. The latter was a member of the Academy, and it is worth noting that both were sisters-in-law of José Palafox (of whom more later), one of the great heroes in the coming Peninsular War against Napoleon.

Of interest for their English style of pose at this time, in 1803–4, are the portraits of diplomats the Conde de Fernán Núñez (along with his wife) and the Marqués de San Adrián. The former, a conservative and biographer of Charles III, became ambassador to France both during and after the French Revolution, while the latter, a francophile, became embroiled in the Napoleonic regime in Spain, and ended up an exile.[7]

Goya had a genuine respect for things English, from engraving to British products in general, and he once quipped in a letter to Zapater from Madrid, dated about 1794, that he was writing from London in the year 1800.[8] It is a pity his little joke could not have applied to real events, in which case he might have come across William Blake! Goya never hesitated to learn from others, whether foreigners or Spaniards who had been abroad. And one such teacher was a certain Bartolomé Sureda. Director of the Buen Retiro porcelain factory, he had studied black mezzotint technique in England, and Goya became interested in this new style. Goya's *Colossus* of about 1810, however—an apocalyptic study of a brooding giant sitting under the moon like a pondering Napoleon—turned out to be an aquatint, not mezzotint, as previously thought.

His portrait of Sureda himself, done about 1805, shows a keen and interesting young man with streaky black hair, as he holds his 'John Bull' hat just coming into fashion, and who seems to be telling the artist all his latest experiences. He forms a contrast with his young wife Teresa, who sits in a chair with a restrained elegant dignity. Goya had long since mastered the almost enigmatic quality in the beauty of Spanish women; and sitters like Doña Isabel de Porcel, Francisca Sabasa y García, or the

Baruso Valdés family of mother and daughter, along with anonymous ladies sporting fans or roses, express his genius at its maturity. Other patrons were his unconventional Bohemian friends, many of them connected with the stage. Among these were glittering performers like the singer Lorenza Correa, the ever-popular actors Pedro Mocarte and Isidro Maiquez, and Manuel García de la Prada, a wealthy theatre friend of Leandro de Moratín;[9] while a totally different kind of sitter was Pérez de Estala, an industrialist from Segovia. The names become legion.[10]

A happy event in these crowded years was the marriage of his son Javier to María Gumersinda. She was the daughter of a rich merchant named Martín Miguel de Goicoechea, a probable cousin of the late Juan Martín of this surname whom Goya and Zapater had known in Saragossa. The wedding took place in the church of San Ginés on July 8, 1805. Turned twenty and seventeen respectively, Javier and María were soon painted by Goya, and this was followed by miniatures of the bride's family, including her mother Juana Galarza. The young couple were given the option in the marriage settlement of living with the Goyas in Valverde Street; but they finally chose to live in Calle de los Reyes, probably at number 7, where premises had been taken on their behalf. Goya and Josefa badly wanted descendants, and were not to be disappointed. For a grandson was born on July 11, 1806. His name was Mariano, and the boy became very dear to Goya.

Family pressures, meanwhile were no doubt spurring Goya to greater professional activity, and in this respect there was no lack of competition for his services. An amusing story concerns José de Vargas Ponce, whom he painted in 1805. Director of the Royal Academy of History (and probable author of a liberal tract translated as "Bread and Bulls" which was highly critical of Spanish society), Vargas Ponce asked Ceán Bermúdez to use his influence with Goya to paint his portrait for this academy in a manner befitting the dignity of his office. Ceán's influence apparently worked; but because the distinguished director had only modest funds from this institution, the portrait, so the story goes, was cut down to the extent that his hands are hidden under his waistcoat and lapel—a happy saving for the penny-pinching academy, in which Goya was kind enough to oblige!

* * * * * * *

Vargas Ponce was a friend of Jovellanos and Lady Holland, among others, and like them was a keen observer and critic, naval history being his special interest. In respect of the navy there was certainly much to reform. For the year 1805 has an ominous ring about it in the history of Spain, when on October 21 the British defeated the combined French and Spanish fleets at Trafalgar. It sounded the death knell for Spain as a major naval power, if not as a great power altogether, caught as she was between Britain's maritime supremacy on the one hand and Napoleon's domination of continental Europe on the other. It also sounded the beginning of the end for Godoy, the most hated man in the country, whose policy of cringing subservience to Napoleon in his renewed war with England was bringing disasters visible to all. No longer could he blame others, like his relative Pedro de Cevallos, who since 1801 had been appointed nominal chief secretary in the government; and his last resort was to push himself ever more ineffectively into the bosom of the reigning sovereigns.

Curiously, there is a link between Trafalgar and Goya in the person of the poet Manuel Quintana. He had earlier composed a famous ode to Juan de Padilla, a Castilian *comunero* leader of 1520, and now wrote a patriotic poem about this naval battle. In a related poem, he expressed Goya's fiery imagination in the same vein, including it with a collection of his works which the poet sent to the artist. In it, Quintana suggests that the English, having bought up Italian art, might now do well to turn to Spain—"Yet the day will come when the foreigner will bow in ecstacy at the sound of your name, too, oh Goya!" the poem reads.[11] Prophetic words indeed. As with Quintana himself, Goya's style was to be strengthened by a critical sense of heroism amid doom and national catastrophe, which can often capture the Spanish popular spirit.

But worse was to follow. The Trafalgar battle was part of a wider war in which England had been joined by Austria, Prussia, and Russia in a huge coalition against Napoleon, who utterly defeated the three continental powers in the most brilliant of all his campaigns. His victory at Austerlitz over the Austrians and Russians on December 2, 1805, meant that the entire Habsburg

empire lay at his feet; and all of Germany fell next. Not for nothing had he crowned himself Emperor of Europe, though he did allow the three continental powers their territorial independence.

It might be supposed that victories like Austerlitz would bring advantage to Spain as Napoleon's ally; but the opposite was the case. For even before the French emperor had finished dealing with his defeated enemies, climaxed by his ostensibly friendly meeting with the Russian Czar at Tilsit in June 1807, he was already casting covetous eyes toward the Iberian peninsula. Godoy's sabre-rattling when his attention was turned eastward had only whetted his appetite. He wanted to extend his continental system into Spain as a rebuff to England, and to implant his version of 'enlightenment' by extending French domination as far as the Ebro River while giving Charles and Godoy a free hand in Portugal. In other words, Spain and Portugal were to be the next victims.

Napoleon had his reasons for thinking that Spain's 'liberation' was going to be easy, and hardly concealed his contempt for his hapless ally. Certainly the omens looked good. As palace intrigues, plots and counterplots, unmasked the growing opposition to Godoy, the nation was tottering on the brink of ruin. Banditry was rife; and stirring the nation at this time was the capture of the notorious brigand El Maragato by Father Pedro de Zaldivia, who managed to turn the gun on his assailant. This incident was depicted by Goya some months later in six oil on-wood sequences like primitive lantern slides, anticipating the film strip of future days.

Conservative national forces in the meantime were finding their champion in Prince Ferdinand, Charles IV's heir and Spain's future king. In personal qualities this prince was to prove even baser than Godoy, but at this stage he symbolized patriotic resistance to mounting French pressures on the country. And he schemed with his supporters to overthrow both his father and the hated Godoy as soon as possible. All this gave Napoleon an ideal opportunity to meddle in peninsular affairs directly. The end result was that both Ferdinand and his father, along with Godoy himself, all fell into Napoleon's triple trap.

The sequence of events was tortuous. By the treaty of Fontainebleu signed on October 27, 1807, the Spanish government

permitted over 30,000 French troops to march into the country
with the ostensible aim of occupying Portugal, which was then
to be divided between Charles IV's grandson the King of Etruria,
and Godoy. But Napoleon's principal aim was to occupy Spain
itself. Within months, nearly 100,000 French troops under Marshal
Junot—a mere trifle compared with what came later—seized a
number of points in the country, from Pamplona to Barcelona,
as a softening-up process. Euphemistically, they were termed
'Corps of Observation'.

In the course of these events, Ferdinand made a half-hearted
bid to seize his father's throne which was foiled by Godoy, who
then made a bid to extricate both himself and his sovereigns from
the precarious position facing them from the French. Godoy's plan
was for them to escape to Spanish America, just as the Portuguese
royal family planned to carry on the struggle against Napoleon
from Brazil. But before this could materialize, Godoy was over-
thrown by rioters at Aranjuez on March 17, 1808. It was a miracle
he only suffered a bloody nose from being trodden on by a horse
after he had emerged from under a pile of furniture in an attic.
Fortunately his wife was spared by the mob, which surely would
have torn her husband to pieces as they did to his portraits, had
he not been protected by the guards; and he was now a prisoner
in the hands of the triumphant Ferdinand.

Dismayed by what had happened to his beloved minister and
as a move to save him, Charles IV at once abdicated in his son's
favor on March 19, 1808; and five days later, 'King' Ferdinand
advanced through Madrid on a white horse amid wild acclaim
to meet the occupying French under Marshal Murat. But Ferdi-
nand's hour of triumph was brief. With Charles having second
thoughts about his abdication, Murat suggested that, together with
his wife, Charles should lay his case before Emperor Napoleon;
and the latter now saw his chance to spring his trap by getting
rid of all three royal nuisances, including Godoy, who stood in
the way of his imperial ambitions.

Before the final act in this dismal story, Goya, who had
returned from Saragossa in March, was asked by the Royal
Academy (of which he was a director once more) to paint Ferdi-
nand on horseback. Goya agreed, but at the end of the month

petitioned the Academy for Ferdinand to pose naturally before him, as had Charles IV. At last Ferdinand consented to sit at 2:30 in the afternoon of April 5, 1808. The sky was clear, the time seemed right. Ferdinand, however, only gave him two short sessions, each lasting three-quarters of an hour. He was in a hurry with other matters, saying he would give him more time when he returned from Burgos.[12] As it turned out, Goya took till October to finish the portrait, minus his sitter, and was aware of its defects even before the paint had dried.

The fact was that Ferdinand never came back from Burgos. He was right about being in a hurry. For by the end of April, both kings, along with María Luisa and Godoy, were all gathered at Bayonne before Napoleon in person. Here the Emperor played off one king against the other in a game of musical chairs that delighted him. He forced Ferdinand to return the crown to Charles, who then gave it to Napoleon, who in his turn eventually gave it to his brother Joseph. The trap had been shut tight. Charles and María Luisa, both pensioned off in France, never returned to Spain. But Ferdinand, whom his mother had in vain tried to declare illegitimate and who was now a prisoner in France, did in fact return to Spain in 1814. As for Godoy, he lived on as an exile in Paris until his death in 1851 at the ripe age of eighty-five, of whom it might be said that the incredible outlasts the infamous. Thus ended the most shameful period in the whole history of the Spanish monarchy.

But not of the Spanish people. Here a different story was to unfold. On May 2, 1808, the citizens of Madrid in the Puerta del Sol, the very heart of the capital, rose up against the French under Marshal Murat. The catalyst was the sight of the young infante, Francisco de Paula, with his sister and uncle, being forced to board a coach by the Royal Palace bound for the same fate as their family; and in the people's rage an equerry was unhorsed in the process. When a French officer gave the command to shoot, the disturbance spread like wildfire to the Puerta del Sol, where the mob was equally enraged at the sight of Mamelukes under Murat's command swaggering about as if they were Moors. With this sudden uprising, the citizens were taking on the whole French occupying force; and by the next morning when the fighting had

subdued, Murat responded with a decree of terror: military tribunals were to summarily condemn to the firing squad any Spaniard found to be armed. About forty were so shot that same evening, which brought the number of Spaniards who had died in the two days' fighting to at least four hundred.[13] But this bloody measure only turned the incident into a wider struggle of resistance against foreign occupation. It escalated into a national war of liberation, soon igniting all of Spain. For what the uprising of May 2 essentially did was to enrage Napoleon himself. Still at Bayonne when he heard the news, he forced the Bourbons to get on with the business of abdicating, and this paved the way for his brother Joseph to assume the throne.

It is believed that Goya and his son Javier were both near the Puerta del Sol when the Mamelukes were firing on the mob, probably going along San Jerónimo Avenue that leads into the square. What is more certain is that the Mamelukes killed some household members of the number 9 residence in this square. This was the home of a banker named Gabriel Balez. Goya and his son were most likely on their way to visit him, especially as the latter was in business with the parents of Javier's wife—the Goicoechea-Galarza couple mentioned earlier.[14] At all events the War of Independence in the peninsula had begun.

Austerlitz and other battles had stirred up an ill wind across the Pyrenees, and were mere names to people living in Spain. Now the war had moved to them. Conversely, new names were to appear in Spanish that soon gave heart to the oppressed peoples of Europe. But second to the terrible tragedies that lay ahead was another tragedy—a spiritual one. For now that Napoleon seemed invincible on all fronts, Spaniards as never before were forced to come to grips with the challenge posed by the ideals of the French Revolution which Napoleon claimed to embody. Indeed no men of reason or reform could ignore it. This dichotomy— rational reform posed by the invader versus physical resistance to the invader also in the name of reform—was felt in nearly every person as a deep dilemma; and Goya was no exception.

TEN
The Storm Breaks Loose

T he dilemma that gripped all Spaniards during the War of Independence, or Peninsular War, can be better understood from a glance at the various ideological proponents who emerged in the process. Foremost were the absolutists. These still clung to the notion of the divine right of kings personified in their legitimate Bourbon monarchs. They were strong among the military, nobles, clergy and the masses of people at large, and it is worth noting that despite the decline of this concept abroad, there were still plenty of Europeans who shared their view. They were thus fighting the French not because of hatred of the French as such, but because the latter were foreign invaders bent on imposing an alien doctrine. Absolutists merged with conservative reformers like Floridablanca, who on a more secular basis favored the restoration of the strong centralizing policies bequeathed by Charles III, and who also resisted pernicious influences from France. Next were the so-called liberals. They likewise respected monarchy, but in a constitutional sense. Believing that the king's right to rule stemmed from the will of the people, they were child products of Charles III's enlightenment, of the French Encyclopedists, of the Declaration of the Rights of Man. Equally loyal patriots in the forefront of the fight against the invaders,

they were if anything even more to the left of the much-vaunted program of stability and order the invaders were claiming to impose. Coalescing into a common Spanish resistance while the war was on, the extremes of these groups became hostile to one another once the war was over.

Ranged on the opposite side to these factions was a much smaller number of francophile Spaniards or *afrancesados*. They were also constitutional monarchists for the same reasons, though often of a younger generation, and they saw in Joseph not a usurper but a sincere reformer as a better alternative to the Bourbons. Convinced by what they thought was a permanent reality for Spain within Bonapartist Europe, they were also patriotic in the sense that they looked upon Joseph as the protector of Spanish national interests whenever he and his brother Napoleon were in conflict. Finally, there was the French army itself, and that tiny group of Spaniards associated with it whose jobs depended on total military victory by the forces of occupation.

Where Goya fits into all this is a complex question; and it might be convenient to begin by viewing him as a cross between a patriot liberal and a 'Josephist' liberal—between a supporter of resistance and a grudging collaborator in the middle of the spectrum, whenever resistance seemed to him self-defeating. Certainly his friends among the patriots fighting the occupation and his friends among the *afrancesados*, both tried to claim him as theirs; but the fact was that in being compounded of both elements in the struggle, Goya resulted in becoming actually a neutral—a neutral, that is, in the sense of being disgusted by war once he had seen it.

Such a despairing attitude was not unique to Spaniards. Europeans everywhere were faced with the same sort of dilemma, and one wonders how men like Charles James Fox or Beethoven, who welcomed the French Revolution at first, would have reacted if confronted by a similar violent situation right on their doorstep. There is scarcely a country that has not experienced foreign occupation and the competing issues it raises, France herself in World War II being torn by the agonizing choice of Nazi collaboration. The Paris of 1940 was the Madrid of 1810.

Another factor to consider is Goya's age; for he was already

in his mid-sixties by this date—an age when he could hardly be expected to knife a Franch soldier after dark unless he had a very good personal reason. Yet for Goya the soldier himself, regardless of side, became the omnipresent symbol of evil. In the darkness of destruction all around there is a haunting power in the pulsating figures he drew, whose angular postures belong to perpetrator and victim alike. It was as if he were a close impartial witness to a universal tragedy. And it was to tell men eternally not to be barbarians that he drew them.

Perhaps the nearest that Goya ever came to expressing positive loyalty was when he finished a portrait of Godoy with the inscription, "Out of love for the general good I love peace, but I accept no law which can give offense to my king."[1] But much water had passed under the bridge since then. The question now was, 'which king?' Was it to be a Bourbon or a Bonaparte who was to guide the destiny of Spain? Profoundly shaken by the events of May 2, 1808, when the Madrid crowds revolted against the French soldiers and thus began the war, he supported their cause but remained hesitant from the start. And subsequent events proved him right. For one year it was Ferdinand's cause that seemed to gain the upper hand, the next year it was Joseph's. And his whole ambivalence as a partisan is best understood if one looks at the war's rival royalist causes.

Though he remained a prisoner in France, Ferdinand was increasingly acknowledged as the legitimate king by the resisting patriots after 1808. Unsavory as he was, at least he was the heir to the Bourbon throne; and the various regional juntas that coalesced into a national central junta began to formulate rules of governance for the people with his eventual restoration in mind. Meeting first in Seville, this central junta then moved to Cadiz, where early in 1810 it handed over power to a regency council empowered to act in Ferdinand's name. Goya of course lived most of the time in occupied Madrid but was aware of what was happening outside the city, aware too that because of his people's diversity, Spain was a country that could not be easily conquered at all. Ferdinand in the meantime earned the somewhat dubious title of 'Desired King.' And here Goya would certainly see the essential contradiction of his predicament. For patriot that he was, instinc-

tively he had reservations about this prince from the beginning. He had first met him before his captivity by Napoleon, when Ferdinand was brusque concerning his portrait sittings. "Can patriotism mean support for one's own absentee prince, and an unreliable one at that?" he must have asked himself many times. And many Spaniards were asking themselves the same question.

Yet what was the alternative? Joseph claimed he would implement representative government along the lines Napoleon had proclaimed at Bayonne; but he could never muster much support among the Spanish people. Dubbed 'Joe Bottles' on account of his fondness for wine, ironically he was considerably more honorable than Ferdinand—hence Goya's sharpened dilemma—who did his best under impossible conditions to make himself popular with his subjects. He would walk casually about Madrid, strolling through its gardens often without an escort, and tried to make his regime as responsive to reforms as his means allowed. But however well-intentioned, he was simply the wrong king at the wrong time. He sought enlightenment for Spain, while his brother Napoleon sought dismemberment. As such, he would always appear as a puppet ruler to the majority of Spaniards. In a word, he became the incarnate symbol of French occupation. Sensing this, and without the authority or means to carry out policy as he wished, Joseph more than once threatened to abdicate. "He has carried the crown in his pocket, but cannot put it on his head," as the saying went.

At the start of the war Madrid was briefly in Spanish hands, and thus it seemed to Goya like everyone else that the patriots could win. Joseph himself did not enter the capital till July 20, 1808, when he found that the revolt begun in May was proving much larger than expected. The crowds were sullen, supporters few. Only two days before, moreover, French forces were routed at Bailén, east of Córdoba, when Marshal Dupont surrendered to General Javier Castaños with 20,000 men. It was Spain's biggest victory, disproving for the first time the invincibility of Napoleonic armies. Joseph was obliged to flee Madrid, subsequently setting up headquarters at Vitoria behind the Ebro River. Further French reverses followed. In an attempt to dominate this river and keep the road open from Bayonne to Burgos, an attack was ordered on Saragossa; but after heavy losses the French could

do no more than fight up to its city walls. As at Gerona they encountered the full force of Spanish fury, this time the city's 60,000 defenders—a number that about equalled the effective strength of the entire Spanish army (about half this figure in addition being still posted overseas). Needing more forces of his own, meanwhile, Joseph by October ordered the siege of Saragossa to be raised. And the hero of the hour was José Palafox, captain-general of Aragon and a brilliant resistance leader not yet turned thirty, who now invited Goya to see the ruins of the city.

Goya at this time had barely finished Ferdinand's portrait—minus of course Ferdinand. Pressed by Palafox to come that very week, he had to excuse himself to the Academy for not presenting it on schedule. He had been asked to paint Saragossa's devastation, "in which I make no apology for the great interest I have for the glory of my country," as he proudly put it.[2] But when he got there, his pride soon turned to horror at the sickening sights, the tell-tale orgies of destruction the siege had left behind—and Goya was a tough man. In his heart he viewed them as mindless testimony to war, not as dedications to a patriotic struggle, and he shunned approval whenever artists drew them in this light. As for his own sketches of the ruins, tradition relates that they were insultingly cut to pieces by French sabres in Palafox's own rooms.[3] Also destroyed were some pictures of saints he did for the little chapel in Monte Torero back in 1798, while still other works perished in the Civil War of 1936-9. What have survived are his subsequent reproductions of the scenes, along with his *Disasters of War* drawings and etchings begun in 1810. There were feats of heroism, of course, such as María Agustina's gallant handling of a siege gun (appearing as number 7 in this series of etchings), which is also referred to by Byron in his *Childe Harold*. And true to form, Goya subscribed money for Palafox's army.

But reckless courage seemed to him ephemeral, victory itself almost irrelevant when weighed against the terrible price his countrymen were paying. Moreover, this first siege was barely over when a second one began with stepped-up ferocity. Napoleon was responsible for it via Marshal Lannes, when angered by French defeats he personally invaded Spain in November 1808 with 300,000 men. Added to those already here, it was the largest ar-

139

my hitherto assembled in contemporary Western history. And Marshal Soult eventually became his senior commander—the ablest as well as the most ruthless of Napoleon's marshals in Spain. Meanwhile the noose pulled tight around Saragossa. Shortly before Christmas, Goya is believed to have witnessed French atrocities at Daroca about fifty miles to the south, and the anguish he felt during his probable visit to Fuendetodos where he was born can well be imagined.[4]

He was exhausted and resigned when he got back to the capital. Madrid had been in French hands again since December 4, this time under Napoleon himself who had forced his way across the Guadarrama mountains. But the Emperor stayed here only eighteen days. His brother Joseph then re-entered the city on January 22, having extracted family oaths of allegiance from the altars of the parish churches ordered precisely on the 22nd of the previous month. Of the 30,000 heads of families who swore fidelity to Joseph, Goya's name was among them. Despite old patrons and friends like the Conde de Altamira and the Marqués de Santa Cruz being deported to France, perhaps one motive explaining his action was the fact that members of the Inquisition were also being arrested on Napoleon's orders; and Goya had old scores to settle on this issue.

Elsewhere the news for the patriot cause was bleak; and this was not improved by the death at Seville in December 1808 of the president of the national central junta of resistance—the redoubtable Floridablanca. This supreme junta included several distinguished figures whom Goya had known and painted; and among its members were Archbishop Luis (Godoy's brother-in-law), Jovellanos, Príncipe Pío of Savoy, Francisco Palafox (brother of José, the hero of Saragossa), the Duke of Infantado, Pedro Cevallos (in charge of foreign affairs), Antonio Cornel (war minister), Francisco de Saavedra (treasurer) and Martín Garay (minister of state). Many junta delegates from the provinces were apprehensive when the Council of the Regency was drawn up in Cadiz the following year, lest its senior conservative members see eye-to-eye with Joseph at the expense of the new popular liberalism that was emerging regionally.[5] (It is worth noting that the political term 'liberal' is of Spanish origin). In other words,

the patriots were already becoming divided between liberals and conservatives, which boded ill for Spain when the war was over.

Saragossa, meanwhile, fell on February 20, 1809. This was indeed the darkest year in the fortunes of the patriots. Palafox was taken prisoner and was to linger four long years in a dungeon at Vincennes. The victorious Marshal Lannes reported that what remained of Saragossa was horrifying to behold; and Goya would have agreed. In other regions, outside of Valencia and the south, the French everywhere were winning. Even the British who had joined with the Portuguese in the common cause of resistance were routed at Corunna by Marshal Soult. And this paved the way for the great Duke of Wellington, who despite an early victory with General Gregorio Cuesta at Talavera in the summer, was to take his time before advancing with his 30,000-man army into northern Spain. In the patriot-held areas to the south and west moreover, things went from bad to worse. The once proud armies of Andalucía and Aragon that had been commanded by Castaños and Palafox respectively, soon crumbled after a crushing Spanish defeat at Ocaña near Madrid in November at the hands of Marshal Soult; and by the end of this year, the French had overrun all of Andalucía except Cadiz, where Castaños subsequently presided over the Regency. When Joseph entered Seville and Málaga, it was reported that this was the happiest time of his life.[6]

With the Spanish army in tatters, it was a ragtag force of guerrilla fighters that came to the fore, loosely cooperating with the Duke of Wellington as the allied commander-in-chief.[7] But the French now had to reckon with the lurking presence of these guerrillas who harassed them from every direction. Their sheer persistence was shaping a new kind of war—a war with resurrected ghosts who had quick knives, who seemed to pop up in the dark as soon as they had been shot down; and the national resistance they embodied became an inspiring example to the oppressed peoples of Europe.

But victory was a long way off. In the seeming hopelessness of an uneven struggle, Goya in the meantime took the view that it was better to survive quietly as an accredited member of the Academy in Madrid (like so many other colleagues), than as an outlaw elsewhere. An artist has to do his job and cannot always

be a chooser. As things stood, all exits from Madrid and its environs were heavily guarded by French troops. To reach the patriot-held pockets in the south with all the risks involved would mean deserting his family and friends, beginning a new uncertain life as a deaf and aging man among his fighting countrymen. He knew he could become a liability to them. But it was not a submissive philosophy that he espoused. He fought his guerrilla wars on canvas; and despite his handicap, he did propose escape, as will be shown later.

The fact was that two principles were still struggling within him—the liberal temptations of Bonapartism imposed by a foreign despotism on the one hand, and the patriotic ideal of liberation with an even greater despotism lurking behind it on the other. In a word, Napoleon's shadow wrestled in his soul with Ferdinand's. And he was unsure which to cast out first. In his secret moments he would not deny some measure of esteem for the well-meaning Joseph, albeit installed by force of arms. He must have felt at times that a peace under occupation that claimed to bring benefits to Spain's suffering masses was better than what seemed a fruitless war, in which no benefits could come at all. But these feelings were brief and pragmatic. Acceptance as a fact of life does not necessarily mean fixed ideological conversion. Much more inner pain was given on this score to his Spanish friends among the *afrancesados*. For they had made a clear-cut choice. Having renounced their own legitimate ruler, these believers in Bonapartism found themselves embarrassingly in conflict with the majority of their own countrymen. Yet to do otherwise and make peace with the patriots could only help perpetuate the very abuses they were seeking to correct. Having made their commitment in a war Napoleon was determined to win—abortively as it turned out—they were increasingly hoisted by their own petard. Perhaps Goya's double-think made more sense than it appeared.

Despite francophile friends like Juan Meléndez Valdés and Leandro de Moratín—the latter an interpreter and librarian under Joseph—Goya could swing closer to the view of his other great friend, the patriot Jovellanos, freed at last from jail in 1808, who refused all offers of cooperation from Joseph before his untimely death in Asturias by November 1811. Goya could never forget

Jovellanos, who always held that Spain's salvation could only be achieved through its independent efforts. And as a self-made bourgeois, Goya could sympathize with the middle-class idea of an elected parliament, or Cortes, which gained momentum as the struggle for independence proceeded. Even Joseph later subscribed to this view, but his conciliatory gestures in this direction were doomed to fail.[8] Liberal patriots were gaining influence by the month, and this would further impede whatever chances existed for an accord between Joseph and conservatives among the resistance.

At all events, Goya was not alone with his inner conflicts. Family could be divided against family. And the dilemma included Joseph himself, who in his vacillating way was at his wits' end to get his brother Napoleon to finance benefits for Spain instead of blindly trying to conquer it. It affected nearly everyone living under an occupation that never seemed to end; indeed it was not till 1813 that the last French soldier left Madrid. In the meantime, despite Joseph's pose as an ideal permanent monarch, Goya in the dark recesses of night knew by instinct that his countrymen were challenging this verdict. He had lived through so much himself, had learned so much. And he understood his people. They were as stubborn, as passionate and contradictory as he was.

* * * * * * *

It was perhaps his sense of belonging to two centuries and two ages, with the world caving in around him, that contributed to his growing feelings of detachment. Everything he had seen or imagined was combining to mutilate the social fabric as he had known it. Yet paradoxically, his relative isolation from current events was not an escape from art but a means of getting closer to art, in which his message need not be for an admiring public, but for himself alone.

Thus during these terrible years, he traced panoramas that could bypass the norms of conventional imagery. It was like a rehearsal for the great black depths that lay ahead. He was entering a world where no one had trodden before. It was not escapism nor betrayal of the patriot cause, but a subjection to life where unhindered he could portray his truth just as he found it. And

because this was interlaced with factual memories, his figures twist and grope convincingly with a compressed horrifying power. Gone was the broad expansive satire of the *Caprichos*. As he saw all the cruelty, the heroism, the devastation of his country, he moved to smaller canvases, as if to explain the failure of mankind in smaller human terms. It was man after all who had gone wrong, not the giant natural world; and even when there were grander conceptions on canvas—his *Colossus* towering above the chaos of fleeing humanity has sheer apocalyptic overtones—it was man alone, not the wrath of God, that had impelled them.

The medium was irrelevant. The harmless satire thrown at seemingly good women nursing their children, at impish priests or prisoners lost in trance, as with many of his drawings, is mild compared with what came now. Paintings too of serenely spinning women, of jolly drunken men, descend into eternal nightmares. The new horrors of war are limned in starker tones— of blacks and purples, ochres and greys—fired by a luminosity proceeding from their depths. The colors are laid on solid thick or else opaquely, with vivid brush strokes writhing into the figures of war that they portray. Like driven men his figures lurch into the limelight or remain hidden in shadow. The common denominator everywhere is violence. There are paintings of bandits and their atrocities, villages in flames, women fighting the soldiers, shootings and hangings, burial pits for the tortured dead. A solitary hurricane and *The Monk's Visit* seem like strange exceptions to the man-made evils. And running through them all, through all the scenes of rape and carnage, is a maddened outrage that points to madness itself. It leads to where reality and fantasy converge, to where the imagined becomes the unimaginable, the unimaginable the real, as sexual brutality is expressed in an unleashed world of cannibals who will mutilate their prey.

Here perhaps the most movingly terrifying painting ever drawn by human hand is his group of savages, of whom one is about to decapitate his ravished victim. The bound and beautiful woman whose tears in reflex go beyond ordinary cries for mercy is joined by the viewer in a common prayer that somehow the sadistic brute will spare her. It was as if Goya had no loyalties beyond what was man's deepest instinct to express. And here his

distortions have their poignancy. This was the world he saw, in which both sides of the conflict—good versus evil but mostly evil, resistance versus force but mostly force—competed in his dreams. For him the supreme reality was failure—in the senseless slaughter, the indiscriminate destruction that was shaping his cynicism and despair. Yet for all this, it is great art. This is because, tragically devoid of humanity as it is and reflecting man's darkest passions, this was how humanity was behaving. Fire and hell can move a man as much as love.

While nothing could expunge this raging inner world, his many-sided genius could encompass conventional subjects as well, when he could revert with ease to accepted professional standards. The public and the private facets of his art coexisted side by side. By 1810, with the occupation at its zenith and when he first began his *Disasters of War* etchings (discussed in a later context), he appeared as a normal citizen of Madrid going about his business. In outwardly conforming to the regime and the public images it presented, he became rather a public image himself.

In February 1810, for example, he was chosen by Madrid's city council to paint an *Allegory* in honor of 'Joseph the First'. That this appears collaborationist is in fact less so when viewed in relation to the long-standing acquaintances of his associated with this project. The council delegate who had selected him in the first place was a distinguished Peruvian, Tadeo Bravo de Rivero, who had sat for him in 1804. No doubt he asked him to do the work as a favor, especially since Goya and his assistant Asensio Juliá had taken part in adorning his house before the French invasion. A wealthy army man and connoisseur of art, this Peruvian had been in Madrid a long time and was a close friend of Admiral José Mazarredo (and family), whom Goya had painted as long ago as 1785 and was now a minister and commissary in Joseph's government. There was thus a common link between the artist and these two men. Moreover, the *Allegory* in question was hardly a sublime glorification of Joseph himself. Goya never was his personal painter—perhaps the most famous portrait of Joseph is that by François Pascal Simon—and he had to resort to prints to obtain his likeness for the oval medallion in the *Allegory*. It was in fact subsequently effaced, then restored,

then effaced once more according to the fortunes of war, thus reflecting the conflict of regimes that Goya had become resigned to. The word *Constitución* appeared in 1813 with the triumph of the patriot cause, but the famous date of May 2 commemorating the revolt of 1808 were the words that finally came to stay.

If pressure from friends was a probable motive behind this work, his desire to protect his academic salary (distinct from his refusal to become a government employee) explains his attendance at an Academy meeting in 1810. Here he would pay courtesy to its protector, the Marqués de Almenara, who along with Miguel de Azanza and General Gonzalo O'Farrill was one of Joseph's chief ministers. In looking at Goya's external attitude to the government, it should be remembered that old friends and patrons like Mariano Luis de Urquijo and the Conde de Cabarrús—*afrancesados* to the core but who, like all their colleagues, thoroughly opposed Napoleon's decree of February 1810 annexing Spanish provinces east of the Ebro—were also members of Joseph's cabinet.[9] Goya had been indebted to these men in the past. He could hardly avoid a nodding acquaintance with them now. But he was not in the quandary that they were. For apart from their embarrassing conflict with patriots, they were caught between two fires in their own camp—between the wrath of Napoleon on the one hand, and their genuine desire for a reformed but independent Spain under Joseph on the other. When Goya (along with Maella and Napoli) collaborated in such acts as selecting some fifty mediocre paintings to go to Paris, or swearing fidelity to 'Honor and the King' in March 1811 while receiving the Bonaparte insignia of the Royal Order of Spain—dubbed by Spaniards the 'Royal Order of the Eggplant' after the vegetable which it resembled—he could claim that these acts were more in the nature of civic or symbolic compliance than of any ideological conviction; and he was careful not to display his insignia afterwards.

But one francophile friend and member of Joseph's council of state who never hesitated to flaunt his insignia, was Juan Antonio Llorente, whom he painted at this time. And here Goya's conviction openly aligned with his. Llorente had been appointed secretary of the Inquisition in Madrid by Charles IV, and he

remained associated with it till Napoleon abolished it in 1808 during his personal invasion. When Joseph re-entered Madrid soon after, he gave Llorente authority over the records of the Inquisition which Llorente used for his highly critical history of this institution, first published in France in 1818.[10] There is no doubt that this renegade convert to enlightenment had a strong influence on Goya, for whom the Inquisition was like a red rag to a bull. But this does not mean that because Goya agreed with some of Napoleon's reforms or continued to paint other *afrancesados*, such as General José Manuel Romero (Joseph's minister of justice) or the writer Manuel Silvela, he could be classed as belonging to their camp. Less political than they, even less intellectual, Goya throughout his life understood the true nature of patriotism, even if their brand of persuasion differed from his.

This detachment from politics helps to explain why Goya could also portray Frenchmen with an easy conscience. He could see them as passing figures in the storm, paying their fee like anyone else, and no doubt would have accepted a commission from Napoleon himself if one had come his way. There was General Nicholas Guye (along with his nephew Victor), painted in 1810, who fought the patriots in a slowly losing war around Madrid. And among francophile women who sat for him were two youthful marquesas—Santiago and Montehermoso. The latter was reputed to be the lady love of none other than Victor Hugo who was in Madrid as a youth, residing in the Masserano Palace where his father Léopold Hugo was chief-of-staff to Marshal Jourdan.[11] The Marquesa's mother, incidentally, became Joseph's mistress when he fled to France. "Montehermoso's wife has an inkwell into which Don Joseph dips his pen," as the saying went.

* * * * * * *

Goya's acceptance of commissions from whatever side also stemmed from the need to provide security for his family; and his private affairs are here examined to shed light on another conflict going on in his mind. This concerns his attraction for another woman who came permanently into his life, together with his desire to escape Madrid. Whether the latter was a product of the former in a flight to 'find himself' as it were, must remain

speculative. But it should be stressed that however much he might be tempted to stray, in a practical sense he never ceased to consider his family's best interests.

Josefa's unsteady state of health needed constant attention; and there was his son and grandson to consider—Francisco Javier and Mariano, who lived not far from the Goyas' Valverde Street home. Gumersinda, it is recalled, was Javier's wife, and Goya painted her family as a group in 1810. Of these, Narcisa Baranaña's portrait is perhaps the most striking, with her black mantilla encasing a bright young face that borders on the sensual. And there is Juan Bautista Goicoechea, proud recipient of the 'Eggplant' Order of Spain, no doubt swelling with pride in the artist's non-committal presence.

But all was not well in Madrid. If civilians were becoming restive from an instinctive sense that the patriot cause could win, there was also the immediate fear of mounting famine in 1811 and it showed in people's faces. One can visualize Goya walking the streets taking note of all he saw. Interestingly, among his works at this time was a series of still-life scenes in a chop-house depicting such appetizing items as woodcock, duck, fish, fruit and a sheep's head, which were the only still-life scenes he ever attempted. Perhaps he was prompted to record these delicacies before they became scarce. At all events the climax of the famine came this terrible winter, when an estimated twenty thousand died from hunger and cold. Despite her relative comfort meanwhile, Josefa grew progressively worse. She died on June 20, 1812, at her home in Valverde Street in her early sixties, and was buried in the cemetery at Puerta de Fuencarral.

Josefa's suffering in these last years was actually less than in her earlier married life, when endless confinements and wranglings had been her lot. No doubt wranglings of a sort persisted thereafter, but these were no longer between her husband and her brother Bayeu, but between her husband and son. Javier was her treasure, as much as their grandson Mariano was Goya's. In her resigned exhausted peace, she could seek consolation in the material wealth her husband had brought her, in the happy moments they had shared here and there, and in the rites of the Church. But above all there was Javier with his promising family,

148

and their proximity to her was surely the true haven of her thoughts when the end drew near.

The main trouble between Goya and his son was unquestionably over the father's attentions to another woman—and quite possibly before Josefa died. This was Leocadia Zorrilla, a distant cousin of his daughter-in-law Gumersinda. It is not known how they first met. Presumably Goya was first introduced to her formally as a distant cousin of the family; or she may have simply caught his eye as a strolling *maja* in the loose wartime atmosphere of Madrid. In either case she would flaunt her attractiveness and outspoken opinions as a fiery young woman turned nineteen by 1809, and there is no doubt that the ever-observant artist, his heart and soul aching for companionship, would have responded to these qualities. About this time however, she married a watchmaker of German origin named Isidro Weiss. They had two sons, but the marriage was unhappy, and after the husband initiated legal proceedings against Leocadia in 1811 on grounds of misconduct, they finally separated in 1814. Her relationship with Goya, already intimate by this time, undoubtedly warmed even more thereafter. Indeed their affair caused further estrangement between father and son, perhaps explaining why they chose to live apart.

In this regard Javier had been handsomely treated in the family will that Goya and Josefa had drawn up on June 3, 1811 (and coming none too soon in view of Josefa's impending death). By its terms, implemented in October 1812, their joint inheritance was divided and bequeathed to Javier as their heir; and the latter now received the house in Valverde Street through rights derived from the mother. But Goya continued to live in it at a reduced rent payable to his son as landlord, while Javier himself kept on the house in Calle de los Reyes. Javier, moreover, received all of his father's art works that were listed in 1812. Eagerly he marked them with an 'X' (the initial letter of his name as spelled in Aragonese), probably to protect himself against any predator.[12] And this could include Leocadia herself.

Goya's portion of the inheritance included about 170,000 reales in money, jewels, and silver, and he agreed to all these arrangements possibly to seek independence of movement in the event of an escape from Madrid. The exact date when he is sup-

posed to have attempted this is unknown. Madrid was liberated in August 1812 (before being briefly reoccupied by the French four months later), so that patriot and British forces in any event would be close to the city throughout much of this year. Tradition has it that after his wife's death he aimed to reach Piedrahíta in patriot territory, but that Javier and his family tipped off the police authorities who threatened to confiscate the Goya effects unless he returned. Certainly under the conditions prevailing at the time he could not have got very far. And though he used the story of his purported escape as defense against collaborationist charges after the war, he was vague about the details.[13]

There were many temptations in any case to hold Goya in the capital. Perhaps he saw in women, Leocadia included, a release from his own grief and outrage. There were his beautiful portraits of actresses—Antonia Zárate and Rita Molinos among them— and of an anonymous woman asleep. He portrayed them in every walk of life, from prostitutes to water-sellers; but there were brilliant studies of men as well, from a knife-grinder to young workers in a forge. Indeed he felt close to all the people of Madrid with their processions, *cucaña* games, and masquerades, which transcended any warring allegiance. He even depicted an atmospheric balloon when the war was over, symbolizing perhaps, the escape he sought himself. Sometimes his racy sketchiness seems to anticipate Daumier, as much as his lively impressionism was to inspire Manet.

And here his most intriguing works are his famous *Majas Sitting by the Balcony*. There are two such scenes done some time between 1809 and 1813, each showing a pair of young ladies flanked by rather sinister-looking attendants.[14] It is thought that one of the girls in the second scene could be none other than Leocadia herself, who became his permanent mistress after the war. If this hypothesis is true, i.e., that Goya was personally inspired to paint her as an object of love, then he would have a possible reason for wanting to leave Madrid in her company.

* * * * * * *

Thoughts of Ferdinand in the meantime must have filled Goya with some trepidation by 1812 as the patriot side drew ever

closer to Madrid. The Duke of Wellington had at last broken the stalemate with such victories as Ciudad Rodrigo and Badajoz, which put Soult and Marshal Marmont decidedly on the defensive. And Spanish partisans everywhere were active. The tables were fast turning on the French, already weakened by Napoleon's invasion of Russia in June. The showdown came on July 22 when Wellington utterly defeated Marmont at Arapiles near Salamanca, and Joseph had to flee Madrid. Wellington entered the city on the same day that Joseph left it, on August 12, and the triumphant 'Duke of Ciudad Rodrigo' was mobbed by its inhabitants.

Now it was Wellington's turn to have his portrait painted. It is interesting to compare Goya's half-length of the famous general—cold, disdainful and proud, the ears set wide from the head—with Sir Thomas Lawrence's more flattering effort two years later—decisive, generous and bold, with handsomely proportioned features. They reflect two divergent styles, one Spanish, the other English, as each artist interpreted his mission. And the plebeian bluntness of Goya clashed with the aristocratic aloofness of Wellington himself as the two men allegedly almost came to blows over the portrait in the artist's studio.[19] Goya completed two other portraits of the Duke, one of them showing him on horseback for viewing by the public. This was indeed Wellington's great hour; and when he finally left Madrid, Goya's mixed feelings about him were surely clearer in respect of the great country he represented.

Accompanying Wellington in the triumphant parade was the redoubtable Juan Martín Díaz, known as *El Empecinado* or 'The Stubborn One.' With Castaños and Palafox he forms a trio of great heroes in the Spanish War of Independence. Outsmarting the French General Guye mentioned earlier, Díaz was never caught, and his powerful face and bright red brigadier's uniform make an impressive portrait when Goya painted him soon after the liberation. The celebrated Palafox also sat to him for an equestrian portrait after his release from captivity in France.

The year 1812 has a special significance in Spanish history, for at this time the great Constitution was proclaimed in Cadiz. Drawn up by the Cortes that had first met two years before under Regency auspices, it was largely the work of middle-class intellec-

tuals, as well as liberals with strong business interests in the Atlantic trade. Influenced by French and American models in an attempt to give rights to all the diverse elements in Spanish society, it consisted of 384 articles and was the most advanced document of its time in Europe. Based on national rather than royal sovereignty, it established a unicameral legislature with the crown having only a suspensive veto. It provided for indirect but broad male suffrage, along with provincial councils and uniform municipalities, and it imposed standardized direct taxes on property and business. Abolished also was the Inquisition, though Catholicism remained the state religion with its right to uphold some church censorship.[16] But inevitably there was strong opposition to it among many of the nobility, military, and clergy, who saw their authority being undermined; and the basis was laid for a bitter fight after liberation between those who supported the Constitution (like Goya himself) and those who opposed it.

As for Ferdinand, his hopes were rising as fast as Joseph's were falling. For in addition, Napoleon's empire was visibly shrinking from the disaster in Russia. And though Joseph was able to re-enter Madrid for yet a third time in December of 1812, the end came for him at Vitoria the following June, when utterly routed by Wellington and the patriots, he subsequently fled to France. In the chaos that spread to his ranks, his silver chamberpot was captured on the battlefield by the triumphant British soldiers.

Ferdinand's main interest during this long captivity at Valençay had been ecclesiastical embroidery. Now as Napoleon's envoys parlayed with him and released him early in 1814, his main interest was to restore despotism. On reaching Madrid in April, which he had not seen for six years, his first acts were to dissolve the Regency, arrest the liberal members of the Cortes, repudiate the Constitution, arrest collaborators and re-establish the Inquisition—all this from the 'Desired King.' Ferdinand was indeed a base man—selfish, revengeful, dishonorable and ungrateful. His one saving grace was his popularity as a 'peasant's man' among the masses and among his absolutist supporters in the army and clergy as well. But the result of his actions was to tear the patriot cause to shreds, as Goya feared.

Yet it was natural for a mere artist to cash in on the liberation spirit of the times, like everyone else. Already in February, Goya had informed the Regency, whose president was none other than his old friend Cardinal-Archbishop Luis (Charles III's nephew), that he would ardently perpetuate with his brush "the most notable and heroic actions and scenes of our glorious insurrection against the tyrant of Europe";[17] and for good measure, he pleaded assistance from the treasury to the tune of 1,500 reales a month. This was pure bombast in view of his already sufficient wealth, but in Spain one always had to plead penury to get things done. Moreover, he knew he had to clear himself of the stain of collaboration which would cost money. And as proof of his patriotism, he could point to his oil studies of the clandestine manufacture of powder and shot, and above all, to his great portrayals of the uprising that had taken place in early May of 1808.

A welcoming reception was given the new king by the Academy on July 8, 1814, which as court painter Goya attended. Commissions were later discussed, but Ferdinand never trusted Goya any more than Goya trusted Ferdinand; and the group of six regal portraits that ensued over the next fourteen months, most of them replete with imperial trappings along with sword or baton, were not personal ones of Ferdinand as such but works by Goya destined for institutions in places like Pamplona and Saragossa. The last time Goya had the doubtful pleasure of Ferdinand posing before him was the ill-fated portrait back in 1808, for which his fee of 9,000 reales, incidentally, was still being paid even now in belated instalments. Neither was Ferdinand disposed to give him much further patronage, remembering the artist's flirtation with his enemies; and apart from any other consideration, the country soon got into a deplorable state under his rule.

As Goya wandered through the forests of his imagination, he knew his path was leading him to where peace could never come. Yesterday it was Napoleon and Joseph who reigned, today it was Ferdinand. And the more of a liberal democrat he became, the greater his disillusion with all of them. Memory and foreboding alike closed in on him. Destruction beckoned from both the past and the future, constraining him as by a rite to consecrate more of its images to art. His graphic vision of war, like

his paintings, was once more terrible to behold—a warning to himself, an expiation, a private gift, a torment of the mind, things unseeable, things to be withheld from the world because the world could not live by terror for long. Nor was the reality he was exposing and his own aloofness due to any decline of his patriotism. It was precisely because of his love of Spain that he felt so much deep wound. His love of peace, his essential neutrality—as if he were looking at the world through a neutral-colored lens—meant aversion to all the cruelties committed in patriotism's name.

His disgust with both regimes along with their mob rule is nowhere better illustrated than in his *Disasters of War* drawings. Begun in 1810 and continuing over the next decade, they progress through the Napoleonic invasion to the Fernandine 'liberation', and in essence are an indictment of both. There are seventy-three sanguine and china ink drawings in all, which form the basis for eighty-two etchings and aquatints. Originally titled *Fatal Consequences of the Bloody War in Spain with Bonaparte, and Other Emphatic Caprichos...* they relate to atrocities inflicted on civilians, to the terrible famine that winter of 1811, and to the reaction under Ferdinand. The captions bear such scathing comments as "For this you have been born," "The Rabble" (where a francophile noble is being defiled by the mob), "This is worse," and "I have seen it" along with its sequence "And this also"—as if Goya were trying to tell the world he had seen everything. The last seventeen etchings clearly refer to the contemporary regime under Ferdinand, the present as it were taking over from the past. Ferdinand is depicted as an enthroned feline being advised by a huge ugly bird, climaxed by such poignancies as "Truth has died," "But will she rise again?" and "Ferocious Monster." Neither are the clergy spared. The last etching, however, rings an optimistic note during a temporary liberal upsurge in 1820 with its emphasis on hope, harmony, and toil, as two figures are cast in resplendent rays of light.

Goya refused to put his work on sale for obvious reasons—his etchings of French soldiers beating up their Spanish victims were begun during the invasion, while those of Fernandine reactionaries in the later *Emphatic Caprichos* coincide with Ferdinand's

own reign. Besides, he was reluctant to incriminate innocent friends like Ceán Bermúdez, who had a set of the *Disasters* in his possession. Goya entrusted the whole series to his son Javier in 1824, who subsequently sold the plates to the Academy. The latter finally published them in 1863 with the title *The Disasters of War*. But the reference to *Emphatic Caprichos* was omitted. These came too close for comfort where the Bourbons were concerned, even forty years later.

Not everything, of course, had been disasters in the forests of his mind. There were moments when he could find peace among his family—with Camilo, Javier, and above all with his grandson Mariano whom he first painted in 1810 and again five years later. Boys were his specialty in serener moments; and in recollecting boys such as Pepita Costa y Bonnels (who sat for him along with his mother in 1813 and whose grandfather had been physician to the Duchess of Alba), perhaps he saw glimpses of his own spent youth, his own past escapades. Then there was Leocadia. Now in her middle twenties and with much experience, she was far from the clinging vine of legend; on the contrary, she was fiery and assertive enough to inspire him with even more liberal dissent. And herein lay his problem which she seemed to bring in focus.

As a silent soldier on behalf of peace—believing that serenity has to be sacrificed when justice and constitutional progress are betrayed—Goya hitherto had hoped that peace might come once the people's will had triumphed. But what was the people's will? As a man of the masses himself, he was mindful of their contradictions, with their passionate concern for human rights as expressed in the Constitution on the one hand, and for human dignity and pride as expressed in conservative peasant traditions on the other. When Ferdinand entered Madrid in 1814, there were shouts for the preservation of feudalism. Too many Spaniards distrusted the nineteenth century, and with the horrors of industrialization that lay ahead, perhaps in some degree they were right. But this could not prevent the shifts of change that Spain inevitably had to face; and the consequent struggle between regions and classes was soon to rend the country with almost the same demonic force that Napoleon had brought.

Perhaps more acutely than others Goya sensed that represen-

tative government, which even Joseph had tried to implement, would be challenged by an uncompromising reactionary conservatism personified in Ferdinand, who yet had the rural majority of the people on his side. Does the will of the people mean what the majority wants, Goya must have asked himself many times, or does it mean progress regardless of numbers, imposed in what is clearly their best interest? And in the absence of a constitution, who would do the imposing if not Ferdinand?

Sensing that a monstrous hybrid war had led to a peace that was a sham, perverting both human rights and human pride, he gave up the fight by eventually leaving Spain altogether. As a silent soldier, he lost the battle for the kind of peace he wanted. But in his defeat he has given us a world with a warning—a world of strange terrifying images and limned with terrifying power.

For the biggest defeat of all, in Goya's view, was war itself. And his basic ambivalence toward the whole Napoleonic invasion is best summed up in his two great scenes when the national uprising began—on May 2 and May 3, 1808. There was first the assault by the crowds on Murat's Mameluke contingent in the Puerta del Sol; and then there followed the executions carried out by French soldiers on the hill of Príncipe Pío outside the capital the next evening. Goya is believed to have been near enough to get a glimpse of the two-day events; and it is interesting that a telescope was later found among his possessions.[18] The drama of street battle he virtually witnessed turns to bloodshed and horror in the second scene, both of which he depicted six years later after seeing a print of *The Third of May* done by a colleague and former sitter, Isidro González Velázquez. Here Goya has focused his massacre on the luminous silhouette of the condemned man with outstretched arms about to be shot. It is not militarily accurate. Nor was Goya's aim just to contrast the brutality of Frenchmen with the martyrdom of Spaniards. The real villain is war itself, not simply the soldiery that conducts it. The victim is everyone, not just the man about to die. And heroes there are none.

In imparting this concept with such striking effect, Goya was starting a new technique of poster-style antiwar pictorialism, with the popular revulsion it evokes. In our own nuclear-terrorist age, such a theme is familiar. And while admittedly it was interpreted

at the time as propaganda for an accomplished victory, for he painted both scenes when the war was over and the patronage of a liberated government had begun, the message is clear: alongside the patriotism lies a deeper expression of outrage at the universal insanity of war. The victory is impersonal. It is this facet of the message that Goya was trying to put across for future generations to grasp; and it has particular relevance for the world of today.

Patriotism, Goya might have reasoned, is a two-edged sword. It all depends on the ploughshare each can best bring.

ELEVEN
Into the Deaf Man's House

F erdinand VII, the 'Desired King,' soon lost his desirability. With the Cortes and the Constitution abolished, with liberals jailed and seignorial rights restored, his absolute rule with its series of incompetent cabals prevented any chance of a sustained national recovery. Even the Spain of María Luisa and Godoy was preferable to what loomed now. Ferdinand's restoration in July 1814 of the Inquisition's tribunal of the Holy Office—'it was thanks to this tribunal that Spain was not contaminated by the errors which caused such tribulations to other countries in the sixteenth century,' as the decree boasted—supplemented a more fundamental decree exempting the clergy from all forms of taxation; and along with the restoration of feudal dues and monopolies and of the now outmoded Council of Castile, such measures brought the country to financial and judicial chaos. And this spread to the armed forces as well. With no one certain, from captains-general down to sergeants, who was properly in command, soldiers everywhere would simply take the law into their own hands and run amok, impelled by local patriotism or plunder, but mostly plunder. As the national debt mounted catastrophical-

ly, and not without endless night arrests and military tribunals harassing patriotic liberals and ex-Josephists alike, Spain was becoming a bankrupt police-state ruled by terror. It was a tragic aftermath in a nation that had shed more blood for freedom than any other. Things came to such a sorry pass in fact, that even when the great powers were virtually willing to admit Spain to the inner councils of the Congress of Vienna that framed the peace settlement after Napoleon's defeat, Ferdinand's methods only put them off. His reaction was too much even for reactionaries. It would not be an exaggeration to say that Ferdinand VII's reign was the worst and most disastrous in Spanish history.

In the political spectrum, there were roughly three main elements—conservatives supporting the Fernandine reaction, liberals supporting the Constitution, and a more liberal-radical element among younger army officers discontented with the lack of all reform and with their low status and pay. By 1820, this included many peasants and workers as well, who while hating seignorial jurisdiction and fearing dispossession and unemployment, were discontented for much the same reasons.

In all of this the one faint gleam of competence rested in Martín Garay, who was appointed finance minister in 1816. A friend of Jovellanos and a minister in the central junta during the recent war, Garay made a valiant attempt at reform by imposing direct property and income taxes on all classes of people. But the mounting bankruptcy of farms and businesses, caused by the previous inept system of indirect taxation and by the corrupt cliques around Garay, had gone too far to make reforms effective. He was dismissed in September 1818, and the country headed toward a major crisis which took place in 1820.

Abroad too, the Spanish Empire was advancing to tottering ruin. Here the continued drain on the treasury was due to the endless military expenditures in trying to bring Spanish Americans to heel. Increasingly since 1810, these colonial subjects were fighting for independence from the mother country; having resisted Joseph, they had soon had enough of Ferdinand as well. And in the process it was symptomatic of the state of affairs that no one at home seemed very much to care, much less to want to enlist in the royalist armies. From a naval point of view also,

Ferdinand's policy of colonial repression proved equally unavailing as Russian ships bought at exorbitant prices could not even put out to sea. The Spain that Goya once knew, so rich and powerful among the nations, was reduced to a hollow shell because of an incompetent king, a regime devouring its own resources, and because of divisiveness among its proud and stricken people.

Goya for his part, while no aspiring politician himself, was soon involved in politics. As a court painter still on the treasury payroll he wanted his salary to continue; but however much the Academy supported him in this, he had to reckon with Ferdinand who distrusted him for his attitude during the war. His two *Maja* paintings, moreover, which had been found among Godoy's things, were still being held by the Inquisition. This awesome institution, restored by Ferdinand almost as soon as he got to Madrid in 1814, was only too anxious to prosecute; and as its emerging factions started vying for power, they zealously denounced not only Goya's francophile friends, but Goya as well. Thus the latter found himself charged on two counts—collaborating with the enemy during the war, which was tantamount to treason, and painting the naked *Maja*, which was tantamount to moral depravity.

His 'purification' case, which included his son, got under way by November 1814; and in preparing his plea before a panel of magistrates responsible to a special royal purification commission, he sought the aid of two friends to give evidence on his behalf. They were Fernando de la Serna and the bookdealer Antonio Bailó, whose wife Goya had painted before the war. Both men did a thorough job in defending his patriotism. They minimized the importance of his receiving the Royal Order of Spain decoration from Joseph, and made much of his intended flight from Madrid during the war, which, they contended, was only thwarted through fear of reprisals against his family by Joseph's police. Goya apparently won the first round in this indictment affecting the political part of his case.[1]

As for the morals part, the director of confiscations informed the fiscal inquisitor of the Holy Office secret chamber, Dr. Zorrilla de Velasco, that the two *Majas* were indeed by Goya, but that

his nude was really an imitation of Titian. This point certainly helped the defendant.[2] Indeed for anyone, even the prosecution, to show disrespect for Italian nudes could also indict the great Velázquez, whose own *Venus* had been so favored by Spanish kings.

In its final report of April 1815 to the Inquisition's so-called 'penalty chamber,' the purification commission reaffirmed among other things the stories of Goya's patriotism, such as his undertaking to paint the horrors at Saragossa, and played down altogether his painting of nude figures.[3] In thus clearing him of any taint, even in respect of his belonging to any subversive organization or Lodge, the commission prepared the way for his resumption to full status as a court painter; and probably his great work commemorating the uprising of May 2, 1808, was a further factor in his absolution.

Perhaps Goya had friends sitting on the panel after all. He was certainly far luckier than most. Purification trials were everywhere. With Leandro de Moratín and Juan Meléndez Valdés banished from Spain along with thousands of other liberals, with Maella dismissed and his actor friend Isidro Maiquez driven mad through his tormentors, Goya could derive but cold comfort from Ferdinand's singular generosity towards him. Despite a royal pay raise (boosted eventually to 50,000 reales by 1826, and worth about 550 pounds sterling), he was in the meantime outraged by others' suffering. He could still paint figures of Ferdinand, along with his cousin the Duke of San Carlos, for such institutions as the Imperial Canal of Aragon, whose director, incidentally, was Martín Garay, the distinguished patriot mentioned above; but he slowly drifted away from royal circles, and his final gesture to Ferdinand was a huge canvas in 1815 depicting a meeting of the bankrupt Philippines company, of which the King was a major shareholder. Among other figures appearing in the canvas were enlightened men like Academy secretary and minister José Munárriz, Indies minister Ignacio Omulryan, and penal theorist Miguel de Lardizábal, all of whom he painted elsewhere at this time. In other respects however, the various directors in the canvas look intensely bored by the proceedings. Perhaps Goya with his old mischief purposely stressed the disproportion between the high

ceiling and the rows of cramped figures ranged along the bare walls, as if to emphasize the decrepitude of Ferdinand's regime.

The following year he took part in a series of religious paintings commissioned for the Queen's apartments in the Royal Palace. Adorning an overdoor in a greyish tint, his work portrays St. Isabel of Portugal curing a sick person, which could be a discreet tribute to Ferdinand's second wife, the wise and moderate María Isabel of Portugal. But Goya's days of flirting with royalty were over. His last remaining tie was his need to continue his hard-won status as court painter on account of the salary that went with it; and in this respect Ferdinand did show appreciation by confirming this status whenever he afterwards requested it. Apparently the King liked his royal Goya portraits even more than Goya did.

As grievances welled up inside him meanwhile, enveloping his work in a kind of twilight which his disillusion engendered, he yet remained young in spirit while barely losing that vital maturity that marked his middle years. Predictably his mind continued along its multi-leveled path. A glimpse at his two self-portraits of 1815, one of them for the Academy, reveals a man in his seventieth year, withdrawn but discerning as ever, and with more than a touch of compassion for humanity. There is no decay of spirit but rather a resolve to brook no compromise with mediocrity, to speak his own dissenting message of the times. And apart from a profile view drawn in 1824 on his way to Paris, these are virtually the last self-portraits he attempted.

As for his deafness that forced him inevitably into a deeper inner world, at least it permitted him the privilege of being attentive to others only on his own terms. The love he felt was increasingly directed at younger relatives around him. There was his fond grandson 'Marianito,' whose pose in 1815 differs considerably from his portrait five years earlier, this time wearing a beaver hat as he stands by a piece of music. How Goya missed the sound of music and laughter. Perhaps while recollecting he could still tap out the rhythm of some *tirana* or *seguidilla* wafting up from long-vanished faces in the street below. Perhaps he would suddenly see Josefa sitting there by her boudoir with her eternal love of clothes, tugging at his heart-strings with her gentle patient

disposition and looking young as he once knew her.

But now there was Leocadia, whom he had seen many times among the strolling *majas* of Madrid. Divorced and at least forty years his junior, she was his triumphant mistress, companion, and housekeeper all in one. Yet she was of a different constellation from the other. More intellectual than dress-conscious, she had learned much from hardship, and the soulful exterior in her slight figure with the dark flashing eyes masked a lively intelligence that matched his own. It was a *quid pro quo* relationship—she grateful for the security of a home in which to sound off her opinions, he grateful for the services she gave him, and with a pretty infant daughter into the bargain. All this kept Goya young. He now had another family close to him, he no longer lived unbearably alone. Leocadia was a new light in his life. Neither age nor disability knows any limit to the pursuit of love, and artists especially have a way of attracting young women to their cause.

Her daughter's name was María del Rosario, and she was born on October 2, 1814. Though she is entered in the baptismal register as the daughter of Leocadia's former husband Isidro Weiss, it is just possible that Goya was the father. Whatever the facts, he became specially fond of little 'Rosarito.' She was born at 2 Mayor Street in Madrid, near which address he was known to sell some of his prints.[4] This suggests that he was intermittently visiting Leocadia around 1815 while still occupying the lonely family home in Valverde Street, now owned by his son. But this solitary world was not to last for long. We can assume that Leocadia placed ever more demands on Goya's time as he shuffled himself and his belongings between the two residences, and that only her ex-husband's existence blocked their chances for a socially acceptable relationship. Whether they would have married even had they been able to, however, remains uncertain.

Here in his studio full of memories in the meantime, he might put the finishing touches to some of his portraits, not all of which were done in his patrons' homes. As he himself could look sad and stern, so too the expression on his sitters' faces—restrained and mellow from the darker tonal brushwork as if reflecting his own past traumas. There was the composer Manuel Quijano from Catalonia and the engraver Rafael Esteve from Valencia, who re-

mained his friends for many years; and there was the tenth Duke of Osuna and his music-loving sister the Duchess of Abrantes. Among other female patrons was the distinguished actress Rita Luna, looking pensive in a rather ponderous setting that hides a fading beauty; while the Condesa de Baena who sat for him three years later in 1819, poses on a couch that seems almost a rarity in the austerity around her.[5]

His professional visits over, he would more keenly put the finishing touches to his drawings, some of them conceived more than a decade earlier. Leocadia would delight in them, stirred by his explanations, and one can see her smiling at their biting satire and amused by the political barbs behind so many of their titles.

These drawings would exhibit a variety of technique, from black, red, or white pencil to china ink and sepia wash, or increasingly sanguine; and here his experiments in etching would shortly extend to lithography. There was the lengthy Album C that continued until 1824 and which is discussed in a later context. Album D had long been laid aside; but Album E (the 'Black-edged') was already being completed by 1815. Early in this latter series there is an interesting adaptation of José Ribera's famous *Bearded Lady*, but progressively the titles lash out with quizzical malice at all the injustice inflicted on the innocent. "You know much and are still learning"—a theme Goya was to use again later—"Who triumphs? There's no one visible," "It doesn't do any good to whine," "Be careful of advice," along with captions to chained prisoners or starving beggars, increasingly reflect his *Disasters of War*.

Another album, with hardly any titles at all, is Album F, completed between 1815 and 1820. These sepia wash drawings focus mainly on man in dramatic situations and involve peasants, soldiers, duellers, dancers and monks, including exorcists. The rest are largely rustic scenes of pack animals or the hunt. There are also drawings outside any album framework, with themes ranging from condemned men in irons ("If he's guilty, let him die quickly") to elephants and witches.[6]

Much of this later work shows a hatred of Ferdinand's regime, from the Inquisition to all the iniquitous arrests, and Goya adds a private horror of his own. He had long been used to the theme

of executions. 'Let him die quickly' is the message conveyed on many occasions. And among his early prints, done in the late 1770s, is a figure of a man strangled by the garotte. Fortunately this form of capital punishment was not so prevalent in Spain as is generally supposed, and was considered in any case socially superior to a mere death by common hanging!

Constrasting with the private output of his albums are his published *Tauromaquia* or bullfight etchings, using aquatint with dry point and burin. The first set of thirty-three etchings fetched 300 reales in 1816, near where Leocadia lived in Mayor Street, and this no doubt gave cause for celebration. Conceived shortly after 1800, perhaps as a continuation of his earlier bullfight panels, these fifty sanguine drawings with a total of fifty-five etchings touch upon the history of the art from the beginning right through to the period Goya witnessed himself. The first etchings were intended to illustrate an edition of a book by Nicolás de Moratín on the origins and development of bullfighting titled *Carta histórica...*, but this idea seems not to have materialized. The later ones illustrate more recent performances by great bullfighters such as Pepe Illo and Mariano Ceballos (whose trick was to mount the bull itself), not to mention a bull's great performance in killing the mayor of Torrejón near Alcalá de Henares. They also play up brilliantly the importance of crowd psychology before the rhythm and fluidity of movement in the arena. All in all, the series proved popular and profitable. The ban on bullfighting imposed by Charles IV had been lifted since 1810, and the public no doubt sought an outlet under the repressive regime of Ferdinand VII.

However true it may be that art flourishes under political repression, Goya with his various crowd-scene paintings could hardly conceal his dislike of the regime and the censoring oppression that went with it. Thus his *Village Bullfight*, *Madhouse*, and other such scenes, from rollicking masqueraders under the arches to more sober blacksmiths, are complemented by his riskier *Tribunal of the Inquisition* and *Procession of Flagellants*. Such grotesqueries Goya apparently felt brave enough to dare before authority, perhaps because he was considered harmless now that his purification case had been laid to rest. At all events these last two works, as well as his *Burial of the Sardine* celebrating Ash

Wednesday (of which there is a related drawing), were believed bought up by his wealthy friend Manuel García de la Prada before being presented to the Academy. He was the same person who had sat for Goya in earlier happier days when he was a colorful theatre figure associated with the now banished Leandro de Moratín. Having enjoyed public office under Joseph, he fortunately escaped a sorry fate, and perhaps he and men of his ilk would see in such Ash Wednesday crowds a faint reflection of their own glittering past.

It is precisely the religious element that runs deepest in Goya's work at this time. There are paintings of a marriage ceremony, of the celebration of the Eucharist, a Mass for a woman delivered, an exorcism, another scene of flagellants, and a portrait of a Franciscan friar—all presumed dated between 1813 and 1819. To this can be added portraits of the apostolic-administrator of Quito, Miguel Flores, and Father Juan de Rojas, whose serious purpose matched their features. External events in some degree were shaping this direction; for on top of the tyranny of a government forcing men to search their souls, a severe famine in 1817 brought physical suffering as well. And in the general gloom Goya was no less caring for others.

His world was still a labor of love, not of hate. As all his people displayed their dramatic devotional frenzy, he could show them Catholic Christian understanding. The potion of superstition sometimes fed to them by ignorant but well-meaning priests coexisted with his own contemplation of the divine received in the traditional faith of his fathers. He viewed this incongruence dispassionately. Religion to him was a kind of palliative reserved for communicant and artist alike, to be accepted a-critically in a sacramental sense because it was part of nature; and from this coincidentally, he could derive his poetic fancies as well. But evil was part of nature also. As such, both light and darkness had an equal validity in his vision, especially as evil in the material world had triumphed. If his quest for an enlightened Spain had been thwarted, however, his quest for enlightened art had not. Even in his darker moments to come, his sincerity of purpose with all the spiritual truths it could uncover, never suffered an eclipse. It is this 'searching' part of his art—the hidden constant in all of

his religious experience—that gives it a mystery within the immanent transcendence that pervades it.

Something of this quality can be seen in his *Saints Justa and Rufina*. Painted for the Seville cathedral in 1817 during his last visit to Andalucía, this was but one of a series of religious works that echoes his great dome fresco in the church of San Antonio de la Florida done two decades earlier. These two sisters became patron saints of Seville after they had apparently supported the cathedral's great belfry when the structure was threatened by an earthquake in 1504. Goya's friend Ceán Bermúdez negotiated the commission with the cathedral council, which settled for a handsome fee of 23,000 reales. Though the work was condemned by many critics—the Conde de la Viñaza called it "the most profane, worldly and disagreeable picture in all the religious work of Goya"—time has withstood the charges.[7] The upward gaze of the two women beneath the shafts of light in an interplay of black and red and yellow is humanized by the fallen masonry around them and in the couchant lion fawning round Rufina's foot. Goya has wisely refrained from historical embellishment; the stress is on two pious beings—identical except that Rufina has the lighter hair—in whom sentience is fused with the amorphous, the ordinary with the sublime, which together contribute to his compelling style and technique. This of course was not new. The same trait of mystic humanism can be seen in his *Taking of Christ*, and in his paintings of the Virgin dating back to 1790 and 1812, and of various saints in general.

Andalucía had a curious effect on Goya, as if he were enchanted by its moons and demons. It was here in his young manhood that he indulged in escapades soon after his marriage. Years later it drew him into a stranger world of sickness and love, wherein the nearness of death and the closeness of the Duchess of Alba prepared him for the *Caprichos*. And it was from here that he now wended his way back to Madrid for even greater religious pictures, unaware of a deeper crisis and catharsis that his journey foreshadowed.

* * * * * * *

On February 27, 1819—the same year that the Prado was first opened as an art museum—Goya at last bought a home for himself and Leocadia from his savings accumulated since the liberation. Lying just outside Madrid, it was known as *La Quinta del Sordo*, or 'The Deaf Man's Villa,' and he bought it from a certain Pedro Marcelino Blanco. Its association with a deaf person originally had nothing to do with Goya and is pure coincidence, the name being derived from a previous occupier. Goya had seen this property before. Not only had he walked in the vicinity many times, probably as early as 1798 whilst engaged on his San Antonio frescoes, but it can be identified in one of his paintings of about 1812 showing two ladies reading a letter. Situated on the right bank of the Manzanares near the Segovia Bridge, it was a refuge from the noise and bustle of the city. Here with Leocadia and her daughter he could survey its twenty-three acres through the large windows of the long low-framed house he had renovated for them, with a new tiled roof. He could survey his kingdom at last, his very own parcel of land with its rising ground encasing a garden between the trees, along with an orchard, fountain, and pond.[8] Here he could potter about at will with a gardener to help him, or just sit in the shadows still warmed by the sun. Perhaps Rosario would be there with him, a dog sniffing at his heel, man and animal cooled by the evening breezes from the river, especially in high summer.

He was seldom alone in his villa, for Leocadia had a young son, Guillermo, living in, while Javier and Mariano were both near enough to visit him. Yet it was to prove the loneliest and strangest villa in any man's existence. For here he was to find demons in his soul like fellow-travellers in an endless journey of night.

But before the demons came, when a deep crisis overcame his being, he first achieved a religious power greater than anything he had experienced. Just as in former times he had stepped out of Andalucía to do great things, from the frescoes in San Plácido to the Christ in Toledo, so now it seemed a breath of the divine was preparing him for a new initiation. It is difficult to explain this crescendo of religion. Perhaps it came from happiness. Perhaps his new-found family affected him in a deeper sense than

he realized, deflecting him from horror at the death of Spain for a while and filling him with a sense of beauty at death itself.

This time it was *The Last Communion of St. José of Calasanz*. Seventeenth-century founder of the Piarist Order for the education of poor children, the Aragonese saint was to grace the new Madrid church of San Antonio Abad, consecrated on August 27, 1819. Goya finished the work that summer and he did it for a nominal fee, the Pía schools of Madrid doubtless reminding him of the one in Saragossa that he had attended as a boy. It was indeed a labor of love. And as he labored, surely he would think of Martín Zapater, of their mutual headmaster Father Joaquín, together with a host of friars he had met and painted down his lifetime, linking his boyhood and manhood to the old man he was now, with life in him still, with tremendous power to create impending death. The strength in his hands made death come alive. "Art breaks no bones while I have the spirit to live" he might have mused, as he studied the altar canvas he had finished at last, with its nonagenarian saint receiving the Eucharist from the bending priest, golden ciborium in hand, the boys' faces around catching some of the sanctity beneath the shafts of light and the tall grey arches thrusting into the blackness above. Of such stuff is great art made. Recalling Ribera, the effect is one of tonal majesty that blends with the dignity of the saint's approaching death.

His *Christ in the Garden of Olives*, also for the same church, has a similar quality, this time with a touch of El Greco and bearing some resemblance to the very first etching of his *Disasters of War*. With these two paintings, who could deny Goya's continuing love for Christianity and the Church? Indeed a mystical humanism could never quite desert him; it was an important dimension to his many-sided self, even as these two paintings were among his last and greatest religious works.

In other respects it was the death part of life that now concerned him more. This was not a death-wish but a premonition of a new suffering—his own and Spain's—that was forcing him to look ever inwards. Here at his villa on the outskirts of Madrid he could be far enough away to meditate or brood, yet close enough to be in touch with friends when he needed them, from church officials to personal physicians. By the end of 1819

he fell gravely ill. It is believed he was suffering from a spell of arteriosclerosis with rheumatic typhoid fever. At all events it was his worst illness since 1793, and only his miraculous enduring strength saved him once more. In the course of his agony he resolved to fight for survival; and the result was a striking painting of himself as a sick patient being treated by his physician, Dr. Eugenio Arrieta. Sheer force of will mixed with trust and gratitude toward his keeper brought salvation and another *tour de force* for posterity to wonder at.

Like the years following his great illness of 1793, this was a time when his work achieved a heightened mysterious power. There were more drawings and etchings, from the long Album C to the final *Emphatic Caprichos* of the *Disasters of War*, climaxed in the famous murals that emerged on his own walls. It was as if he were being pulled through a long black tunnel from which there was seemingly no escape. And to better understand this crisis, some comments are necessary about political events taking place at this time.

In 1820 an army uprising led by Major Rafael del Riego forced Ferdinand to restore the Constitution of 1812. Its causes stemmed from discontent among officers at their low status and pay, the postwar economic depression with accompanying financial chaos, and the incompetent rule of Ferdinand himself. The new regime at first was in the hands of moderate liberals who had gained experience at Cadiz during the Constitution's framing in 1812. Seignorial domains and separate church legal jurisdiction were abolished, along with the Inquisition, while church orders were put under state control with many of their monastic lands confiscated and sold. The country, moreover, was soon divided into more than fifty administrative provinces.[9] It was not long, however, before this 'triennium' regime of 1820-3 became polarized between moderate and radical elements. The latter who were termed *exaltados*, were pushing for more democratization at the city levels of government and for harsher measures against the Church, in which the Jesuits who had come back in 1814 were expelled for the second time. With landowners now joining the Church against what they viewed as liberal-radical excesses, with peasants fearing the breakup of their communal land rights, and

with workers smashing machinery for fear of losing their jobs as a consequence of some industrialization, a civil war was impending; and this gave Ferdinand his chance to exploit this widening breach in society.

Conveniently enough, France was anxious to play her role as a restored great power within the reactionary Holy Alliance framework that now dominated Europe. Backed by a decision taken at the Congress of Verona, French troops invaded Spain in April 1823. It was a far cry from the invasion of 1808. Now it was French conservative forces fighting *for* Spanish dynastic legitimacy, not against it, in face of Spanish leftist liberals; and supported by many peasants in the countryside, these forces captured the Cadiz fortress of the Trocadero in August, thus freeing Ferdinand from liberal control. The 100,000 'sons of St. Louis' and the Spanish 'army of faith' had done their work. But the ferocity of the triumphant reaction carried out by justice minister T. Calomarde exceeded anything that had happened in 1814, embarrassing even the French. With thousands of army officers, along with liberals and radicals, jailed or banished, many of them executed, and with nearly all the preceding reforms repealed, Spain was 'back to square one' where absolutism was concerned. The Inquisition too was subsequently restored before its final abolition in 1834. Riego's liberal uprising, moreover, marked the death knell of the Spanish Empire in mainland America; for in the process it had unnerved conservative colonial society in Mexico and Peru, which now joined the successful movements for independence.

The effect of this reaction on Goya can well be imagined. As a supporter of the Constitution, he had willingly sworn allegiance to it in 1820 at the last meeting of the Academy he ever attended. Now he had seen his hopes dashed. And the rebels who had used his caption to number 58 of his *Caprichos* as their revolutionary slogan—"Take it, you dog"—saw their hopes dashed also. Riego was shot in November 1823. And more tragically for Goya, because he had known him and painted him as one of the heroes in the War of Independence, Martín Díaz was shot two years later—a culmination of many executions which by this time had driven the old man into self-imposed exile in France.

Album C (the 'Diary') which continued into 1824, shows how

external events could fundamentally shift his outlook. Intermittently compiled over the previous two decades and done mainly in china ink with sepia wash, this album of 124 drawings moves from its *capricho*-like beginnings involving burlesque fantasies and distortions toward more strident criticisms of society, until by 1820 there is the inevitable parade of Inquisition and government victims of the Fernandine reaction. Then with the installed regime of Riego the satire briefly softens, before it lunges again at reactionary types in general, this time with violence.[10] The album's themes are all-embracing. There are jabs at mothers ("A good woman, so it seems"), at cripples worn by toil ("This is how useful men end up"), and at lazy or evil priests, as if religion itself had finally succumbed. While there is hope during the Riego regime ("Divine Liberty" and *"Lux et Tenebris"* showing Truth holding the Constitution), this soon reverts to a feeling of betrayal afterwards. Titles like "For having Jewish lineage," "What cruelty," "One is stripped forever," speak their own clear outrage. Elsewhere there are dialogues between the artist and Inquisition victims like Galileo or the sculptor Torrigiano; while a quizzical Divine Reason like an illustrative parody shows a goddess holding the scales of justice seemingly filled with bird-seed while she flails the birds! "Don't spare anyone," the caption reads.

Perhaps the most moving scene is one titled "For being liberal?" showing an imprisoned girl in chains. Indeed the attraction of this long series lies not only in its masterly progression into caustic strident satire, but in the attraction of the figures themselves. They are often images of the divine about to be warped by tyranny and vice, or else have already become deformities whose original pristine innocence can only be guessed. As usual, it is man who is both jailer and victim.

There were also his *Disparates*, meaning follies or absurdities. Covering a span of eight years beginning in 1816, these drawings like his other works reflect the vicissitudes of politics in the same sense that they were probably interrupted by the collapse of the liberal-radical regime in 1823, which plunged Goya into deeper gloom. They are among the more enigmatic of his drawings, comprising twenty altogether, and done in sanguine and red wash. From these, twenty-two etchings were made, some of them with

aquatint. They move into boundless dimensions of irrationality, where use is made of proverbs, literary texts, sexual and allegorical symbols and social satire. The *Disparates* or Follies are captioned with caustic comments accompanied by such epithets as "feminine," "of fear," "foolish," "flying," "furious," or "general." There is some emphasis on riding and circuses, such as a "carnival folly" and "folly of young bulls," in which there are scenes showing a woman dancing on her horse mounted on a slack rope, and a horse abducting its own woman rider. Other figures depart from the folly theme altogether, such as "The Despondency of Satan."[11]

The title *Proverbios* coexisted for a while with the title *Disparates*, and was so used when prints were made and sold by the Royal Academy after Goya's grandson Mariano presented the plates to it in 1864. But the latter title has triumphed. Some of them, incidentally, resemble the *Caprichos*. The second etching, for example, "Folly of Fear," shows a scarecrow-like figure that reflects capricho 52 ("What a tailor can make"). In this Folly, a priest impressed with his importance is as hollow as the tree he is dressed in. The *Disparates* also reflect uprisings against tyranny. "Recognized Folly," for example, shows a man who is brighter than his fellows in having seen through two sham figures of authority that are made of wood and cloth. Symbolizing despotism and reaction, they will strike at the bright young man in vain, for the latter will wisely fill his breeches with straw to avoid their blows!

Goya's works by now had become like a rehearsal for the great black depths that lay ahead. Religious themes would still cling to him—there is a penitent St. Peter and a militant St. Paul juxtaposed with a certain *Tío Paquete*—but these grandly human treatments in oil often descend to gloomier themes in a dozen smaller oils on tinplate and panel where violence can appear. Depicted among them are Joseph's tunic, a duel, an execution of a witch, along with a carnival scene and bandits killing their victims. They are related to the darkest moods he ever went through, climaxed by the *Black Paintings (Las Pinturas Negras)*. Like suspensions between time and eternity these left their mark on the Deaf Man's Villa.

* * * * * * *

The *Black Paintings* were executed in oils on plaster, appearing directly on the white walls of his house. Much use was made of palette knife and even fingers. They were painted on two floor levels—in the dining room downstairs and the reception room upstairs—between early 1820 and the autumn of 1823. Fourteen works emerged altogether—six downstairs and eight upstairs—some of them accompanied by additional sketches. Here they remained for fifty years, until in 1873 they were all transposed onto canvas at the initiative of Baron Frederick d'Erlanger, a banker who had bought the villa. After an unsuccessful exhibition of the paintings in Paris, d'Erlanger presented them to the Prado in 1880. They show other colors besides black—ochres and whites among them—but because this color predominates, the title *Black Paintings* has survived. Though they underwent some sloppy alterations on the part of restorers, each painting's original position in the villa has been reconstructed with a high degree of accuracy by scholars. Sadly, the villa itself was subsequently demolished to make room for a railway siding.

On the ground floor to the left of the dining-room entrance was perhaps the most intriguing of all these works. It is the mysterious black-veiled lady *La Manola* and presumed to be Leocadia herself, according to a young artist friend of Goya named Antonio de Brugada who knew them both well when he was in Bordeaux. Others see in the lady the Platonic ideal of poetry, like the soul of Prometheus. At all events her posture, while melancholy, is singularly arresting. Wearing a mantilla against a background of sky, she leans by a shoulder of what might be a billowy couch (some would have it a vault), which has a forelengthened effect as if extending actually into the room. Design and shape are suspended, as it were, in a kind of dream. This fusion of the poetic with the mysterious reflects many influences Goya had absorbed over the years—classical, Christian, baroque and the grotesque—including works by Ribera, the greatest Spanish engraver hitherto, whose famous etching *The Poet* Goya most likely studied. Some of all these qualities can be seen in the figures that emerged to the right of the dining-room entrance. Forming a sort of counterpart to 'Leocadia,' one of the figures

could be taken for Goya himself symbolically—an old man leaning on a stick. At his ear a monkish head gestures obscenely, like a demon tempting old age, perhaps suggestive of the mood underlying the entire work. Indeed the theme of an old man with a stick and other such postures are reflected in his Albums C, F, and G (the latter done in France), which could either be autobiographical semblances or parts of incidental groups he may have seen.

At the far end of the dining room to the left appeared *Saturn* devouring his child, recalling Rubens's work on this theme; while to the right appeared *Judith* at the beheading of the Assyrian general Holofernes—a subject which Goya repeated five years later. *Saturn*, along with *Judith*, are extraordinary expressions of male and female power. They could be subjective extensions of himself and Leocadia, though it might be bordering on the far-fetched to suggest that the devoured child symbolized the rejected Javier, and the executed general symbolized Leocadia's divorced husband, Isidro Weiss!

Facing each other on the opposite side walls were his *Witches' Sabbath* and *The Pilgrimage of San Isidro* respectively. The former shows grotesque crowds gathered round a devil in the form of a goat (or as witch-lovers might explain, a horned creature who is merely earth's consort); the latter depicts lost souls stalking the landscape with frenzied singers in the foreground. It is doubtful whether its place on the right wall had any symbolic significance. But strikingly, the haunted lost look of the people in both works points up their negative superstitious quality so markedly that, untypically for Goya, they are deprived of dignity as individuals. Perhaps his thoughts of the peasant 'army of faith' that supported the triumphant reaction in 1823 had turned his disgust into despair.

On the upper floor to the left of the reception-room entrance (looked at from the opposite end above the dining room) were figures of two old men eating; and it is conjectured that this was in the area where food was passed from the kitchen into the dining room below. Could one dare to presume that Goya was inspired by the delectable savors of bean and chickpea soups, of paellas and pastry wafting up the stairs? Interestingly, to the right of the entrance he depicted a dog, which was the sort of place where

a dog might easily roam if food were around. He may have started in this simple way, but the result was completely different. All that we see is the tip of its nose against a white-flecked body peeping above ground level in what appears to be a deadly suffocating sandstorm. Perhaps this animal, so immaculately dear to Goya, became a symbol of innocence, sacrificed like the people of Spain to some avenging fire (the tyranny of 1823?). At all events, he has seized upon a terrible compassion through the yellow colors of his rage.

At the far end of the room to the left appeared a group of figures reading, while to the right—a pair of women and a man laughing. Such themes again are reflected in his albums, especially Album F. Most probably he had seen such types in or around the neighborhood, perhaps among his servants. But here the rage has cooled to portray characters more convivial than the ghoulish figures eating opposite, as if digestion had brought on merriment and entertainment.

Finally, it was on the side walls of this upper floor where some of the most perplexing of these *Black Paintings* were to be found. To the left, two men were fighting with cudgels. This is straightforward enough, but next to this towards the door appeared his flying figures suggesting the Furies pursuing Orestes, with a fourth figure, bound, representing man—a work that has been variously titled *Atropos, El Destino*, and *Las Parcas*. To the right, facing the men with cudgels, was his *Holy Office* or *Pilgrimage to the Fountain of San Isidro*. With grotesque-looking inquisitors in the foreground, this possibly represents the punishment of man, and here no doubt Goya had Ferdinand's regime in mind. Next to it towards the door and facing the Furies pursuing Orestes, was his most mysterious work of all—his famous *Fantastic Vision* or *Asmodea*. It shows two flying figures—a woman attached to the back of a man, with the man pointing to some distant mountain. Some see in it a hermaphroditic quality in the two joined beings striving towards a Promethean promised land. Others see in it a facet of the demon from the book of Tobias pointing to a witches' sabbath. But as with many works in this strange assembly, no clear explanation can be given.[12]

Their fascination throughout is that the enigmas they hold

offer the temptation of a solution. But since they are enigmas, no solution is definitive, at least not without loss to their haunting mystery which is part of their power. Through the medium of irrationality, Goya has raised the ugly and the melancholy, even the obscene, to the level of great art—a much more difficult task than with beauty alone. Only his great experience enabled him to do this. With extreme subjectivity, moreover, he has succeeded in creating works that postulate some association with an external world. They are not sheer symbolism. But it is doubtful if any coherent thread runs through any of them that can point to the key of their unraveling, even if he intended this originally. The figures can be smiling skulls suspended between life and death, in spaces great and small and lacking any common denominator. Greek mythology, ancient history, Spanish legends, often with moral and allegorical overtones or current satire, all pour out their visions disjointedly, with compassion or invective, as if each perspective came from separate compartments in Goya's brain. If there is any link at all, it is his mood of despondency and deep despair, not because of anything innate within himself or remorse at his own condition, but because of man, especially the condition of Spain, which his inner crises had revealed to him in sharper tones. His brooding has been shaped by political events, his mental state fractured in their wake.[13]

Certainly it must have been gloomy in these rooms on wintry evenings. But what if the sun shone? How less gloomy, then, the blacks and yellows in the airy light? On the walls around him, like parapets of one's castle, he had discovered new dimensions linking the ancient fresco with the modern mural. Fantasy, hallucination, nihilism, comedy and terror—he had used them all to bring the inexpressible to solid shape, like a visual philosopher probing through dreams to reach an other-worldly universe.

"Fantasy abandoned by reason produces impossible monsters," Goya wrote while composing the *Caprichos*. By freeing reason from its chains, as here, allowing it to walk away, he has produced the monsters, and the monsters have become the mind of man.

TWELVE
The Exile at Bordeaux

In September 1823, Goya decided to make over the villa to his grandson Mariano to avoid its possible confiscation by the government. The *Black Paintings* came to an end. So did an epoch in Goya's life. Encouraged by Leocadia, he was forming a decision to get out of Spain altogether. He would go to France where Leocadia could later join him.

With Ferdinand back in the saddle once more, the revived reaction of 1823 was too much for Goya to stomach. The purification trials, the military tribunals, were hard at work again. And his own association with liberals that had already tainted him in the eyes of the government, combined with fears for the safety of his family, were further reasons that prompted him to action. It was also a fact that Leocadia's son Guillermo had joined the now discredited militia under Riego, and surely they were being watched. Though Goya's fears were probably exaggerated, we cannot blame him for his attitude. He had seen enough. Yet his decision to leave was taken only after a long inner struggle. To opt for exile meant pain for any Spaniard, as for an ancient Roman. But in doing so he was only following thousands of others, who unlike him were denied the luxury of a choice.

The scene of the departure from the villa is not recorded.

But easily imagined are the final glances at his incriminating drawings and wall paintings, and more tangibly, the concern about what to do with the family. Little Rosario, now just nine years old, was sent to stay with architect Tiburcio Pérez y Cuervo, who along with a related architect, Juan Antonio Cuervo, had recently been painted by Goya; while he himself sought refuge with an Aragonese priest, Father José Duaso y Latre, a former royal chaplain and another recent patron. Other sitters at this time were Ramón Satué and María de Puga, whose husband served as witness when Goya handed over legal powers of attorney in a deed of February 1824 to collect any court painter's salary due from the treasury.[1] He was leaving nothing to chance in the course of his plan to emigrate.

The immediate problem was getting out. But within three months, as Leocadia doubtless commuted between Goya and her daughter bearing the latest news, came word of an amnesty signed by Ferdinand on May 1. Prompted by Leocadia, Goya saw his chance. Pleading ill health so as not to lose his salary, he received a six-month permit to take the mineral waters at Plombières in the Vosges mountains; and he duly crossed the frontier towards the end of June.

But Goya didn't go to Plombières; Lorraine was very far away. Instead he went to Paris, stopping over three days in Bordeaux where he was taken care of by his old émigré friend Leandro de Moratín, who was subsequently rewarded with a portrait. And Manuel Silvela was on hand to greet him as well. He arrived, as Moratín recounted it afterwards, "deaf, old, slow, and weak, without knowing a word of French and without bringing a servant (which he needed more than anyone), but so happy and desirous of seeing the world. He was here three days, two of which he ate with us in the capacity of a young student. I advised him to be back by September and not delay in Paris, otherwise he'd be let in for a surprise on account of the weather, which could easily finish him off..."[2] His principal concern on arriving in Paris, Moratín went on in writing these words to his friend Juan Antonio Melón, should be never to go out except in a carriage, though he doubted whether Goya would agree to such a condition. Melón, who had known Goya well in Madrid, was a long-

standing correspondent of Moratín, and had kept him informed about the state of Goya's health before the latter's emigration. He had also presented the artist with a copy of the posthumous works of Moratín's father, Nicolás.

Goya apparently heeded Moratín's advice in not dallying too long in Paris. But nothing could dissuade him from seeing the great city on his own terms, when he was nearly eighty, just as he had seen Rome as a young man. He stayed in a hotel at 15 rue Marivaux, where he was helped by two friends named Arnao and Ferrer. González Arnao was a lawyer who had made the plans for his journey; Joaquín de Ferrer, who had been in Spanish America, was a politician having once served as an elected liberal in Spain, which was enough to damn him in Ferdinand's eyes as with thousands of other exiles. Along with his wife Manuela, Ferrer had many sittings with Goya in Paris. They commissioned his famous *Suerte de Varas* bullfight scene, as also it is believed, his striking *Death of the Picador*, a drama of blood and sand truly come to life.

The money Goya earned from his commissions was a welcome relief to an old man stranded no longer in a strange city. Now he could view Paris with a greater peace of mind. He could roam through its streets and squares, observing the new gaslights as he emerged from the shadows, watched in turn by the French police who yet could find nothing subversive about him whatever. (Not only was he deaf, the police reported, but his French was too excruciating to cause any trouble!). Whether with friends or alone, he would surely view the works of Géricault and Gérard, or those of Ingres, Delacroix, and Lawrence in the Paris Salon, muttering now and then, *"no es eso"* (that's not it). And prompted by Ferrer, he would study the latest techniques in lithography. Here he would recall, perhaps, his first effort in this field five years before in Madrid, when *An Old Woman Spinning* first emerged in the workshop of their mutual friend, José Cardano. Now it was the Vernet brothers, Charles and Horace, who would teach him all the latest tricks in this skill. More importantly, among his friends was Martín Miguel de Goicoechea, father of his daughter-in-law Gumersinda and whom he had painted in 1806 and 1810. As a wealthy merchant he was able

to help him considerably with his affairs after their return together to Bordeaux.

* * * * * * *

Arriving here in September 1824, Goya was joined at last by Leocadia with the children, Guillermo and Rosario; and the excitement of their meeting over, they settled at 24 Cours de Tourny. Goya soon began to correspond with Joaquín de Ferrer. He mentioned his study of miniature, and in praising Rosario for her keenness to learn the same art expressed the hope that Ferrer would take her under his wing in Paris. "I should like you to regard her as if she were my own daughter," he wrote.[3] Over the next few months in fact, he himself produced a delightful set of forty miniatures on ivory, many of them unfortunately lost. They cover a wide range of figures treated in a light vein, from *majas* and lunatics to lusty men and men grown old, in which the laughter of a Falstaff runs through them all. And not excluded is his pet subject—a dog being deloused.

He was not alone in his self-imposed exile. To Moratín, Silvela, and Goicoechea can be added Antonio de Brugada, who together formed a coterie of Spanish liberal exiles clustered around their artist. What a feather in their cap to have him as one of theirs! Here in Bordeaux, in the café along rue de la Huguerie run by Braulio Poch, this little group would forgather to discuss politics and literature, dreaming of the day when Spain would have a constitution again. And Goya would watch them, as if understanding every word. He would peep at them from behind his newspaper, nodding his thoughts in between sips of chocolate, ensconced in his favorite chair like an ackowledged king among them. Soon in his russet frock coat and trousers, frilly shirt with huge cravat, eye-glass dangling from its ribbon, he would look the perfect cosmopolitan. And with his white hair protruding beneath the latest brimmed top hat (instead of his accustomed travel cap), he took on a resigned air of distinction. But these impressions were deceptive. *Afrancesado* as he had surely become in at last admiring the best principles of the French Revolution with the others, he yet remained a Spaniard to the core who turned his thoughts longingly toward Madrid.

Tragically his homeland was in a mess, internally rent from its own wounds. No longer could this be blamed on foreigners; Spain had to answer for herself, polarized as she was between regional and societal divisions which a more cohesively developed middle class might have avoided. And Goya who loved his country more than anyone, was now separated from it not because his love had lessened but because he could express it more freely from a distance. Consoled as he was by compatriots around him, he aimed to return nonetheless, and was soon to do so on two occasions.

But meanwhile he had to clarify his position with the Spanish government. His permit being due to expire, he now sought the help of his son Javier in petitioning Ferdinand for a six-month extension. This time it was to take the waters at Bagnères, which lies in the Pyrenees region and was more accessible than Plombières. His real motive, of course, was to protect his court painter's salary, while he eked out his living in Bordeaux. It was a bad winter that Christmas of 1824. A weaker man might have succumbed. But strong as Goya was, with a warm hearth to sustain him, he yet at times showed the mean temperamental side of his nature—finicky, fretful, and as penny-pinching as ever. He was scarcely considerate of Javier. Despite his expressions of regret at not seeing him, one suspects from his letters that he rather took him for granted, resigned as he probably was to the hurt he had given his son over Leocadia. Javier was there to transfer money from his salary and estate, Goya's main motive in any case being to provide for his grandson Mariano. He was fearful about not having enough money, but his fears were unfounded; he could easily survive from the sale of his works. We can understand, of course, an old person's concern in this regard, but he was touchy about other things as well. And as he badgered Javier to get on with the business of his extended permit, he seemed obsessed by the motive behind what he was doing. For in the same breath he could write that much as he loved the people of Bordeaux, this was not sufficient reason to abandon his country.[4] The stubborn contradictions in his nature had returned. He wanted to live, it seemed, in both France and Spain at the same time. And Moratín noticed that his relations with Leocadia were getting rather strained.

If their arguments were due to the uncertainty of their legal position, the tension must have eased when early the next year Goya's application was granted. For a time during the first half of 1825, there was peace and harmony, with Goya obviously enjoying the good food and wines of Bordeaux as he basked in its tranquil climate. But following an illness, the old restlessness returned. Indeed the nearer his second permit got to running out of time, the moodier he became. Despite his physical comfort, Moratín noted that "at times he gets it into his head that he has a great deal to do in Madrid, and if they'd let him he'd be on his way astride a dark chestnut mule, replete with cap, cloak, walnut stirrups, wine-bag and saddle bags."[5] Moratín would resort to such images for anyone who had become a hopeless case!

Then finally came the good news that Goya's application to continue living in France had been granted. This time it was for a whole year beginning in the summer of 1825, thanks once more to Javier's efforts, the approval being given rather resignedly by Ferdinand and his ministers who must have been getting tired of the very mention of the renowned artist's name.[6] But by now Goya was no longer feigning ill health. He did suffer that past spring from a severe bout of bladder problems complicated by a perineum tumor; and genuinely needing rest and recuperation, he had actually forwarded via Javier the proper medical certificates to the authorities.

With his customary rejuvenation after an illness (and jubilation at getting another permit out ot Ferdinand), Goya in his serener moments set about zealously studying new techniques in art. Just as he had worked with miniatures on marble, so now it was lithography on stone, impressed as he was with its polished finish. The result was his famous *Bulls of Bordeaux* of 1825. The four original drawings are titled "The American Bullfighter Mariano Ceballos," "A Brave Bull," "The Diversion of Spain," and "The Division of the Plaza." From these Goya made fine etchings, and a hundred copies were run off by the printer Cyprien Gaulon, whose portrait he also drew. Through a process of rasping by which dark areas on the stone alternate with lighter grooved streaks, the emerging figures are more realistic and down-to-earth than in his previous work. Yet they reflect his tinplate paintings

of 1794, his *Tauromaquia* etchings, and bullfight scenes done in Paris for the Ferrers. They are a kind of finale in his life, even as they evoke some of his earliest memories. He remarked to Moratín in October of this year, 1825, that he had fought bulls in his time, and that with a sword in his hand he feared no one.[7] Perhaps he was thinking of his journey across Spain bound for Rome when he was a young man.

These etchings on stone were a success in France; and had Goya pursued the matter he would have noted that his *Capricho* etchings were also enjoying a clandestine circulation. As it was, he informed Ferrer that he had long since left the *Capricho* plates in the care of the royal calcography authorities who had the copyright, and he seemed to imply he had other ideas for their improved sale in the years ahead.[8] Though these plans never materialized—he was rather losing interest in them by this time—it was nonetheless in France, not Spain, where his *Caprichos* first won full recognition.

In the autumn of 1825, Goya rented new quarters in rue de la Croix-Blanche. It was a cozy detached house, newly built on a north-south axis where the light was good for his drawings, and with a little garden. Peace reigned again, intermittently. Indeed Goya and Leocadia could be seen going out together, sometimes to attend some local entertainment. And a common factor for both of them was undoubtedly Rosario. Now fast growing up, she would delight to play in the garden, and Goya adored her, calling her his "Mariquita" or lady-bird. She was a ray of sunshine to an aging man, as she followed him around taking a great interest in his artist's things, as children are wont to do. And when Goya taught her how to draw, she warmly responded, and with an aptitude she also displayed for the piano. She was a lively intelligent girl, excelling in parlor games, and Moratín noted that she would chatter in French like a woodlark, sew, or run around amusing herself with local children of her own age.[9] She delighted her mother also, who seeking a refuge from her many chores, would break out of her sultry mood and join in the fun.

In his calmer moods Goya continued his drawings, including Albums G and H which extended into his final years. Album G (also known as the 'Bordeaux') is worked with a soft thick

lithographic pencil; and perhaps as he sketched number 54 in this series—an old man leaning on two sticks (*"Aun aprendo"* or "I am still learning")—he would think of José Cardano in Madrid or the Vernet brothers in Paris who had taught him so much. Goya indeed never feared to learn from others, even in old age. There are over fifty drawings in this album, transforming what he had seen in Paris or Bordeaux into dream-like fantasies in motion— madmen and performing animals, giants and flying dogs, a guillotine and raving ducks, as if all animate beings, from the queerest creatures to the condemned, had frenzied common souls. Yet inserted in this Platonic-fetishistic world is a Holy Week celebration like a Spain still beckoning.

Indeed his last album of all, Album H, begun in 1824, has a distinctly Spanish flavor. Often lacking titles altogether while more numerous than in the preceding albums, these drawings sometimes show his signature for lithographic reproduction and they represent an advance in his technique. Flying themes recur (including one on Daedalus), along with children, weddings, witches, and old folk squat and bow-legged as in *The Bulls of Bordeaux*, all interspersed with tame serpents or crocodiles; but characteristically there are monks (one of them with a guitar) and *majas* (one of them with castanets), as well as scenes of violence and bullfight incidents. Perhaps one day this will be called the 'Spanish' album.

Nostalgia was at work again. He longed to see his son, and fretted whenever he received no word from him. This time his affection was sincere; certainly his fretting had more reason. For Martín Goicoechea, his loyal relation and the one friend he could rely on to patiently handle his affairs (such as ensuring his legal receipt of the money Javier had been sending over from Spain), had died in June 1825. Goya felt bereft and helpless. One is reminded of Juan Goicoechea in earlier years, along with Zapater, Yoldi, Pirán and all the rest who had helped him with his family affairs at Saragossa. Impatient with paperwork as always, he would again appeal to friends around him; and among these was a local banker named Jacques Galos, painted in March 1826, who now stepped into Martín's shoes as the artist's confidant. But despite such firm assistance, Goya felt the need more than ever

to discuss family affairs with his son in person. Madrid, like Album H, was beckoning still. And this time he resolved to do something about it.

There was panic of course among his family and friends. They were used to his moods whenever his permit was due to run out, but this time that gleam in his eye told all. Already he had made some snide but harmless remark about the French, which was his cantankerous way of telling everyone that he intended to leave them for a while. We may forgive his lack of charity towards his hosts. In actual fact he liked Bordeaux and its people and he was generally treated with courtesy by the French authorities. But by May he had fully decided on Madrid to straighten out his status with Ferdinand once and for all. Moratín, as usual, resignedly prepared his journey. The latter wrote to his friend Juan Antonio Melón, informing him of Goya's plans to travel alone and that he ought to congratulate him on arriving should he be lucky enough to avoid any mishap on the way; should he not arrive however, Melón needn't be surprised because the least misfortune would soon leave him a stiff corpse in the corner of some lodging![10]

Goya got to Madrid that summer of 1826. He was tough and persistent as ever. He stayed here two months, during which time he sat for Vicente López, Ferdinand's favorite court painter. It is a fine portrait, academic and traditional, and differs in this respect from Goya's own later portraits with their severe tonal effects. This was a step toward bigger events, for on June 17 he received word that his request for a permanent pension based on his court painter's annual salary of 50,000 reales had been granted, and that he could return to France at will for reasons of health.[11] This was triumphant news indeed. The question of extending his salary had long been moot; now the government had at least concurred, this time apparently without strings. Magnanimous as all this was on the part of Ferdinand who had trounced all his enemies and thus could afford to be generous, the fact was that not even a king would want to defy public opinion and withhold tribute from a man who had served not one, but three Bourbon kings in the course of his long career. There was also the more practical consideration, noted officially, that the 50,000 reales

salary wouldn't last long because the recipient was so old!

It was with an immeasurably lighter spirit that Goya travelled back to Bordeaux. He was happy at having seen members of his family, his pension confirmed, his freedom of movement clarified. It was literally like money in the bag. Despite deteriorating eyesight and pain in his finger joints which another harsh winter in 1826–7 did nothing to assuage, his uncrushable will continued to sustain him. As friends passed in and out of the light in his home to offer their appreciation—and one can see Rosario peeping at his sketches under the master's close eye—there were still more works flowing from his brain, still more sitters, and new resolutions as well.

Incredibly, he visited Madrid once more, in 1827, as if he was thoroughly at home in two countries.[12] Here at the age of eighty-one he gave his full attention to his fond grandson Mariano, now turned twenty-one, who proved a spirited if highly-strung scion of society. Mariano could do no wrong in Goya's eyes— perhaps he saw in him the perfect fulfillment of the gentleman he would like to see in his descendants. And he now painted his portrait for the third time, giving him all the vitality proper to his youth. A dimple subsequently appeared on his left cheek in the picture, but this was not an admiring tribute on the artist's part, for many years later it was found that it was entirely due to a fault in the canvas. Chance plays strange tricks with paintings. A view of the Corsican coast for example, done by the great British portraitist and landscape artist Edward Francis Wells (1876–1952) in about 1910, shows a perfect sailboat in the distant water which was caused by a fortuitous chip![13]

Goya met many friends in Madrid. Among them were Rafael Esteve, who had sat for him in 1815, and probably Juan Bautista de Maguiro, a Navarrese banker who became his new confidant and secretary. There was a personal reason for Maguiro's role in Goya's life, for in virtue of his marriage to Gumersinda's sister Manuela, he became the husband of Mariano's aunt, which was enough to win grace in the artist's eyes. And the resulting portrait of Maguiro in his bourgeois frock coat and trousers is one of singular gaiety and brightness, like a farewell to the gloom Goya had known for so long. Indeed he felt very much at ease in

Madrid, as if an airy youthfulness had stolen over him for the last time. And as he greeted the ladies of the season and the fashionable men-about-town, he seemed like an institution himself, safe at last from the prying eyes of Ferdinand's government.

Even Ferdinand seemed to have mellowed a bit in his last years, as the triumphant absolutist began to court the bourgeoisie. This was not, of course, in the interests of any meaningful progress, but mainly because, confronted by a wave of reactionary fanatics who made their presence felt from Catalonia to Navarre, he feared losing the support of the French in fighting the liberals. And we see him at the end of his reign before his death in 1833 chiefly concerned to preserve his dynasty on behalf of his surviving infant daughter.[14] Ironically after his death, his very allies among the upper clergy received a devastating blow when their representation in the Cortes of 1834 slumped from nearly thirty members previously, to five. For the *exaltados* of the Triennium days, now termed *progresistas*, had joined with the middle classes and urban militia to censure the new government; and in the process, reactionary fanatics among the Carlist pretenders to the throne provoked a backlash, which gave the anticlerical forces their chance to wreak vengeance and temporarily to weaken the Church.[15]

But all this lay in the future. As for Goya, had he survived into the 1830s he might have been tempted with his stalwart liberalism to return to Spain once more, there to end his days in his native country.

So long as he had breath in him meanwhile, he sought to entertain the Muses to the end. To this final period belongs a series of striking images which have their customary mysterious appeal. There is a male sleepwalker lost in a kind of trance, a friar with a crucifix, a Titian-like head of an old man pensively looking down, reputed to represent St. Peter, and two studies of anonymous young women. His style shows a synthesis of form and character, with light and shade crowding out multifarious detail, and usually with a minimum of color. Yet Goya could break out into color when he wanted to, as he roamed the pathways near his home back in Bordeaux, absorbing the scenes

of a rural pre-industrialized France that passed before his eye.

In the last months of his life he might be seen touching up his Album H sketches. He was dreaming of Spain of course. Not even Bordeaux with its wines, its pleasant climate and people could turn him into a Frenchman. Increasingly at siesta time his thoughts turned to his family, when images of his son and of the Madrid they once shared closed in upon him. He reached a point when a letter from Javier would make the days tolerable.

Learning that Javier and some of his friends intended to visit Paris by way of Barcelona after a jaunty trip through Gibraltar, he begged his son early in 1828 to visit him en route, informing him he could draw funds on Galos's bank and sending his greetings to Rafael Esteve and the Maguiro couple.[16] He also expressed shock at the "assassination" of a certain Gallardo—presumably a reference to the liberal poet Bartolomé Gallardo, who was always getting into trouble with the government.

As the weeks wore on Goya grew restless in the extreme. Just as Moratín had implored him not to delay in Paris, so now Goya wrote and implored Javier with the same urgency. He could stop over in Paris with his friends if he must, but he should stay for an extended period in Bordeaux, "which is a better city and more suitable for Mariano's needs. . . and you will spend less." Goya's aim was to use every persuasion to have the legal, or licit, side of his family near him. He was especially concerned for Mariano. In this same letter he agreed to cover their expenses, since Javier would know what was in "Marianito's" account in Galos's bank. He also pointed out that when he drew money from this bank for one month's expenses, he ascertained that there was a deficit of three thousand francs applicable to the 12,000 reales income from this account.[17] The money, of course, largely came from the remittances Javier had been sending in the first place.

Mariano, surely, was the true apple of his eye. He was also his legitimate blood from whom the line of Goya would descend and on whom he had settled jointly with Javier the vested income mentioned above. But he genuinely wanted to see Javier as well, his one and only son and the chief family beneficiary, and hoped forlornly that he would spend the summer with him—the summer that never came.

There is no evidence that he had any presentiment of his impending death. He was eager to greet Javier and his friends, who at this time were approaching Barcelona bound for the French frontier. As late as the end of March 1828 he could still stand firmly on his feet. He had suffered a stroke, which had prompted a post-haste call to Javier's family; but having taken the Valerian herb powders recommended by his Spanish landlord, José Pío de Molina, in his newly rented quarters on the third floor of 39 Fossés de l'Intendance, he now felt better.[18] Molina's impressionistic half-finished portrait was the last work he ever did.

*　*　*　*　*　*　*

The end came in the middle of April. Leocadia was there, along with his daughter-in-law Gumersinda and grandson Mariano, who had both arrived by the end of March. It was on the second day of April that he fell seriously ill. Paralysis had set in, gripping his right side. As each day passed it spread over his whole body, slowly cutting off the stream of life. Realizing the end was near, he motioned feebly that he needed to make a will, but Gumersinda replied that this has already been done. Then as the minutes slid by, he drifted into sleep. He died three hours later, just after Leocadia had retired under strain, his loyal friend Antonio de Brugada and his landlord José de Molina, among others, watching over him to the end. Cerebral apoplexy had taken its toll. It was approaching 2 a.m. on April 16, 1828.[19]

The doctor said afterwards that his end was painless in such a surprisingly strong man, but Leocadia had her doubts. He was buried in the Grande Chartreuse cemetery in the tomb of the Goicoechea family next to Martín Miguel; and about the same time, incidentally, his brother Camilo was laid to rest in Spain.

Javier met Molina at Bayonne on April 19, still thinking his father was alive. As it was, he arrived four days late. We can imagine Goya's disappointment during these last few weeks. For having written to Javier back in December 1824 that perhaps he might live to ninety-nine like Titian, he was cheated on two counts: his son had not come, and Titian was to live the longer. But the former was infinitely the greater blow. If the deepest love did not subsist between them, at least there was the common bond

of family and memories.

Yet a mystery surrounds the circumstances of Goya's final wishes. Javier was amply provided for in the will of 1811, and he was now additionally a rich man from the Duchess of Alba's will and the royal copyright for the *Caprichos*. It seems incredible, therefore, that Goya never provided for Leocadia in any second will. Granted that neglect was often the fate reserved for mistresses—the case of Nell Gwyn or Lady Hamilton comes quickly to mind—yet knowing Leocadia, one would have thought she could have prized one out of him. But no record of any disposition exists. Was it sheer meanness on his part, or forgetfullness, or did he mistakenly trust Javier to look after the weaker members of his adopted family? And as he lay dying and gestured for the need to make a will, was this a last-minute attempt to put things right, with Gumersinda deliberately confounding his intentions by telling him that he had already made one? As it was, Javier treated the hated Leocadia shabbily in the extreme, allowing her only a little money and conceding her rights to but a little of the family furniture. Perhaps the rift between the two sides of the family had gone too deep for anyone to make amends— the condescending legal heir habitually at odds with the usurper stepmother. But what of Goya? What could have impelled such a grave omission on his part, family-minded as he was, if only because of the untold distress this would inflict on Rosario, whom he adored about as much as Mariano?

Potentially penniless, Leocadia felt desperate on account of the children. There was Guillermo Weiss as well as Rosario to consider. The former, soon tiring of Bordeaux's low apprenticeship wages, moved back to Spain to join the militia; but because of political conditions inside the country he was hard put to communicate with his mother. As for Rosario, deprived of study in both art and the piano and fretful as ever, she at last received an introduction to the Duchess of San Fernando, thanks to her mother's persistence; and she was able to study at the Prado for a while before becoming drawing mistress to Princess Isabel (the coming Queen of Spain and daughter of the Regent, María Cristina of Sicily, Ferdinand's last wife).[20]

Leocadia in the meantime wrote a pitiful letter to Moratín

who was in Paris, describing the family plight and begging for help;[21] and in her distress she approached both Melón and Maguiro for the same reason. But little came of her pleas, especially as Moratín became ill and was dead by the summer of 1828. Her financial situation grew steadily worse until by 1831 she was obliged to seek assistance from the French minister of the Interior.[22] Curiously, in this year she gave Rosario's age as twenty, even though she had been born in 1814. Perhaps she had the idea to present her daughter more convincingly as the legitimate offspring of Isidro Weiss. If the latter were indeed Rosario's father (or someone else other than Goya), as seems more probable, then Goya's failure to provide for her becomes a little more understandable, as he blindly relied on Javier's charity to look after her future welfare. But the matter proved largely irrelevant in any case because tragically, Rosario expired in 1840 on account of a fever, which cut short a promising career. Leocadia herself died in Madrid in 1856, two years after Javier, while Mariano lived till 1874.

At the turn of the century, Goya's remains (minus his skull which was never found) were exhumed and brought to Madrid, and in 1928 transferred to the chancel in the little church of San Antonio de la Florida. His old homes in Desengaño and Valverde Streets have long since disappeared. A stone's throw from the Gran Vía, these streets embrace commercial buildings and a convent, with not a few streetwalkers between. None can tell you where Goya lived. But many will tell you where the remains of Goya lie—in the modest chancel mentioned above. It is a fitting resting-place for the great artist. Memorial streamers from the Academy in the national colors are draped around it in tribute. Because of his frescoes alone—centered in that crowning miracle of St. Anthony of Padua that encrusts the dome above like jewels—the church has become a shrine. And there are mirrors to aid those who crave a reflected view.

VALEDICTION AND A HOMECOMING

Goya's death in 1828 was generally unnoticed by the world beyond fond remembrances, trite phrases, official obituaries. There was no funeral à la Voltaire, no public eulogy by the government of Spain. At most there was a sketchy biography by his son for the proceedings of the Academy three years later. He was looked upon in official circles as a figure who had had his time, tainted by political heresy en route. Sickness in fact lay at the root of his artistic quaintness, and his etchings were best forgotten, though his portraits just passed muster because they praised the right societal figures. He was merely an Aragonese painter somehow gone wrong; and only a few Spaniards like Valentín Carderera, himself an Aragonese, showed much interest. It was not until later on in the century that a wider interest was shown when his etchings were discovered stacked away like encrusted incubi. Till then, the Prado itself had only a handful of his paintings on its books; and it was only as a painter that he was known.

Outside Spain, artists like Delacroix, Daumier and Manet, among others, and writers like Alfred de Musset, Gautier, Baudelaire and Hugo praised his work, especially as an etcher. It was in France where his genius first won recognition in both forms, which the Impressionists did much to further; while in Germany by the early twentieth century much scholarly work was done on the circumstances of his life. In English-speaking countries on the other hand, beyond a few loners like Richard Ford, William Stirling-Maxwell and John S. Sargent, and the compilers of his etchings in the British Museum, there was an uncomfortable evasion at the mention of his name. While the worth of a Murillo work could be counted in thousands of dollars before 1914, a Goya could often be counted in hundreds.

All this of course has changed since then, thanks to scholars of every hue and nationality who have pieced together, like bits of a jigsaw puzzle, the facts of his life and work. And only now is his universal greatness beginning to be understood.

In other words, to say that Goya is merely the most Spanish of all artists is itself a half-truth. Certainly he was Spanish to the

core—in his intensity, his fluctuations of mood, his bombast and showmanship, his jocular and earthy wit, his love of crowds and love of humanity within the crowds. But something more than all this lies at the root of his being. It is something to do with his enormous strength and an acquisitive raw intelligence that went with it. He worked in ever shifting dimensions of experiment. He used society to expose new follies, religion to reveal new sublimities, the supernatural to unmask new faces, ugliness to lay bare new beauty, politics and war to release new outrage. In his irreverence he was a daring explorer and innovator at all levels. Irrational fantasy we may grant him (who but a Spaniard could conceive the *Caprichos* or the drawings of Album G?), but to be unafraid of the Devil as well, such as using street *majas* for angels, is what makes him a man *extraordinaire*, which lifts him out of and beyond the framework of a narrow ethnic definition. The French critic Jean-François Chabrun said that Goya was not one great artist but at least twenty, all separate and clearly defined.[1]

It is this 'multiple irreverence' in Goya that carries him beyond what conventional artistry was designed to perform. In his devotion to its techniques as a youth and to the civilization it represented, he was at once an unwitting rebel, and long before disillusion set in he stripped it of subservience to kings and courts even as he continued to serve them. He moved art into fresher air; so that while this loosening of royal patronage was an inevitable trend in all countries after the French Revolution, he hastened the process in his own country, giving the artist a new professional dignity and independence. But he did it subtly, like a conjurer who assumes a multiple role. His tactics were discreet, even as his transition (after a terrible illness) was unconscious. From the group portrait of Charles IV and his family, in which grand decadence is masked by sanctioned touches of intimate featuring that borders on satire (without this being obvious to his sitters), to the great canvases of the 1808 uprising, in which the immorality of war is masked by an agonizing patriotism, Goya has revealed the raw-boned skeleton of an entire society. Spain was his hunting ground, but it is the ground of every nation. In the end it is everyone to whom he speaks.

Yet as a rustic turned bourgeois-democrat, he never lost respect for aristocrats or priests as individuals, nor preached the inevitability of revolution. He was merely a revolutionary artist; and as if this were not enough, he became one of the greatest advocates for expressive change in the history of Western civilization. But not even this easy definition can quite explain him away.

For as he forged ahead with his perceptions, drawing new ideas from the mold of a crumbling society, his world of pencil and paint becomes not merely a critique of life itself but an exposition of what life can become. He is both a commentator and a prophet. Through realism and impressionism, satire and puppetry, silhouette and symbol, he has foreshadowed things whereby war, terrorism, nihilism and annihilation, whether we like it or not, bear a distinct resemblance to our present-day world, and on a scale no one else had done before. If Europe supposedly ends at the Pyrenees, it is below the Pyrenees where a new world begins for us all. And the human beings he gives us, mostly good in their self-sacrificing innocence but also bad in their sacrifice of others, are like signposts of both a love and a warning. Ahead of his time, he never accepted the moral credo that there necessarily has to be a cause worth forcing on others. He, Goya, is the one who is sane; it is the impersonal world outside that is insane, and no doubt Goya meant to convey this without presumption.

Partly explaining this phenomenon is his instinctive sense of time and change in all their infinite varieties. It would not be an exaggeration to attribute his great gifts largely to his sense of history. Having bridged two centuries, he learned from experience that civilizations rise and fall and that man in all his devotions to daily living too easily can become their helpless victim; and Spain was an incidental breeding-ground for this awareness. This was not sheer fatalism on his part but a fact of life. Yet how he refused to buckle under the strain! It is one of the paradoxes of this remarkable man that having suffered through all the malaise of a disintegrating society that reached its nadir in his own country after a glorious but terrible struggle of liberation, he reached the pinnacle of an artist's fulfillment in himself. For this alone, for his fearless unwillingness to compromise with mediocrity and repression, he stands high among his fellows.

Today the artist and historian, psychologist and critic, indeed humanity in general, are under obligation to him. And not for his innovative techniques alone. Nor is it just the release of the imagination that he has taught us. He has given us a sense of our own worth and purpose. "What image or any form thereof can there be, which is not itself a copy of divine nature?" he once asked.[2] Man as an expression of this, unique but malleable and dangerously vulnerable, as Goya discovered in himself with his own temptations, is the key to this perception; and this essential duality—uplifted man with all his capabilities and the leveling monster within that pulls him down into violence and chaos—is as much a special part of Goya's world as our own.

Through all the tragedy and contradiction nonetheless, there is a corollary of hope. One has only to look at his portraits of children to appreciate this stark simplicity. He seems ageless—loving youth and better able to portray it the older he becomes. He is in fact an unusual link between the past and future, from Mengs to the French impressionists, and beyond, in whom one senses a continuum of shifting taste and technique, sometimes at one with, at other times outside of, the age in which he lived. Among the last of the old masters, he is the first of the moderns. He is eclectic and pervasive all in one, but without succumbing to the straightjacketing formulas or moral dogmatism that an age can often impose. Youth thus always delights him, in whom he saw his own darting off at a tangent. Yet in a way, his message remains religious. Past all the jaunty mischievousness of his early genre scenes, the erotic pagan symbolism, he shows us at last where peace can be found in the soul. It is in the sacristies and chancels of the churches, among the domes and arches of the great cathedrals. Here the unevenness of life can be arrested, great things conceived, even death made beautiful. For it was the sacred that he loved, not the sanctimonious. At the same time he knew that part of the drama of life is to laugh at life's ineptness and fragility, with the comic and the carnivals and all the childlike folk who revel in them. Perhaps not even Shakespeare loved the youthful masses as much as he, though at the reverse dramatic level the skull in Hamlet and the 'shuffling off of mortal coil' unite them both. For both men, death as much as lively lyricism is made a

fitful art.

If there is any flaw in Goya, it is his reluctance to express at the intermediate level of experience an ideal romantic love between a man and a woman. True, there are gallants and their ladies as there is Cupid and Psyche and all the playful caballeresque suggestions, but depicting a deep permanent commitment which, say, English portrait painters were so good at, is somehow missing. One senses that whatever aura he imparted to the two jointly was done uninspiringly for professional reasons alone. Indeed there is passion, but it seems singly directed (and not necessarily towards the woman), which his formidable artistry has aroused in him. Here we may find the key in Goya's own imperfect life—the proud trumpeter of a four-wheeled carriage riding roughshod over the sober ties of marriage. Yet the man who could do this in all vanity could look after his family and love his special friends, show charity where it was due. He was kind but not quiescent; in other respects his notion of ideal love was tempestuous and erratic like the world around him.

Neither do his drawings, for all their contrived magic, rest for one moment in an idyllic setting of a Garden of Eden, unless it be the few faint pointers to himself with his Duchess of Alba. But it should not be forgotten that, even as he probably sensed a newer romanticism in Chateaubriand's style during his lifetime, it was hardly a romantic age in Spain. This, perhaps, is to beg the question if one presumes to see in Goya antecedents for the future. No one, however, can win top marks in everything. An artist is judged in relation to his aims. Romanticism shown in a couple with deep feelings for each other may not have been his strong point (any more than landscape as an end in itself); but certainly aestheticism was, for his women at their best are portrayed in all their consummate beauty. He, Goya, is the sensual exponent of this quality, and if there is any romanticism at all, it comes from himself with full immediacy, impinging directly on his subject.

Complementing this approach is a compelling suggestiveness of feature that so often charges the individual with a radiant strength. The fired moments in time become frozen in time. What portrait can rival that of Bartolomé Sureda with its unfathomable

enigmatic appeal, or that of the bullfighter Pedro Romero or Juan Martín Díaz, or the last one of Mariano with its burst of open youthfulness? His male figures can be as intriguing as his female ones, from the supposed 'Josefa' of 1798 to those of the Duchess of Alba. With either sex there is an act of capture, as if all the secrets of their personality are known to the artist and conveyed in a double image to the world—for the world first to see, and then discover further.

It is this quality of mystery, of the unexpected—the fleeting manifestations of divine nature sealed to a permanent nature— that makes his work so great. Perhaps the most striking portrait he ever painted was about the last he ever completed. It is *La Lechera de Burdeos (The Milkmaid of Bordeaux)*, which his banker friend Juan de Maguiro tried to prize out of Leocadia after his death.[3] It could have been that Goya caught sight of her one day near his home, complete with milkpail and donkey returning from market. Luminous and poetic in pose, the girl in her finely spun dress—a chromatic texture of blue and green and rose and gold like gossamer in the late afternoon sunlight—looks down in an enveloping aura that anticipates Renoir's impressionism half a century later. Goya in his eighty-second year has saluted youth. The poetry of human beings was always in his heart.

There is an amusing story about this portrait. A young Englishman whose enthusiasm for Goya was greater than his knowledge of Spanish, translated the title *La Lechera de Burdeos* as 'The Prostitute of Bordeaux.' He had confused the Spanish word *'lechera'* with the English word 'lechery'—a fatal gaffe. How Goya would have laughed! And if this pensive milkmaid could somehow be alive today, how much gold would the world press into her hand to find out more about her incredible discoverer.

NOTES TO THE CHAPTERS

Terms and abbreviations used in the notes:

PRADO refers to the original manuscript letters of Goya to his friend Martín Zapater which are preserved in the Prado Museum, Madrid.

SALAS refers to Goya's letters to Zapater, published as *Cartas a Martín Zapater*, Madrid, 1982, edited by Mercedes Agueda and Xavier de SALAS. In addition to those in the Prado, this work reproduces Goya's letters to Zapater located elsewhere.

DIP. refers to the *Diplomatario*, Zaragoza, 1981, edited by Angel Canellas López, which reproduces letters by Goya and correspondence relating to Goya in general.

BN. Refers to the Biblioteca Nacional, Madrid, Division of Manuscripts, in this case citing the original Diary of Leandro Fernández de Moratín, and two letters of Leocadia Zorrilla (Goya's mistress) to Moratín.

For publishers' names in regard to secondary works, see the Bibliography.

NOTES TO CHAPTER ONE

1. Guillermo Díaz-Plaja, *Goya en sus cartas y otros escritos* (Zaragoza, 1980), p. 81.
2. For these early details, see Cerefino Araujo, "Goya en su época," *Ateneo científico . . . de Madrid: La España del Siglo XIX* (Madrid, 1887), pp. 6–7; and Valerian von Loga, *Francisco de Goya* (Berlin, 1921), pp. 3–5.
3. Pierre Gassier, *Goya* (Lausanne, Switzerland, c.1975), p. 17.
4. Jeremy Mulvey, "Palace Decoration at the Spanish Bourbon Court," *Apollo* (London, October 1981), p. 231ff.

5. Leslie Jones, "Peace, Prosperity and Politics...," *Apollo*, pp. 220–27.

NOTES TO CHAPTER TWO

1. Anthony H. Hull, *Charles III and the Revival of Spain* (Washington, D.C., 1980), pp. 97–120, *passim*.
2. Pierre Gassier, *Goya: Todas sus pinturas* (Barcelona, 1981), vol. 1, p. 12.
3. Ibid., p. 5.
4. This was not his first signed work. His *Tobias and the Angel* and *Virgin Weeping by the Dead Christ* were both signed before 1771, the former dated as early as 1762; while his *Feast of Esther and Ahasuerus* (with its pendant *Haman's Pardon*), his *Sacrifice to Vesta* (with its pendant *Sacrifice to Pan*), along with his *Venus and Adonis*, were signed in this same year, 1771.

NOTES TO CHAPTER THREE

1. DIP., Goya to the Academy of Arts in Parma, Rome, April 20, 1771, p. 205.
2. Nigel Glendinning, *Goya and his Critics* (New Haven, Conn., 1977), p. 33.
3. For further details of Goya's early relations with the Bayeu family, see Valentín de Sambricio, *Tapices de Goya* (Madrid, 1946), vol. 1 (Texto, Advertencia preliminar), pp. 23–8.
4. PRADO, Goya to Zapater, c.December, 1782, Ms. 11. Goya's letters to Zapater in the Prado, and others located elsewhere, can be consulted in Mercedes Agueda and Xavier de Salas (eds.), *Cartas a Martín Zapater*, Madrid, 1982.
5. SALAS, Goya to Zapater, Aug. 9, 1780, p. 58.
6. Ibid.
7. Ibid., Goya to Zapater, c.September, 1781, p. 71.
8. Guillermo Díaz-Plaja, *Goya en sus cartas y otros escritos* (Zaragoza, 1980), p. 38.
9. Nigel Glendinning, *Goya and his Critics*, p. 35.

10. Archivo Histórico Nacional, Madrid, Charles III to his son, c.July, 1776, Legajo 2453.
11. PRADO, Goya to Zapater, April 26, 1783, Ms. 13, in which he refers to a letter of credit for the 3,000 reales the Duke has lent to Goya.
12. Francisco J. Sánchez Cantón, "Los niños en las obras de Goya," *Goya, Cinco estudios* (Zaragoza, 1978), pp. 69–87.
13. The unfinished proofs were often different from the finished prints, which Goya had changed to impart a more eighteenth-century flavor. For further details, see Eleanor A. Sayre, *The Changing Image: Prints by Francisco Goya* (Boston, Mass., 1974), p. 21.
14. DIP., Sabatini to Múzquiz via Marqués de Montealegre, Feb. 4, 1779, p. 410.
15. SALAS, Goya to Zapater, Jan. 9, 1779, p. 49. The four pictures that Goya mentions were probably among the six tapestry cartoons delivered from the factory on January 5 of this year. These were; *The Fair of Madrid, The Crockery Vendor, The Soldier and the Lady, The Hawthorn Girl, Boys Playing at Soldiers,* and *Girls in the Go-Cart.*
16. DIP., the Duke of Losada to Manuel de Roda, Oct. 8, 1779, p. 412.

NOTES TO CHAPTER FOUR

1. SALAS, Goya to Zapater, c.July 21, 1780, p. 56.
2. DIP., Goya to the Junta de Fábrica del Pilar, March 17, 1781, pp. 227–233.
3. Ibid., Félix Salcedo to Goya, March 30, 1781, pp. 423–26.
4. SALAS, Goya to Zapater, July 25, 1781, p. 64.
5. Ibid., Goya to Zapater, July 14, 1781, p. 64.
6. Ibid., Goya to Zapater, Feb. 25, 1780, p. 51.
7. Ibid., Goya to Zapater, April 25, 1787, signing himself "Paco el Gordillo," p. 164.
8. PRADO, Goya to Zapater, c.December, 1782, Ms. 11.
9. Ibid., Goya to Zapater, P.S., Nov. 13, 1781, Ms. 10.
10. See note 4, *supra*.
11. PRADO, Goya to Zapater, c.October, 1781, Ms. 8.

12. Ibid., Goya to Zapater, Oct. 6 and 20, 1781, Mss. 7 and 9.
13. Ibid., Goya to Zapater, Nov. 13, 1781, Ms. 10.
14. SALAS, Goya to Zapater, Jan. 11, 1783, p. 91.
15. Ibid., Goya to Zapater, Jan. 22, 1783, p. 94.
16. Ibid., p. 95.
17. The name of María Bayeu's husband was Marcos del Campo, but her brother-in-law's first name is unknown.
18. PRADO, Goya to Zapater, Sept. 20, 1783, Ms. 15.
19. SALAS, Goya to Zapater, March 3, 1784, p. 114.
20. Ibid., p. 101, and PRADO, Goya to Zapater, Ms. 58, both dates unknown.
21. DIP., Jovellanos to Goya authorizing payment for his efforts, Oct. 11, 1784, p. 431. The three saints were Benito, Bernardo and Raimundo.
22. SALAS, Goya to Zapater, Dec. 11, 1784, p. 126.
23. PRADO, Goya to Zapater, Jan. 14, 1785, Ms. 21.
24. Ibid., Goya to Zapater, March 30, 1785, Ms. 23.
.25. DIP., Goya, Gregorio Ferro, and José del Castillo to Floridablanca, April 25, 1785, pp. 263–4, and SALAS, regarding Floridablanca's response, pp. 128–9.

NOTES TO CHAPTER FIVE

1. SALAS, Goya to Zapater, July 7, 1786, p. 148.
2. Goya also depicted the masons as drunk (in a work for the Osunas), but on this occasion was displaying loyalty to Charles III. See Edith Helman, *Jovellanos y Goya* (Madrid, 1970), p. 248ff.
3. Ramón Gómez de la Serna, *Goya* (Madrid,, 1943), pp. 44–6.
4. SALAS, Goya to Zapater, Jan. 10, 1787, p. 158.
5. Ibid., p. 159. The saints were Josef, Liutgarde, Bernardo, and Roberto. The last two were combined in one altarpiece, thus making three altarpiece paintings in all.
6. Three other bank directors whom Goya painted were José del Toro, the Marqués de Tolosa, and Francisco de Larrumbe.
7. See chapter 7, note 11, *infra*.
8. PRADO, Goya to Zapater, March 25, 1786, Ms. 29.
9. SALAS, Goya to Zapater, Aug. 1, 1786, p. 152.

10. Ibid., Goya to Zapater, April 25, 1787, p. 164. The same theme about having a "month" of correcting at the Academy is mentioned by Goya in two letters during 1786 (in the second one as a favor to Bayeu), prompting him to complain that he had so much work to do he had no time or place for anything. See PRADO, Goya to Zapater, March 11, 1786, Ms. 28, and Ibid., Goya to Zapater, Dec. 16, 1786, Ms. 31.
11. PRADO, Goya to Zapater, May 4, 1787, Ms 34.
12. SALAS, Goya to Zapater, Nov. 28, 1787, p. 178.
13. PRADO, Goya probably to Zapater (mostly in his clerk's handwriting), Nov. 19, 1788, Ms. 42.

NOTES TO CHAPTER SIX

1. PRADO, Goya to Zapater, April 25, 1789, Ms. 43.
2. SALAS, Goya to Zapater, June 23, 1789, p. 194
3. PRADO, Goya to Zapater, c.December, 1789, Ms. 47.
4. SALAS, Goya to Zapater, Feb. 20, 1790, p. 202.
5. Ibid., Goya to Zapater, May 23, 1789, p. 192.
6. DIP., Campomanes to Goya, c.1790, p. 443.
7. PRADO, Goya to Zapater from Valencia, Aug. 28, 1790, Ms. 48.
8. Ibid., Goya to Zapater in French, Nov. 14, 1787, Ms. 38. Bourgoing praises Goya as "rendering faithfully the manners, dress, and pastimes of his country" in his *Nouvelle Voyage en Espagne* (Paris, 1789), vol. 1, p. 249.
9. PRADO, Goya to Zapater, regarding expenses involved in his nobility claim, c.1791-2, Ms. 50.
10. DIP., Livinio Stuick Vandergotten to Charles IV, April 13, 1791, pp. 446–47.
11. SALAS, Goya to Zapater, c.1792, p. 212.
12. DIP., Goya's report to the Academy of San Fernando, Oct. 14, 1792, p. 310.

NOTES TO CHAPTER SEVEN

1. Elizabeth Lady Holland, *The Spanish Journal, 1791-1811* (London, 1910), p. 117.

2. DIP., Sebastián Martínez to Pedro Arascot, March 19, 1793, p. 454.
3. Ibid., Martínez to Zapater, March 29, 1793, p. 455. The need to treat the sick man with compassion was stressed by Zapater to Francisco Bayeu in a letter dated the next day.
4. PRADO, Goya to Zapater, c.1793, Ms. 51.
5. Jacob Gustav de la Gardie's comment in his diary. 1815, quoted in Nigel Glendinning, *Goya and his Critics* (New Haven, Conn., 1977), p. 54.
6. BN., Diary of Leandro Fernández de Moratín, Ms. 5617, recording his meeting with Godoy and Aranda, April 7, 1792, p. 21, and Ibid., recording his visit to England for a year as from August 1792, p. 30ff.
7. DIP., Goya to Bernardo de Iriarte, Jan. 4, 1794, p. 314.
8. SALAS, Goya to Zapater, April 23, 1794, p. 218.
9. PRADO, Goya to Zapater, May 21, 1794, Ms. 53.
10. SALAS, Goya to Zapater, c.June-July, 1794, p. 223.
11. That his Alameda paintings of *The Swing* and *The Accident* with the donkey portray the Duchess of Alba (referred to in chapter 5) is endorsed by Pierre Gassier. See his *Goya* (Lausanne, Switzerland, c.1975), pp. 31, 34, 35.
12. Francisco J. Sánchez Cantón, *Vida y Obras de Goya* (Madrid, 1951), p. 55.
13. Elizabeth Lady Holland, *The Spanish Journal*, p. 92.
14. D. B. Wyndham Lewis, *The World of Goya* (New York, 1968), p. 107.
15. PRADO, Goya to Zapater, c.August 2, 1794, Ms. 55.
16. DIP., Joaquín Aralí to J. Agustín Ceán Bermúdez, P.S., July 22, 1796, p. 462.
17. Malcolm Anderson, "Our Lady of the Dew," *Anglo-Spanish Society Quarterly Review* (London, Spring 1984), no. 128, pp. 15–17.
18. BN., Diary of Leandro Fernández de Moratín, Ms. 5617, recording his meetings with Goya and Martínez in Cadiz intermittently from Dec. 23, 1796, to Jan. 10, 1797, p. 51.
19. Xavier de Salas inclined to the view that Goya, stricken with illness, didn't return to Sanlúcar during the later part of his stay in Andalucía. See his *Goya* (London, 1979), p. 84.

20. Pierre Gassier, *Goya: Todas sus pinturas* (Barcelona, 1981), vol. 1, p. 10.

NOTES TO CHAPTER EIGHT

1. SALAS, Goya to Zapater, c.1792, p. 210.
2. These and other Goya drawings are stored in boxes in the Prado, often paired with a corresponding etching, and are not normally for viewing by the general public in this form.
3. The model for Goya's *Los Chinchillas* (with the definite article put in the wrong gender presumably to expose male foibles) stems from *El dómine Lucas*, a cape and sword comedy by J. de Cañizares, according to Edith Helman in her *Jovellanos y Goya* (Madrid, 1970), pp. 183-197.
4. F. D. Klingender in his *Goya in the Democratic Tradition* (London, 1948), p. 212, stressed the emancipation of the people as Goya's main theme; this plays down Goya's other main theme—imaginative art, also associated with man though not necessarily with social issues.
5. DIP., re. the Academy's acceptance of Goya's resignation, April 4, 1797, p. 463.
6. SALAS, Goya and friends to Zapater, c.December, 1797, p. 228.
7. PRADO, Goya to Zapater, c. March 27, 1798, Ms. 56.
8. For intricacies of this period, see Elizabeth Lady Holland, *The Spanish Journal, 1791-1811* (London, 1910), pp. 116, 303; Klingender, op. cit., pp. 76-8; and Richard Herr, *The Eighteenth-Century Revolution in Spain* (Princeton, New Jersey, 1958), pp. 399, 419, 427-28.
9. Goya's portraits in the 1790s not mentioned in the text include: Félix de Larriátegui (1794); Gil de Tejada (1795); Judge Altamirano (c.1797); Unknown Man in a Brown Jacket (c.1798); and the Marqués de Bondad Real (1799).
10. BN., Diary of Leandro Fernández de Moratín, Ms. 5617, recording his meeting with Goya to see his pictures at San Plácido on May 21, 1798, p. 59.
11. PRADO, Goya to Zapater, July 2, 1788, Ms. 41. in which he refers to the interest by the then Archbishop of Toledo

(Francisco Lorenzana) for him to work presumably on a representation of Christ. For a description of the painting *infra* in text, see José López-Rey, "Goya's *The Taking of Christ*," *Apollo* (London, October 1981), pp. 252–54.

12. DIP., Goya's announcement to the public re. the *Caprichos* (formulated two years earlier), Feb. 6, 1799, p. 328. See also Eleanor A. Sayre, *The Changing Image: Prints by Francisco Goya* (Boston, Mass., 1974), pp. 55–6. According to some sources, the two days allowed for their sale after Feb. 19 (see text *infra*) was in fact a longer period which extended into March.

13. The four church fathers were Sts. Ambrose, Augustine (of Hippo), Gregory the Great, and Jerome—the same as he painted earlier for the parish church of Remolinos, though in different postures.

14. SALAS, Goya to Zapater, Oct. 3, 1799, p. 233.

15. Pierre Gassier, *Goya: Todas sus pinturas* (Barcelona, 1981), vol. 2, p. 4.

16. Quoted in Guillermo Díaz-Plaja, *Goya en sus cartas y otros escritos* (Zaragoza, 1980), p. 94.

17. Ibid.

NOTES TO CHAPTER NINE

1. DIP., María Luisa to Godoy, Oct. 9, 1799. p. 470.

2. BN., Diary of Leandro Fernández de Moratín, Ms. 5617, recording his viewing of Goya's pictures in the salons of the Royal Palace, Feb. 11 and 17, 1800, p. 68.

3. DIP., Miguel Soler to the royal treasury, Oct. 6, 1803, p. 477.

4. Miguel Lloris and Micaela Sáenz (eds.), *Los Dibujos de Goya* (Zaragoza, 1978), p. 14.

5. An artist's donkey is a four-legged stool with a rest for a drawing-board used by students. Goya was surely familiar with such a device when he was painting instructor at the Academy, not to mention during his own training days.

6. See *The Daily Telegraph* (of London), Jan. 29, 1986, p. 21.

7. See Appendix A, Political Leanings of some of Goya's patrons from 1808.

8. PRADO, Goya to Zapater (jokingly from London on August 2, 1800), Madrid, Aug. 2, c.1794, Ms. 55.

9. BN., Diary of Leandro Fernández de Moratín, Ms. 5617, recording his meeting with Manuel García de la Prada (and earlier, with his actress wife), May 22, 1806, pp. 86, 106. García was corregidor of Madrid under Joseph Bonaparte, and Moratín's friendship with the pair lasted throughout his exile in France.

10. Other Goya portraits from 1801–08 include: Antonio Noriega (1801); José Queraltó (1802); Joaquina Candado (c.1803); Alberto Foraster (1804); Ignacio Garcini and wife (1804), Eugenio de Palafox (1804); the Soria family (c.1805); Evaristo de Castro (c.1806); Marquesa de Castrofuerte (c.1806); Condesa de Frutos (c.1806); Leona de Valencia (c.1806); Antonio Ibañez (c.1806); Francisca Chollet y Caballero (1806); students of the Pestalozzi Institute, founded by Godoy (1806); Marqués de Caballero and wife (1807); and Pantaleón de Nenín (1808).

11. Albert Derozier, *Escritores políticos españoles, 1789–1854* (Madrid, 1975), p. 20; and Nigel Glendinning, *Goya and his Critics* (New Haven, Conn., 1977), p. 53.

12. José Camón Aznar, "Goya en los años de la Guerra de Independencia," *II Congreso de la Guerra de la Independencia y su época* (Zaragoza, 1959), p. 6ff.

13. Hugh Thomas, *Goya: The Third of May 1808* (New York, 1973), p. 44.

14. Xavier de Sales, *Goya* (London, 1979), pp. 117–8.

NOTES TO CHAPTER TEN

1. Quoted to Nigel Glendinning, *Goya and his Critics* (New Haven, Conn., 1977), p. 63.

2. DIP., Goya to José Munárriz, secretary to the Academy, Oct. 2, 1808, p. 362.

3. Elizabeth Lady Holland, *The Spanish Journal, 1791–1811* (London, 1910), p. 324.

4. José Camón Aznar, "Goya en los años de la Guerra de Independencia," *II Congreso de la Guerra de la Independencia y su época* (Zaragoza, 1959), p. 6.

5. Elizabeth Lady Holland, *The Spanish Journal*, pp. 408–413.
6. Michael Glover, *Legacy of Glory: the Bonaparte Kingdom of Spain* (London, 1972), pp. 149–162.
7. There were of course many good commanders left in the field—Joaquín Blake for example, who reorganized an army in Murcia.
8. Miguel Artola, *Los Afrancesados* (Madrid, 1976), pp. 161ff., 196.
9. Ibid., pp. 169–171.
10. Richard Herr, *The Eighteenth-Century Revolution in Spain* (Princeton, New Jersey, 1958), p. 448.
11. Pierre Gassier, "Goya and the Hugo Family in Madrid, 1811–12," *Apollo* (London, October 1981), pp. 248–251.
12. Xavier de Salas, *Goya* (London, 1979), pp. 108, 114.
13. DIP., re. Goya's purported flight from Madrid in c.1812, Nov. 18, 1814, p. 490.
14. One of these balcony scenes came into the possession of Ferdinand's cousin, the Infante de Sebastián, by 1830.
15. DIP., Ramón de Mesonero Romano's account of the near fight between Goya and the Duke of Wellington in the presence of Javier and General Alava in August 1812, p. 484. The story is probably apocryphal, though the Duke may well have posed before Goya on many occasions in an impatient mood.
16. Stanley G. Payne, *A History of Spain and Portugal* (Madison, Wisconsin, 1973), vol. 2, p. 427. For further details, see *Goya y la Constitución de 1812*, Museo Municipal exh. catalogue (Madrid, 1982).
17. Quoted in DIP., Goya to the Regency, Feb. 24, 1814, p. 369.
18. Xavier de Salas, *Goya*, p. 119.

NOTES TO CHAPTER ELEVEN

1. DIP., Fernando de la Serna (assisted by Antonio Bailó) to corregidor M. Gamboa, defending the motives for Goya's purported flight from Madrid in 1812, Nov. 18, 1814, p. 490.
2. Ibid., Confiscations director to fiscal Inquisitor Dr Zorrilla de Velasco of the Secret Chamber, along with the latter's report, March 16, 1815, p. 491.

3. Ibid., Purification commission's report to the Penalty Chamber, April 8, 1815, p. 492.
4. Ibid., re. Rosario's birthplace and birth on October 2, 1814, p. 93.
5. Other Goya portraits at this time include: M. Fernández Flores (1815); Francisco del Mazo (1815); and two unknown women, one of them with a black veil (c.1819).
6. Miguel Lloris and Micaela Sáenz (eds.), Los Dibujos de Goya (Zaragoza, 1978), p. 40.
7. Quoted in José Pita Andrade, Goya (Madrid, 1979), p. 33.
8. Francisco J. Sánchez Cantón, Goya. la Quinta del Sordo (Florence, Italy, c.1965), passim.
9. Stanley G. Payne, A History of Spain and Portugal (Madison, Wisconsin, 1973), vol. 2, p. 431.
10. Miguel Lloris and Micaela Sáenz (eds.), Los Dibujos de Goya, p. 38.
11. Ibid., p. 41.
12. See F. J. Sánchez Cantón, Goya and the Black Paintings (London, 1964), passim; and José López Vázquez, Goya: El programa neoplatónico de las Pinturas de la Quinta del Sordo (Santiago, 1981), passim, who stresses Goya's philosophic symbolism as a way of understanding the Black Paintings.
13. Gwyn A. Williams in his Goya and the Impossible Revolution (London, 1976), pp. 136–9, while viewing the Black Paintings as a fulfillment of the Caprichos of 1799 with their suspension between reason and unreason and hence offering no cogent explanation, yet denies any madness in Goya's nightmarish mood on account of the revolution of 1820, which Goya coherently welcomed with joyful symbols in his drawings.

NOTES TO CHAPTER TWELVE

1. DIP., Goya's powers of attorney to Gabriel Ramiro, Feb. 19, 1824, p. 385.
2. René Andioc (ed.), Epistolario de Leandro Fernández de Moratín (Madrid, 1973), Moratín to Juan Antonio Melón, Bordeaux, June 27, 1824, p. 586.

3. DIP., Goya to Joaquín M. Ferrer, Oct. 28, 1824, p. 386.
4. Ibid., Goya to Francisco Javier, Dec. 24, 1824, p. 388.
5. R. Andioc, *Epistolario*, Moratín to Melón, April 14, 1825, p. 619.
6. DIP., Javier to Ferdinand VII, June 21, 1825, p. 502.
7. R. Andioc, *Epistolario*, Moratín to Melón, P.S., Oct. 7, 1825, p. 646.
8. DIP., Goya to Ferrer, Dec. 20, 1825, p. 389.
9. R. Andioc, *Epistolario*, Moratín to Melón, Oct. 30, 1825, p. 647.
10. Ibid., Moratín to Melón, May 7, 1826, p. 663.
11. DIP., Ferdinand VII to Goya, June 17, 1826, p. 506.
12. Xavier de Salas, *Goya* (London, 1979), p. 162.
13. A substantial portion of this artist's work is in the collection of Herr Peter Scheiwe in Münster, West Germany.
14. Of Ferdinand VII's four marriages—to María Antonia of Sicily (died 1806), María Isabel of Portugal (died 1818), María Amalia of Saxony (died 1829), and María Cristina of Sicily (died 1878)—only the last produced a surviving heir. This was Princess Isabel, and the fact led to the Carlist wars, fought on behalf of Ferdinand's brother Carlos who claimed the throne on the ground that the Salic law debarred women from succeeding, even though this law had actually been revoked by Charles IV. In his last years, Ferdinand placed his hopes for the future in his daughter, who succeeded him as Isabel II after his death in 1833. She proved a dissolute queen, and was deposed in 1868.
15. See Appendix B, Professional Backgrounds of Cortes members. For an explanation of Carlists, see note 14, *supra*.
16. DIP., Goya to Javier, Jan. 17, 1828, p. 392.
17. Ibid., Goya to Javier, March 12, 1828, p. 393–4.
18. Ibid., Goya to Javier, March 26, 1828, p. 394.
19. BN., Leocadia to Moratín, April 28, 1828, Ms. 12963–40.
20. See note 14, *supra*.
21. BN., Leocadia to Moratín, May 13, 1828, Ms. 12963–40.
22. DIP., Leocadia to the French minister of the Interior, Oct. 14, 1831, p. 579. For a treatment of Goya during his last years at Bordeaux, see Jacques Fauqué, *Goya y Burdeos, 1824–1828* (Zaragoza, 1982), *passim*.

NOTES TO VALEDICTION AND A HOMECOMING

1. Quoted in D. B. Wyndham Lewis, *The World of Goya* (New York, 1968), p. 214.
2. DIP., Goya to the Academy, Oct. 14, 1792, p. 312.
3. Ibid., Leocadia to Juan de Maguiro, Dec. 9, 1829, p. 515.

SELECT BIBLIOGRAPHY

Note: Publishers are given to titles only after 1900.

AGUEDA, Mercedes, and Xavier de SALAS. *Cartas de Francisco de Goya a Martín Zapater*. Madrid, Ediciones Turner, 1982.

ANDERSON, Malcolm. "Our Lady of the Dew" (details of Coto Doñana). *Anglo-Spanish Society Quarterly Review*, London, no. 128, Spring, 1984.

ANDIOC, René (ed.). *Epistolario de Leandro Fernández de Moratín*. Madrid, Editorial Castalia, 1973.

_____, René & Mireille (eds.). *Leandro Fernández de Moratín, Diario, Mayo 1780-Marzo 1808*. Madrid, Editorial Castalia, 1967.

ARAUJO, Cerefino. "Goya y su época." *Ateneo científico, literario y artístico de Madrid. La España del siglo XIX* (Colección de conferencias históricas). Madrid, 26 conferencia, 1887.

ARTOLA, Miguel (with preface by Gregorio Marañón). *Los Afrancesados*. Madrid, Ediciones Turner, 1976.

BERUETE Y MONET, Aureliano de. *Goya as Painter*. Selwyn Brinton (trans.). London, Constable, 1922.

BIHALJI-MERIN, Oto. *Francisco Goya: the Caprichos, their Hidden Truth*. John E. Woods (trans.). New York, Harcourt, Brace, 1981.

BLANCO SOLER, C., et al. *La Duquesa de Alba y su tiempo*. Madrid, EPESA, 1949.

BOSQUED FAJARDO, Jesús-Rodrigo, and Antonio MARTÍNEZ (eds.). *Cartuja de Aula Dei*. 10 nos. Zargoza, Foto-Acción Ediciones, 1979.

BOURGOING, Jean-François. *Nouveau voyage en Espagne*. 3 vols. Paris, 1789.

CAMÓN AZNAR, José. *Los Disparates de Goya*. Barcelona, Instituto Amatller, 1952.

_____. "Goya en los años de la Guerra de Independencia." *II Congreso de la Guerra de la Independencia y su época*. Zaragoza, Institución Fernando el Católico, 1959.

CANELLAS LÓPEZ, Ángel. *Diplomatario* (correspondence

relating to Goya). Zaragoza, Institución Fernando El Católico, 1981.

CAÑIZARES, J. de. *El dómine Lucas*. Madrid, 1746 and 1764.

CARDERERA, Valentín. "Biografía de D. Francisco Goya, pintor." *El Artista*, Madrid, II, 1835.

CEÁN BERMÚDEZ, Juan Agustín. *Historia de la Pintura*. 5 vols., some in ms. form. Madrid, 1823–24.

CHARLES III. Ms. letter to his son the Prince of Asturias. Madrid, Archivo Histórico Nacional, Legajo 2453, c.July 1776.

DEROZIER, Albert. *Escritores políticos españoles, 1789–1854*. Madrid, Ediciones Turner, 1975.

DERWENT, Lord George. *Goya: An Impression of Spain*. London, Methuen, 1930.

DÍAZ-PLAJA, Guillermo. *Goya en sus cartas y otros escritos*. Zaragoza, Ediciones de Heraldo de Aragón, 1980.

EZQUERRA DEL BAYO, Joaquín. *La Duquesa de Alba y Goya*. Madrid, Blass, 1927.

FAUQUÉ, Jacques. *Goya y Burdeos, 1824–1828*. Zaragoza, Ediciones Oroel, 1982.

FORD, Richard. *A Hand-Book for Travellers in Spain and Readers at Home*. 2 vols. London, 1845.

GASSIER, Pierre. *Dibujos de Goya. Los álbumes*. Barcelona, Noguer, 1973.

_____. *Goya*. James Emmons (trans.). Lausanne, Switzerland, Skira, c.1975.

_____. "Goya and the Hugo Family in Madrid, 1811–12." *Apollo*, London, October 1981.

_____. *Goya: Todas sus pinturas*. 2 vols. Barcelona, Noguer, 1981.

_____, and Juliet WILSON. *Goya: His Life and Work*. London, Thames and Hudson, 1971.

GAUTIER, Théophile. *Voyage en Espagne*. Paris, 1845.

GLENDINNING, Nigel. *Goya and His Critics*. New Haven, Conn., Yale University Press, 1977.

_____. "Goya's Patrons." *Apollo*, London, October 1981.

GLOVER, Michael. *Legacy of Glory: The Bonaparte Kingdom of Spain*. London, Leo Cooper, 1972.

GODOY, Manuel. *Memorias de don Manuel Godoy*...(an

apologia). 6 vols. Paris, 1839.

GÓMEZ DE LA SERNA, Ramón. *Goya*. Madrid, La Nave, 1943.

GOYA, Francisco de. Ms. letters to Martín Zapater, 1774–1799. Madrid, preserved in the Prado. See also AGUEDA, Mercedes, op. cit.

Goya y la Constitución de 1812. Museo Municipal exhibition catalogue. Madrid, 1982.

GUDIOL, José. *Goya*. Priscilla Muller (trans.). New York, Abrams, 1965.

GUERRERO LOVILLO, José. "Goya en Andalucía," *Goya: Revista de Arte*, Madrid, no. 100, Jan.-Feb., 1971.

HARGREAVES-MAWDSLEY, W. Norman. *Eighteenth-Century Spain, 1700–1788*. London, Macmillan, 1978.

HARRIS, Enriqueta. *Goya*. London, Phaidon, 1972.

HARRIS, Tomás. *Goya: Engravings and Lithographs*. London, Faber, and Oxford, Cassirer, 1964.

HELD, Jutta. *Farbe und Licht in Goyas Malerie*. Berlin, W. de Gruyter, 1964.

HELMAN, Edith. *Jovellanos y Goya* (a group of articles, eg., from *Hispanic Review*, Philadelphia, XXVI & XXVII, and *Insula*, Madrid, XV). Madrid, Taurus, 1970.

_____. *Trasmundo de Goya*. Madrid, Revista de Occidente Press, 1963.

HERR, Richard. *The Eighteenth-Century Revolution in Spain*. Princeton, N.J., Princeton University Press, 1958.

HOLLAND, Elizabeth Lady. *The Spanish Journal of Elizabeth Lady Holland, 1791–1811*. 2 vols., edited in one vol. by the Earl of Ilchester. London, Longmans, Green, 1910.

HULL, Anthony H. *Charles III and the Revival of Spain*. Washington, D.C., University Press of America, 1980.

JONES, Leslie. "Peace, Prosperity and Politics in Tiepolo's *Glory of the Spanish Monarchy*." *Apollo*. London, October 1981.

JOVELLANOS, Gaspar Melchor de. Ms. Diary, in which Goya's church paintings are described, 1801. Published by courtesy of the Marqués de Lozoya, 1946.

KLINGENDER, F. D. *Goya in the Democratic Tradition*. London, Sidgwick and Jackson, 1948.

LAFUENTE FERRARI, Enrique. *Los desastres de la guerra de*

Goya. Barcelona, Instituto Amatller, 1952.
_____. *The Frescoes in San Antonio de la Florida in Madrid.* Stuart Gilbert (trans.). New York, Skira, 1955.
_____. *Goya, his Complete Etchings, Aquatints and Lithographs.* R. Rudorff (trans.). New York, Abrams, 1962.
LICHT, Frederick. *Goya, the Origins of the Modern Temper in Art.* London, John Murray, 1979.
LLORENTE, Juan Antonio. *Histoire critique de l'Inquisition d'Espagne.* 4 vols. Paris, 1818.
LLORIS, Miguel, and Micaela SAENZ (eds.). *Los Caprichos.* Zaragoza, Museo Provincial, 1978.
_____. *Los Dibujos de Goya.* Zaragoza, Museo Provincial, 1978.
LOGA, Valerian von. *Francisco de Goya.* Berlin, G. Grote, 1921.
LÓPEZ VÁZQUEZ, José Manuel B. *Goya: El Programa neoplatónico de las Pinturas de la Quinta del Sordo.* Santiago de Compostela, Velograf, 1981.
LÓPEZ-REY, José. *Los Caprichos.* Princeton, N.J., Princeton University Press, 1953.
_____. "Goya's *The Taking of Christ.*" *Apollo*, London, October 1981.
MATHÉRON, Laurent. *Goya.* Paris, 1858.
MAYER, August L. *Francisco de Goya.* Munich, F. Bruckmann, 1923.
MORATÍN, Leandro Fernández de. Ms. Diary (beginning with that of his father, Nicolás de Moratín). Madrid, Biblioteca Nacional, Ms. 5617, 1782–1808. See also ANDIOC, op. cit.
MORATÍN, Nicolás Fernández de. *Carta histórica sobre el origen y progreso de la corrida de toros en España.* Madrid, 1777.
MULVEY, Jeremy. "Palace Decoration at the Spanish-Bourbon Court." *Apollo*, London, October 1981.
NÚÑEZ DE ARENAS, Manuel. "La Suerte de Goya en Francia." *Bulletin hispanique*, Bordeaux, LII, no. 3, 1950.
ORTEGA Y GASSET, José. *Velazquez, Goya and the Dehumanization of Art.* Alexis Brown (trans.). London, Cassell-Studio Vista, 1972.
PAYNE, Stanley G. *A History of Spain and Portugal.* 2 vols. Madison, University of Wisconsin Press, 1973.

PITA ANDRADE, José Manuel. *Goya*. Madrid, Silex, 1979.

QUINTANA, Manuel José. *Al Combate de Trafalgar*. Madrid, c.1806.

REGLÁ, Juan, and Santiago ALCOLEA. *Historia de la cultura española. El Siglo XVIII*. Barcelona, Editorial Seix Barral, 1957.

ROTHENSTEIN, Sir William. *Goya*. London, 1900.

_____. *Men and Memories: Recollections*. 3 vols., esp. vol. 1. London, Faber & Faber, 1931–39.

SALAS, Xavier de. *Goya*. G. T. Culverwell (trans.). London, Cassell-Studio Vista, 1979.

_____. *Los Proverbios ó Disparates*. Barcelona, Gili, 1968.

_____. See AGUEDA, Mercedes, op. cit.

SAMBRICIO, Valentín de. *Tapices de Goya*. 2 vols. Madrid, Patrimonio Nacional, Archivo General de Palacio, 1946.

SÁNCHEZ CANTÓN, Francisco J. (with an appendix by Xavier de Salas). *Goya and the Black Paintings*. London, Faber & Faber, 1964.

_____. *Goya: La Quinta del Sordo*. Firenze (Florence), Sadea-Sansoni, c.1965.

_____. "Los niños en las obras de Goya." *Goya, Cinco estudios*. Zaragoza, Institución Fernando el Católico, 1978.

_____. *Vida y Obras de Goya*. Madrid, Editorial Peninsular, 1951.

SAYRE, Eleanor A. *The Changing Image: Prints by Francisco Goya*. Boston Mass., Museum of Fine Arts, 1974.

_____. *Late Caprichos of Goya*. New York, Philip Hofer, Walker & Co., 1971.

SORIA, M.S. "Goya's Allegories of Fact and Fiction." *The Burlington Magazine*, London, XC, 1948.

STIRLING-MAXWELL, Sir William. *Annals of the Artists of Spain*. 3 vols., London, 1848.

TEJADA, José Moreno de. *Excelencias del pincel y del buril*. Madrid, 1804.

THOMAS, Hugh. *Goya: The Third of May 1808*. New York, Viking Press, 1973.

TRAPIER, Elizabeth Du Gué. *Goya and his Sitters*. New York, Hispanic Society of America, 1964.

_____. "Only Goya" (on cleaning the Alba portrait). *The*

Burlington Magazine, London CII, 1960.

VARGAS PONCE, José de. Presumed author of "Pan y Toros." Madrid, c.1796.

VIARDOT, Louis, et al. *A Brief History of the Painters of All Schools*. London, 1877.

VIÑAZA, Conde de la. *Goya: Su tiempo, su vida, sus obras*. Madrid, 1887.

WEISS. Leocadia. See ZORRILLA, *infra*.

WILLIAMS, Gwyn A. *Goya and the Impossible Revolution*. London, Allen Lane, 1976.

WILSON, Juliet, see GASSIER, Pierre, and Juliet WILSON, op. cit.

WYNDHAM LEWIS, D. B. *The World of Goya*. New York, Clarkson H. Potter, 1968.

YOUNG, Eric. *Francisco Goya*. London, St. Martin's, 1978.

YRIARTE, Charles. *Goya*. Paris, 1867.

ZAPATER Y GÓMEZ, Francisco. *Goya. Noticias biográficas*. Zaragoza, 1868.

ZORRILLA DE WEISS, Leocadia. Two ms. letters to Leandro de Moratín. Madrid, Biblioteca Nacional, Ms. 12963-40, April 28 and May 13, 1828.

Note on Periodicals.

Special issues on Goya appeared in *Apollo* ('Goya and the Spanish Tradition'), London, October 1981; *The Burlington Magazine*, London, CVI, no. 730, January 1964; *Goya: Revista de Arte*, Madrid, no. 100, Jan.-Feb., 1971; and *Revista de Ideas Estéticas*, Madrid, IV, nos. 15-16, July-Dec., 1946.

Appendix A. Political leanings of some of Goya's patrons from 1808.

Conservative patriot	Liberal patriot	Francophile
Duchess of Abrantes	Conde de Altamira	Tadeo Bravo de Rivero
J. A. Céan Bermúdez	Sra. Bailó	Conde de Cabarrús
Father José Duaso	Juan Martín Díaz	Manuel García de la
Ferdinand VII	Father J. Fernández	Prada
Conde de Fernán Núñez	de Rojas	Juan B. de Goicoechea
Floridablanca	Joaquín Ferrer	Martín M. de Goicoechea
I. González Velazquez	Jovellanos	Bernardo de Iriarte
Miguel de Lardizábal	Isidro Maiquez	Juan Antonio Llorente
Marquesa de Lazán	José Palafox	José Mazarredo
Archbishop Luis	T. Pérez y Cuervo	Juan Meléndez Valdés
José Munárriz	R. de Posada y Soto	Marquesa de
Ignacio Omulryan	María M. de Puga	Montehermoso
10th Duke of Osuna	Francisco de Saavedra	Leandro de Moratín
Duke of San Carlos	Marquesa de Santa Cruz,	José M. Romero
Marquesa de	daughter of the Osunas	Marqués de San Adrián
Villafranca the	Ramón Salué	Marquesa de Santiago
younger	José de Vargas Ponce	Manuel Silvela
	Leocadia Zorrilla	Mariano de Urquijo

Note: Conservatives later were generally split on whether to support the Constitution or not. Those nearest to Ferdinand VII would obviously tend to oppose it, regardless of inner convictions.

Appendix B. Professional backgrounds of Cortes members.

Year of election	Land, business, and various middle class	Government and military	Clergy	Total
1810	105	101	97	303
1820	45	69	35	149
1822	61	60	28	149
1834	130	53	5	188

Reproduced by courtesy of Stanley G. Payne from his *History of Spain and Portugal*, vol. 2, pp. 426 and 438, published by The University of Wisconsin Press, 1973.

INDEX

Note. For Goya's individual works, see under Goya: works, or else under the appropriate patron, subject, or institution. For Spanish names, see under the first part of the family name where possible, e.g., José de Vargas Ponce would be under Vargas.